Hong Kong University Press thanks Xu Bing for writing the Press's name in his Square Word Calligraphy for the covers of its books. For further information, see p. iv.

TransAsia: Screen Cultures

Edited by Koichi IWABUCHI and Chris BERRY

What is Asia? What does it mean to be Asian? Who thinks they are Asian? How is "Asian-ness" produced? In Asia's transnational public space, many kinds of cross-border connections proliferate, from corporate activities to citizen-to-citizen linkages, all shaped by media — from television series to action films, video piracy, and a variety of subcultures facilitated by internet sites and other computer-based cultures. Films are packaged at international film festivals and marketed by DVD companies as "Asian," while the descendents of migrants increasingly identify themselves as "Asian," then turn to "Asian" screen cultures to find themselves and their roots. As reliance on national frameworks becomes obsolete in many traditional disciplines, this series spotlights groundbreaking research on trans-border, screen-based cultures in Asia.

Other titles in the series:

The Chinese Exotic: Modern Diasporic Femininity, by Olivia Khoo

Cultural Studies and Cultural Industries in Northeast Asia: What a Difference a Region Makes, edited by Chris Berry, Nicola Liscutin, and Jonathan D. Mackintosh

East Asian Pop Culture: Analysing the Korean Wave, edited by Chua Beng Huat and Koichi Iwabuchi

Horror to the Extreme: Changing Boundaries in Asian Cinema, edited by Jinhee Choi and Mitsuyo Wada-Marciano

TV Drama in China, edited by Ying Zhu, Michael Keane, and Ruoyun Bai

Series International Advisory Board
Ackbar ABBAS (University of Hong Kong)
Ien ANG (University of Western Sydney)
Yomi BRAESTER (Washington University)
Stephen CHAN (Lingnan University)
CHUA Beng-Huat (National University of Singapore)
Ian CONDRY (Massachusetts Institute of Technology)
DAI Jinhua (Peking University)
John Nguyet ERNI (Lingnan University)
Annette HAMILTON (University of New South Wales)
Rachel HARRISON (School of Oriental and African Studies, University of London)
Gaik Cheng KHOO (Australian National University)
KIM Kyung-Hyun (University of California, Irvine)
KIM Soyoung (Korean National University of Arts)
Helen Hok-Sze LEUNG (Simon Fraser University)
Akira Mizuta LIPPIT (University of Southern California)
Feii LÜ (National Chengchi University)
LÜ Xinyu (Fudan University)
Eric MA (Chinese University of Hong Kong)
Fran MARTIN (Melbourne University)
MOURI Yoshitaka (Tokyo National University of Fine Arts and Music)
Meaghan MORRIS (Lingnan University)
NAM Inyoung (Dongseo University)
PANG Laikwan (Chinese University of Hong Kong)
Michael RAINE (University of Chicago)
Bérénice REYNAUD (California Institute of the Arts)
Lisa ROFEL (University of California, Santa Cruz)
Krishna SEN (Curtin University of Technology)
Ubonrat SIRIYUVASAK (Chulalongkorn University, Bangkok)
Eva TSAI (National Taiwan Normal University)
Paola VOCI (University of Otago)
YOSHIMI Shunya (Tokyo University)
ZHANG Zhen (New York University)

CINEMA AT THE CITY'S EDGE
FILM AND URBAN NETWORKS IN EAST ASIA

edited by Yomi Braester
and James Tweedie

HONG KONG UNIVERSITY PRESS

Hong Kong University Press
14/F Hing Wai Centre
7 Tin Wan Praya Road
Aberdeen
Hong Kong

© Hong Kong University Press 2010

Hardback ISBN 978-962-209-983-8
Paperback ISBN 978-962-209-984-5

All rights reserved. No portion of this publication may be reproduced or transmitted in any form or by any means, electronic or mechanical, including photocopy, recording, or any information storage or retrieval system, without prior permission in writing from the publisher.

British Library Cataloguing-in-Publication Data
A catalogue record for this book is available from the British Library.

Secure On-line Ordering
http://www.hkupress.org

Printed and bound by Goodrich Int'l Printing Co., Ltd., Hong Kong, China

Hong Kong University Press is honoured that Xu Bing, whose art explores the complex themes of language across cultures, has written the Press's name in his Square Word Calligraphy. This signals our commitment to cross-cultural thinking and the distinctive nature of our English-language books published in China.

"At first glance, Square Word Calligraphy appears to be nothing more unusual than Chinese characters, but in fact it is a new way of rendering English words in the format of a square so they resemble Chinese characters. Chinese viewers expect to be able to read Square Word Calligraphy but cannot. Western viewers, however are surprised to find they can read it. Delight erupts when meaning is unexpectedly revealed."

— Britta Erickson, *The Art of Xu Bing*

Contents

Acknowledgments . vii

List of Contributors. ix

Introduction: The City's Edge . 1
 James Tweedie and Yomi Braester

• INTERLUDE 1: Arriving in the City; Touring the City;
 Watching the City. 17
 Yomi Braester

Part I. The City Vanishes

 1. Affective Spaces in Hong Kong/Chinese Cinema. 25
 Ackbar Abbas

 2. Ghost Towns . 37
 Dudley Andrew

• INTERLUDE 2: Workspace. 49
 James Tweedie

Part II. A Regional Network of Cities

 3. Taipei as Shinjuku's Other . 55
 Emilie Yueh-yu Yeh

 4. City of Youth, Ocean of Death:
 Taiyōzoku on the Edge of an Island . 69
 Yiman Wang

• INTERLUDE 3: Neon. 89
 James Tweedie

Part III. The City of Media Networks

5. Transfiguring the Postsocialist City:
 Experimental Image-Making in Contemporary China 95
 Zhang Zhen

6. Noir Looks and the Flash of Transgression:
 Trauma and the City's Edge(s) in *A Bittersweet Life* 119
 Susie Jie Young Kim

7. Technology and (Chinese) Ethnicity. 137
 Darrell William Davis

- INTERLUDE 4: In the Name of the City. 151
 Yomi Braester

Part IV. The City Is Elsewhere

8. Imaging the Globalized City:
 Rem Koolhaas, U-thèque, and the Pearl River Delta 155
 Chris Berry

9. At the Center of the Outside:
 Japanese Cinema Nowhere . 171
 Akira Mizuta Lippit

Notes . 181

Index . 197

Acknowledgments

This volume is the outcome of a conference held at the University of Washington in April 2006. The conference was made possible by generous grants from the East Asia Center and the Institute for Transnational Studies at the Henry M. Jackson School of International Studies and the Simpson Center for the Humanities at the University of Washington. We are grateful to the staff at these centers, and especially to Miriam Bartha, Kristi Roundtree, and Kathleen Woodward, for their help in securing and facilitating these grants.

We have been very lucky to work with a forthcoming team at Hong Kong University Press, first with Colin Day and Ian Lok, and then with Dennis Cheung, Michael Duckworth, Dawn Lau, and the two anonymous readers. Their attention and patience have made this book much better.

We are most indebted to the contributors to this volume and to the other participants in the conference, whose feedback has enriched the essays published here: Robert Chi, Kyung Hyun Kim, Helen Hok-Sze Leung, Lin Wenchi, and Michael Raine, as well as our colleagues from Cinema Studies and East Asian Studies at the University of Washington who attended the conference.

Contributors

Ackbar Abbas, Professor of Comparative Literature, University of California, Irvine.
Ackbar Abbas's book *Hong Kong: Culture and the Politics of Disappearance* was published in 1997. He is the editor (with John Nguyet Erni) of *Internationalizing Cultural Studies: An Anthology* (2004). He has also published essays on modern Chinese painting, Baudrillard and Benjamin, film theory, and postmodernism; and he writes and lectures frequently on contemporary East Asian urban culture.

Dudley Andrew, R. Selden Rose Professor of Comparative Literature, Yale University.
Dudley Andrew examines films through the lens of aesthetics, and has recently published *What Cinema Is!*. He is currently developing a book entitled *Conceiving World Cinema*.

Chris Berry, Professor of Film and Television Studies, Goldsmith's College, University of London.
Chris Berry's primary publications include: (with Mary Farquhar) *Cinema and the National: China on Screen* (2006); *Postsocialist Cinema in Post-Mao China: The Cultural Revolution after the Cultural Revolution* (2004); (edited with Kim Soyoung and Lynn Spigel) *Electronic Elsewheres: Media, Technology, and Social Space* (2010); (edited with Nicola Liscutin and Jonathan D. Mackintosh) *Cultural Studies and Cultural Industries in Northeast Asia: What a Difference a Region Makes* (2009); (edited with Ying Zhu) *TV China* (2008); (editor) *Chinese Films in Focus II* (2008); (edited with Feii Lu) *Island on the Edge: Taiwan New Cinema and After* (2005); (edited with Fran Martin and Audrey Yue) *Mobile Cultures: New Media and Queer Asia* (2003); and (translator and editor) Ni Zhen, *Memoirs from the Beijing Film Academy: The Genesis of China's Fifth Generation Filmmakers* (2002).

Yomi Braester, Professor of Comparative Literature, University of Washington.
Yomi Braester is the author of *Witness against History: Literature, Film, and Public Discourse in Twentieth-Century China* (2003) and *Painting the City Red: Chinese Cinema and the Urban Contract* (2010).

Darrell William Davis, Honorary Associate Professor in Visual Studies, Lingnan University, Hong Kong.
Darrell William Davis is the author of *Picturing Japaneseness: Monumental Style, National Identity, Japanese Film* (1996), co-author of *Taiwan Film Directors: A Treasure Island* (2005) and *East Asian Screen Industries* (2008), and co-editor of *Cinema Taiwan: Politics, Popularity and State of the Arts* (2007).

Susie Jie Young Kim, Lecturer, UCLA.
Susie Jie Young Kim's research interests include Korean and East Asian cinema, the "new woman," colonial modernity, trauma and memory, and the historically marginalized subject in 1960s–1970s Korean literature. Her publications include: "What (not) to Wear: Re-fashioning Civilization in Print Media in Turn of the Century Korea," in *Positions: East Asia Cultures Critique*; "Sinsosol and the Emergence of 'New Literature': The Discourse of the New in the Great Han Empire," in *Reform Projects and Modernization during the Great Han Empire Period*; and essays on Korean cinema in *Critical Filmography on World Cinema* (forthcoming). She has edited a special volume of *Manoa: A Pacific Journal of International Writing* on Korean literature.

Akira Mizuta Lippit, Chair of Critical Studies, School of Cinematic Arts, and Professor of Comparative Literature and East Asian Languages and Cultures, University of Southern California.
Akira Mizuta Lippit's teaching and research focus on four primary areas: the history and theory of cinema, world literature and critical theory, Japanese film and culture, and visual cultural studies. Lippit's published work includes two books, *Atomic Light (Shadow Optics)* (2005) and *Electric Animal: Toward a Rhetoric of Wildlife* (2000). In addition to his two completed books, Lippit is presently finishing a book-length study of experimental film and video, and has begun research for a book on contemporary Japanese cinema, which looks at the relationship of late-twentieth and early twenty-first-century Japanese culture to the concept of the world. His published articles have appeared in scholarly journals of film, literature, and culture, including *1895, Afterimage, Assemblage, Criticism, Discourse, Film Quarterly, InterCommunication Quarterly, Modern Language Notes, Paragraph, Public, Qui Parle,* and others. They have also

appeared in national and international exhibition and museum catalogues and in scholarly anthologies. He has published widely in international venues, and his work has been translated in French, German, Italian, Japanese, and Korean. Prior to his appointment at USC in 2005, Lippit held appointments in film studies at the University of California, Irvine, San Francisco State University, and the University of Nebraska-Lincoln. Since 1995, he has been a visiting professor of humanities at Josai International University in Japan.

James Tweedie, Assistant Professor of Comparative Literature, University of Washington.
James Tweedie's essays have been published or are forthcoming in *Cinema Journal*, *Public Culture*, *Screen*, *SubStance*, and *Twentieth Century Literature*, as well as the edited volumes *Cinema Taiwan* and *Opening Bazin*, and the anthology *Queer Screen*. He is currently completing a comparative study of cinematic new waves in the post–World War II era.

Yiman Wang, Assistant Professor of Film and Digital Media, University of California, Santa Cruz.
Wang Yiman is completing a book on cross-Pacific film remakes. Her work on film remakes and adaptation, border-crossing stars, Chinese cinema, and DV documentaries has appeared in *Quarterly Review of Film and Video*, *Film Quarterly*, *Camera Obscura*, *Journal of Film and Video*, *Literature/Film Quarterly*, *Positions: East Asia Cultures Critique*, *Journal of Chinese Cinemas*, *Chinese Films in Focus* (edited by Chris Berry) and *Idols of Modernity: Movie Stars of the 1920s* (edited by Patrice Petro).

Emilie Yueh-yu Yeh, Professor of Film Studies, Director of the Centre for Media and Communication Research, and Associate Director of the David C. Lam Institute for East-West Studies, Hong Kong Baptist University.
Emilie Yueh-yu Yeh's publications include: (with Darrell Davis) *Taiwan Film Directors: A Treasure Island* (2005), (with Sheldon Lu) *Chinese-Language Film: Historiography, Poetics, Politics* (Choice's 2005 outstanding academic title), (with Darrell Davis) *East Asian Screen Industries* (2008), and *Phantom of the Music: Song Narration and Chinese-Language Cinema* (2000). She has written more than thirty journal articles and book chapters. Her current research projects include China's film marketization and Chinese *wenyi* pictures.

Zhang Zhen, Associate Professor of Cinema Studies, New York University.
Zhang Zhen is the author of *An Amorous History of the Silver Screen: Shanghai Cinema 1896–1937* (2005) (awarded MLA's "Honorary Mention for First Book"),

editor of *The Urban Generation: Chinese Cinema and Society at the Turn of the Twenty-First Century* (2007), and co-editor of the forthcoming *Screening TransAsia: Genre, Stardom, and Intercultural Imaginaries*. Her articles have appeared in numerous journals, anthologies, and catalogues in several languages. Her current research projects include orphanhood and the melodrama of postwar sinophone film history, and the DV generation: remaking Chinese cinema and society. Zhang Zhen is also a widely published poet and essayist.

Introduction: The City's Edge

James Tweedie and Yomi Braester

The city's edge is the place where the urban environment encounters its limits, a site where existing conceptions of the city are challenged and redefined. More than any other regional network of cities, the built environments of East Asia have pushed toward the vanguard of a new urbanism. The pace and scale of the transformation of cities in East Asia beggar even the essential vocabulary inherited from architecture and urban planning, compelling critics to qualify or supplement references to the city with modifiers like "global," "world," or "mega." On the outskirts of these major urban centers or in sparsely populated counties far from the metropolis, in areas formerly occupied by farms or barren land, the boomtowns known as "instant cities" crop up. Over roughly the same period the digital revolution has resulted in an equally profound transformation of media ecologies throughout the region, as film yields to digital technology and hypermedia, forcing filmmakers and critics to envision a future after the decline of celluloid and the particular communal experience of movie theaters. The instant or world city becomes a laboratory for media produced, circulated, and consumed on a global scale and in a trice. Experiments with new media are nowhere more evident than in the city films and other modes of urban culture emanating from East Asia in the current era of globalization. The reimagined city also pushes cinema to its edge. *Cinema at the City's Edge* is a book about the relationship between visual images and urban space, but it begins from the premise that its key terms — "cinema" and the "city" — no longer mean what they did even two decades ago. The essays collected in this volume propose several redefinitions of those concepts, while focusing in particular on the relationship between the media and urban networks under construction throughout East Asia.

In recent city films from mainland China, Hong Kong, Japan, South Korea, and Taiwan, urban space becomes a display for the newfound abundance and consumer culture that accompany the region's "economic miracles," the uneven distribution of that wealth, and the role of image cultures in the production

and cultivation of consumer desires. In these films we also encounter an almost entirely urbanized environment, a world where the once-fundamental dichotomy between urban and rural has been displaced, where the social and economic dramas of the new era are staged across emergent and historical forms of the city. With the rapid outward expansion of urban areas throughout East Asia, the "edge" of the city has become as vague and indistinct as the seemingly endless industrial and residential suburbs sprouting up on the farmland and villages that once marked the passage into a rural ecology. Taken together, the new urban films from East Asia provide a closely observed and precisely catalogued record of urban experience during this transitional moment. Throughout the twentieth century, extravagant and tantalizing representations of the city circulated around the region and world, projecting spectral images of urbanity far beyond the more proximate verges of the city; but new screen and dissemination technologies have increased the speed and extended the reach of those images, establishing virtual links between the city and its outside. As they follow these new developments in the urban cinema of East Asia, the essays collected in this volume undertake a series of related tasks: they document previous conceptions of the city film and observe the emergent image environments that appear in moments of crisis and historical transformation; they rethink the relationship between film or media practices and these new environments; and they trace connections among cities in East Asia, constructing and mapping a region marked by audacious experiments in urbanization and its images.

Pushing the Boundary: Recent Developments in East Asian Urbanism

The cinematic visions of an increasingly urbanized life may take the form of naïve modernist fantasies or alarmist dystopias, yet they also engage with an undeniable demographic reality: the world as a whole, and East Asia in particular, is accelerating toward an unprecedented degree of urbanization. According to the UN's *2007 Revision of World Urbanization Prospects*, "the world population will reach a landmark in 2008: for the first time in history the urban population will equal the rural population of the world and, from then on, the world population will be urban in its majority."[1] The report predicts that by 2050, 6.4 billion of an estimated global population of 9.2 billion will live in cities, and Asia occupies a position of exceptional importance in this narrative of frenetic urban development. The authors write that "most of the population growth expected in urban areas will be concentrated in the cities and towns of the less developed regions. Asia, in particular, is projected to see its urban

population increase by 1.8 billion, Africa by 0.9 billion, and Latin America and the Caribbean by 0.2 billion. Population growth is therefore becoming largely an urban phenomenon concentrated in the developing world" (1). China alone is expected to add 466 million residents to its already crowded cities, crescendoing toward an urban population of approximately one billion by mid-century (8). Earlier developing cities in the region — Tokyo and Seoul, for example — will house an increasing percentage of their nation's citizens and residents, as Japan and South Korea also shift toward a more urbanized and less rural society (though they anticipate an overall decline in total population figures consistent with demographic trends in these relatively wealthy states). And Hong Kong, for many years the model for the development of mainland Chinese cities like Shenzhen, Guangzhou, and Shanghai, now struggles to reinvent itself in a new era when the Pearl River Delta alone hosts at least three major hubs of economic activity and the center of gravity in the Southeast Asian economy has gradually shifted across the border to Guangdong. The urban centers of East Asia's previous eras of explosive economic development are confronted by a world reconstructed in their image, a polycentric network of cities. Taken as a whole, the East Asian region contains about half of the world's largest cities measured by population and density, and five of the ten fastest growing cities.[2] At the same time, many of these cities expand out of their traditional centers and incorporate formerly distinct areas within the nominal boundaries of the city: the urbanized area of Shanghai municipality, to take one prominent example, increased by almost 500 percent between 1985 and 1995.[3] One of the most urgent tasks for architects, artists, politicians, urban planners, and virtually anyone concerned with the state of urban development is to imagine qualitatively new urban forms that match in their radicalism and creativity the quantitative changes that will continue to register in the urban landscape and at the edge of the expanding city.

Edging toward the Global

Over the past several decades, and especially from the 1990s on, the relentless process of urbanization has inspired an outpouring of empirical research and theory-building from scholars in disciplines ranging from urban studies to sociology, from art history and cinema studies to history and political science. But the most insightful of these studies begin by acknowledging the limits of historical analogy when describing recent trends in urbanization, especially in the most dynamic regions in the world, and particularly in the current era of globalization. The result is a series of attempts to think at once about realities in the grounded and circumscribed domain of the city, neighborhood, street,

or home, and the abstract and intangible global forces that eventually manifest themselves at the local level. One of the most perceptive and influential of these scholars, Saskia Sassen, traces a network of "global cities" where corporate command-and-control functions are concentrated, and where financial transactions are initiated, negotiated, and concluded.[4] She also demonstrates that the ethereal exchanges taking place over computer networks require an extensive support infrastructure, resulting in dramatic changes in the concrete reality of these global cities and their work force. But even Sassen's work, which focuses at once on the immaterial and the material, the speculative networks linking cities and their physical effects on the ground, narrows its attention to a handful of major metropolitan areas that house corporations with global reach and ambition, along with the high-level business services they require. Scholarship on the global city therefore describes an exceptional and rarefied environment in the new world system, and it privileges two geographical and political scales — the city and the world — over the various entities that occupy less prominent positions in the contemporary geopolitical imagination. The imperative to move beyond the certainties of immediate experience and instead confront the intellectual and political challenges of globalization — the process that Neil Smith calls "jumping scales" from the intensely local to broader spatial and conceptual categories — must also consider the levels of analysis skirted in this rush toward analysis on the scale of the world.[5] As Ashley Dawson and Brent Hayes Edwards write in their essay on "Global Cities of the South," "The global cities of the developed world are an increasingly anomalous embodiment of the urban realm and public space."[6] They observe the persistence of a North-South divide despite the ubiquitous rhetoric of globalization and propose a research agenda focused on the experience of urbanization in the global South. They also construct a model of urban cultural studies that revises the nationalist framework of much postcolonial theory and rejects the developmentalist logic of late capitalism. They present a vision of the world glimpsed not from office towers and shopping malls, but from the centers of material production that rarely feature in the image economy of globalization.

The next wave of scholarship on cities must also take into account the shift in gravity from the Euro-American city to the urban forms of East Asia, while remembering that the region is more than the fortunate site of capitalism's latest round of so-called "economic miracles."[7] Cities all around East Asia have been engulfed in a "world-city craze" in recent years, and the region's cultural and political capitals have hosted the most prestigious cosmopolitan events, including the recent Beijing Olympics. A handful of cities now find themselves inching ever closer to the center of global economic and cultural life. They have witnessed the meteoric, vertical rise of their central business

districts, the solidification of their status as command centers in the national or regional economy, the global distribution of a carefully composed image of the city centering on well-known architectural landmarks, and the proliferation of "brandscapes," with their familiar icons and slogans locating a particular space within a network of similarly globalized environments.[8] The city occupies an increasingly crucial role in an all-encompassing economic and ideological agenda. Political, business, and cultural leaders assiduously market these new urban forms as the site of a utopian future realized in the present. But at the same time, the condition of these privileged cities remains exceptional, especially in their showcase tourist and financial districts. A regional perspective on the representation of cities opens onto a multiplicity of urban forms and experiences that stretch across the North-South divide, with glitzy hypermodernization accompanied by persistent and extreme poverty, and economic expansion on an unprecedented scale alongside relative stagnation and neglect. Over the past half-century, and especially over the past three decades, East Asia has emerged as the world's principal factory of both economic miracles and uneven development, with these discrepancies apparent not only across national borders or in the gap between urban and rural areas, but also in the erratically globalized topography of cities like Beijing, Shanghai, and Seoul. To examine the urban condition across this region is to confront both the tantalizing allure of global capitalism and its most appalling failures.

Like the work of Dawson and Edwards, *Cinema at the City's Edge* considers tendencies that extend beyond the individual metropolis or the nation, while proposing another geographic entity — the East Asian region — as a grounding in material and historical relations and a ballast against the more dominant and immaterial images of globalization, especially those centered on the ghostly transactions across twenty-first-century communications networks. Filmmakers, programmers, and scholars, including many contributors to this volume, have been exploring this relatively intangible realm with increasing urgency in recent years. Major and emerging film festivals like Hong Kong, Pusan, Tokyo, and Yamagata have long featured Asian productions not only to promote directors from the region, but also to accentuate the connections and commonalities that would otherwise remain implicit. The 18th Hong Kong Kong International Film Festival in 1994 adopted the unusual strategy of pairing off two cities, Hong Kong and Shanghai, with film cultures that were intricately intertwined for decades. This special program, titled "Cinema of Two Cities," highlighted the migration of key figures in each industry, as well as the more elusive but also more enduring aesthetic influences that accompanied these movements of people and films.[9] Many recent attempts to discover an East Asian identity remain elusive and abstract, including the imaginary kinship among purportedly Confucian

civilizations. But regional integration takes material form in the convergence of East Asian screen cultures through the intra-Asian funding of film production, importation of TV series, and reinvention of the cell phone as the key platform for image dissemination.

Computer monitors and cell phone screens now stand metonymically for a particular, usually corporate model of globalization, a utopia of free and unfettered flows of information and images, a "charismatic" vision unmatched at the moment by any competing conception of internationalism.[10] But by thinking comparatively across the varied terrain of cities and the East Asian region as a whole, we hope to balance the allure of these idealized flows with other modes of image-making, including films that both lose themselves in the gushing stream of digital media and ground themselves in the concrete reality of cities.

The City Made of Cinema

Cinema at the City's Edge also considers the unstable and protean identity of cinema in the contemporary image economy. Film today exists in a state of paradoxical centrality and obsolescence because, while it provides the strategies for visualizing and theorizing the historical realities of the early twenty-first century, celluloid itself is passing through a period of transition and volatility, as an era of late cinema winds down and resolves into a digital age. Many essays in this volume are concerned not only with film per se, but also with experimental documentaries, avant-garde videos, anime, and other emerging media or genres. Contemporary urban space has developed into a pressing concern for filmmakers, though the big-screen film is only one of many formats now mobilized to imagine and disseminate moving images, and the efficient conversion of ideas onto "four screens" (film, television, web, and mobile) has become a driving ambition for artists and media executives. But even as images are designed to be small and portable instead of "larger than life," cinema lingers on in often unrecognized forms, as a template for filmmakers operating primarily in newer media or as a conceptual framework for scholars analyzing an unfamiliar media landscape organized around these plural and proliferating screens. This obligation to think through the implications of an increasingly digitalized media environment is nowhere more pressing than in the recently transformed urban environments of East Asia, where governments and consumers have embraced new media technology with unrivaled enthusiasm and recent waves of urbanization have paralleled the burgeoning of television, the Internet, or mobile video rather than, for example, the rise of the grand downtown theater. Lev Manovich and others have noted the importance of a

cinematic imagination for the digital artists and media corporations who import a superficial appearance and underlying conceptual apparatus borrowed from cinema. Likewise, architecture and urban theory conceived within the orbit of emerging media remain indebted to the revolutionary art forms of the now-distant twentieth century. The metaphor of the image flow persists as one of the dominant conceptual models of our time, with ramifications in various domains of artistic, intellectual, political, and economic life; and cinema maintains a lingering if under-recognized presence in many of these post-cinematic debates. While filmmakers and critics continually revisit Marxist struggles over the "right to the city" or Benjamin's writing on the city of consumption, with the arcades, train stations, and museums that together constitute its "dream houses of the collective,"[11] they also find themselves returning to André Bazin's age-old question: "What is cinema?" To understand either the city or the cinema in its current forms requires that we also grapple with the other half of this historically intertwined pair.

City Films: An Edgy Genre

The city film, as a genre of sorts that involves a reconsideration of both urban environment and cinema, has undergone a stunning revival in the last quarter-century, especially in China, Hong Kong, Japan, Korea, and Taiwan. By way of an example, we may look at the careers of Taiwan's most prominent directors since the 1980s. Edward Yang repeatedly located his films in the urban environments of a modernizing, then globalizing Taiwan, from *Taipei Story* (Qing mei zhu ma, 1985) to *The Terrorizer* (Kongbu fenzi, 1986), *A Confucian Confusion* (Duli shidai, 1994), and *Yi Yi* (2000). Over the same period, the films of Hou Hsiao-hsien — whose career began with a series of nostalgic films set primarily in Taiwan's rural past, before the economic miracle of the 1970s and 1980 — have migrated irreversibly toward the city, especially Taipei. The main characters and environments of Hou's first films — children playing under trees in *Summer at Grandpa's* (Dongdong de jiaqi, 1984), or streetfighting teenagers roaming village streets in *A Time to Live and a Time to Die* (Tongnian wangshi, 1985) — have yielded pride of place to a new generation of youth with few affective links to the countryside. Several of Hou's films narrativize this movement from rural mountaintop or seaside spaces, including the early works *Cheerful Wind* (Feng'er ti ta cai, 1981) and most poignantly *Boys from Fenggui* (Fenggui lai de ren, 1983); yet by the time of *Millennium Mambo* (Qianxi manbo, 2001) and the final segment of *Three Times* (Zui hao de shiguang, 2005) even Hou has settled down among the deracinated youth of Taipei and reinvented himself as a maker of city films. *Café Lumière* (2003) extends this process of dislocation, as the filmmaker fashions

Tokyo as the cinematic and urban imaginary for his increasingly transnational vision of Taiwan.

By contrast, Tsai Ming-liang's films have always displayed an obsession with the physical environment and historical fate of Taipei. Tsai's camera rarely ventures beyond the boundaries of the city, with the notable exception of the sojourn in Paris chronicled in *What Time Is It There?* (Ni neibian ji dian, 2001). Tsai's films contemplate a certain category of anonymous modernist urban architecture just as it begins to show its age; his movies search for the particularity of Taipei within these generic spaces. To continue with the list of Taiwan directors, Chen Kuo-fu repeatedly stresses the formative impact of arriving in Taipei on his sensibility as a filmmaker, and even suggests that "all my films are about Taipei deep down."[12] While the eponymous conceit of *The Personals* (Zhenghun qishi, 1998) allows various character types to converge on a teahouse in search of a date, constructing an account of the city through the personalities and idiosyncrasies of its inhabitants, the supernatural thriller *Double Vision* (Shuang tong, 2002) focuses on the façades of Taipei's sleek office towers and the superstition, fear, and mystification that lie just beneath the surface of glass curtain modernity. Even more recently, a new generation of directors, from Lin Cheng-sheng to Leon Dai, has imagined the city at once as a backdrop for youthful romance and as an object of fascination in its own right, as an engine of the various desires — romantic, careerist, consumer — that drive the narratives. These are only some of the prominent examples amidst the many contemporary films that take Taiwan's cities, most notably Taipei, as an object of fascination, contemplation, and inquiry. A similar process has taken place in other cities in the region, as evidenced by the wave of urban cinema currently displayed on screens in China, Japan, Hong Kong, and South Korea, and by the essays in this volume. Throughout East Asia, urban space and experience have become a motivating concern and organizing pattern for contemporary filmmakers.

Cutting-Edge Scholarship: The State of the Academic Field

At the same time that filmmakers have found themselves drawn to representing contemporary urban environments, film scholars have increasingly paid attention to the relationship between cinema and the city. Recent edited volumes and monographs have noted that for much of its history film has been primarily an urban medium and charted the simultaneous development of cinema and cities since the turn of the twentieth century.[13] Filmmakers recorded the first films in urban environments, and audiences gathered in makeshift theaters to watch actualities and early narrative films. Scholars have examined the urban

movie-going experience in the heyday of the grand movie palaces that allowed audiences to bask momentarily in the glamor of Hollywood and indulge in the fantasies of consumption displayed on screen. The most influential of these studies is arguably Miriam Hansen's work, which over the course of several essays and the book-length *Babel and Babylon: Spectatorship in American Silent Film*, locates the mass art of cinema in the context of other forms of emerging media and consumption practices in the early twentieth century, including photography, radio, popular journalism, and fashion. Cinema developed into a primary mechanism for mediating between residents, many of them recent arrivals from abroad or domestic migrants, and the new urban experience. Film became "the first global vernacular" as its images circulated along an emerging network of modern cities.[14] Recent studies, including the transnational project "The Modern Girl around the World" and the Shanghai-focused research of Zhang Zhen, have examined the particular and variable manifestations of this "vernacular modernism" among women and youth audiences, as well as locations at the margins of the European and American film industries.[15] While films and fashions traveled between Manhattan and Paris, Hollywood and Shanghai, the city was remaking itself in the image of the movies, becoming more "cinematic." But by the late twentieth century the new paradigm for urban planning was not modernity but the "experience," with narrativized environments unfolding according to the constrained trajectory of a plotline and spectacular vistas carefully framed for the beholder or camera. The city is now imagined as cinematic in the earliest conceptual stages, even before it assumes a concrete form. As Christine Boyer argues in *The City of Collective Memory*, "The representational model for this new urbanism of perpetual motion in which fatuous images and marvelous scenes slide along in paradoxical juxtapositions and mesmerizing allusions is the cinema and television, with their traveling shots, jump-cuts, close-ups, and slow motion, their exploited experience of shock and the collisions of their montage effect."[16] While urban planners and architects began to accentuate the narrative and cinematographic potential of cities, the orientation and sensibility of cinema grew increasingly urban. Geoffrey Nowell-Smith suggests that the city film is characterized above all by the "recalcitrance" of the urban space that appears on screen, by "its inability to be subordinated to the demands of narrative."[17] In the most resolutely urban cinema, the city appears as both second nature, the inevitable background for modern stories whose proper domain is urban space — and an uncontainable excess that threatens to overwhelm the stories themselves, an object of attention as fascinating as any narrative. From aggressively marketed downtowns to the dynamic and experimental verges of the city, East Asia is constructing the prototype for a new urbanism. City films from the region are located at the vanguard of this

urban transformation, and they assign the city itself a position of exceptional prominence in their images and stories, as a problem to be contemplated rather than an appropriate setting for more important matters. The chaotic and protean form of urban space, and the power politics and utopian promise of the city, re-emerge as the primary representational and conceptual challenges for artists from the region.

From the Horizon to the Edge

This volume does not seek to offer a grand reconception of urban film theory. Yet certain themes begin to surface and challenge prominent paradigms, especially those that regard the city as a given, an environment that houses the citizen defined primarily as spectator and thereafter recedes into the background. For one, the city emerges not only as a host for cinematic activities but also as a dynamic entity subjected to interventions by policymakers, planners, and investors, as well as to the visions of administrators, residents, and nonofficial organizations — from grassroots activists to underworld triads. The city's edge outlines the limitations of a cinema founded on the dynamics of spectatorship and stresses the challenge posed by new media and new patterns of urban governance. Hansen, writing about early cinema, has contended that cinema provided a "horizon for the experience of modernization and modernity."[18] Filmmakers at the turn of the twenty-first century have looked beyond the horizon of modernity and found out that neither the city nor the cinema is adequate to define their experience. The horizon provided to early filmgoers — an alternative sphere based on the privileged position of the spectator and activated by the "publicness" of the cinematic experience — has at once drawn closer and grown hazy, as flourishing screen technologies support portable and private experiences rather than the collective interactions of the theater. The contemporary media ecology has fragmented the viewing public and opened new possibilities for a less concentrated and geographically located community. These emerging forms of cinema and the city, now filtered through digital media and defined by networks connecting widely dispersed global hubs, therefore question the place of the viewing subject and inherited notions of the public sphere. The challenges and infinite promises glimpsed at this imaginary horizon were domesticated in local reception contexts, materialized by actual subjects operating within specific cultural institutions, and rooted in particular cities and neighborhoods. Now the publicness of media is often experienced in front of the individual television or computer screen, with the possibility of virtual interaction placing this encounter at the border between public and private; the random encounters and physical proximity of bodies that energized a downtown

theater district have been replaced by the carefully orchestrated commercial transactions of the mall and multiplex; and if spectators once viewed this vague horizon of experience while surrounded by the undeniable materiality of the urban environment, if the unsettling dynamism of cinema eventually grounded itself in buildings and streets, then urban subjects now find themselves inhabiting a space where the horizon of images and the substance of the city begin to merge. At once concrete and virtual, this urban space is constructed of the most material of objects and traversed by the most intangible flows of information. The city's edge is not only a geographical location on the outskirts of town; it is also a space where concrete and immaterial realities merge, where urban environments and the media fuse into a historically new formation, where the images and screens migrate out of the theaters and constitute the stuff of cities, and where virtual communities and digital documentaries resist the devastating effects of contemporary municipal planning. In this new urban environment, it is no longer possible to determine where the city ends and cinema begins.

The City and Beyond: Chapter Outline

As evidenced by the essays and by the films they discuss, the city is much like the proverbial elephant that cannot be grasped in its entirety at once. The essays that comprise the intellectual core of this book approach the challenging but fruitful field of East Asian urban cinema from a variety of geographical, philosophical, and methodological orientations. To further capture the fragmented nature of the city, we have added illustrated commentaries that should be read contrapuntally to the essays rather than as extensions of or commentaries on them. These screen shots and brief annotations are also attempts to prioritize the visual register over the rhetorical mode more common to critical writing. Fredric Jameson suggests that globalization is a "communicational concept, which alternately masks and transmits cultural or economic meanings," and he proposes that we examine that concept like a multi-faceted object, rotating it "in such a way that it takes on these distinct kinds of content, its surface now glittering in light and then obscured again by darkness and shadow."[19] Viewed as facets of a much larger whole consisting of interlocking media and urban networks, of films made in various technologies and genres and located in cities throughout East Asia, these brief observations and the longer essays illuminate as many dimensions as possible of this chaotic and fragmented whole.

The book begins by considering whether the city as we have known it has ceased to exist. Both Ackbar Abbas and Dudley Andrew comment on how the city has lost its material attributes. The architectures of information have, so to speak, melted all that is urban into air. It is not, however, that the city has simply

disappeared, but rather that it must be sought in a realm beyond space. Anthony Vidler has already noted that contemporary architecture is characterized by "the postspatial void," where spatial terms such as "virtual space" and "cyberspace" cover up our inability to think of life without space.[20] Abbas, who has famously argued that Hong Kong embodies a "culture of disappearance," comes close to arguing that the city is a form of disappearance. For Abbas, the contemporary Asian city (more specifically, the Chinese coastal metropolis) "can no longer be represented." In learning the language of global architecture, the city is perhaps more typically manifested in the form of absence. In Abbas's description, the city is crossed over, glossed over, overlaid, overwhelmed. The city is over. But at the same time, in this incoherent and fragmented space, there are edges everywhere, and in that space between lie the threat of continued disintegration and the opportunity for reimagined identities and images unencumbered by the inevitable accumulation of clichés. And as Dudley Andrew notes, there is an afterlife that endures beyond the end of twentieth-century urbanization. Once the center of gravity has shifted and "the identity of cities has evaporated" in the face of the uniform vision of the generic city, filmmakers are trying to capture the image of the ghostly remains. The recent spate of horror films across East Asia attempts to redeem the city's liminal spaces and the invisible at the heart of urban existence.

In "A Regional Network of Cities," the second section in this volume, two essays examine the circulation of people and images as they trace eccentric cinematic maps across East Asia. These essays occupy an intriguing and understudied space between the familiar domain of the local and the ethereal realm that beckons whenever we speak of the globe. Yiman Wang's study of the paradigmatic Taiyōzoku film *Crazed Fruit* (Kurutta kajitsu; Ko Nakahira, 1956) and its Hong Kong remake develops a model for dealing with the vexed relationship between the original and the copy, while resisting the temptation to see the former as the creation of an organic local environment and the latter as an inevitable manifestation of a more generic and secondary global modernity. Instead, she argues that the "Generic City" described by Koolhaas and the related category of the remake, which is usually founded on the premise that the original can be distilled down to a generic form and replicated elsewhere, are produced through particular strategies and technologies. Rather than assuming that the generic is the end result of a preordained process of globalization and modernization, she examines the mechanisms that allow filmmakers to manufacture this "genericity" as they travel between Japan and Hong Kong and construct a standardized space on the studio lot. Emilie Yueh-yu Yeh charts the movement between Tokyo and Taipei in a series of films by Miike Takashi, and argues that Taiwan has become a privileged site for the representation of

a *mukokuseki* aesthetic that foregrounds hybridity and a cosmopolitan ideal rather than deeply rooted traditions. She identifies precursors to this *mukokuseki* approach to cinema in the 1950s and suggests that the continued presence and increasing prominence of this mode of filmmaking allows us to examine the globalization of the aesthetic and cultural sphere in East Asia over half a century, and especially in the past two decades. Yet she suggests that "Taiwan is mukokuseki's perfect terrain," in large part because of its specific historical experience under colonial occupation and in the contemporary global economy. Taipei becomes the terrain for Japanese crime stories not because it is one city among many, a generic and eminently replaceable site akin to a studio set, but because it is Taipei, a location with a history of transnational conflicts and exchanges that precede the border-crossing image flows of today. The essays by both Wang and Yeh open onto the process of globalization by first following the itinerary of artists, objects, and images along precise routes in East Asia. Rather than launch immediately toward the global horizon, they first examine the regional circulation that has for more than a century shaped the identity of cities like Hong Kong, Tokyo, and Taipei. Retracing those material networks is a necessary step in any grounded study of globalization.

In Part III, "The City of Media Networks," the authors examine the crucial role of media technology, and especially digital media, in the representation of contemporary East Asian cities, suggesting that the twin academic and artistic fascinations with the city and new communicative media arise in tandem and remain tightly interlaced. Focusing on contemporary mainland Chinese DV documentaries and avant-garde video art, Zhang Zhen observes that these alternative cinematic modes return repeatedly to images of the expanding Chinese megacities. She writes that portable cameras, indistinguishable in many cases from the devices carried by the average tourist, allow filmmakers to capture the reality of the contemporary city while evading many of the restrictions that impede large-scale productions. Under these conditions, she writes, "almost the entire city is a ready-at-hand inexhaustible set that experimental photographers and filmmakers discover and claim as their borderless studio or backlot." But at the same time these digital images are easily manipulated and transformed, opening onto possibilities for fanciful and utopian image-making that the city itself forecloses in the present political and economic situation. These documentaries and avant-garde videos occupy the unstable border between reality and the surreal that the Situationist International once explored, and Zhang locates their transformative potential in their status between the century-old traditions of realist and almost magical cinema: these films manage to capture the material and corporeal life of contemporary Chinese cities, while also envisioning a utopian sphere possible under current conditions only in the

aesthetic dimension. For Darrell William Davis the entirely digital spaces in Japanese cinema begin to question the category of the city itself, as they venture far afield from the Beijing or Shanghai depicted in the documentaries and "on-the-spot" films discussed by Zhang. Davis considers anime that, instead of rooting themselves in readily recognizable locations, depict cyborg spaces and completely constructed worlds, massive computer-generated cities without any concrete or steel. But he also observes that the animated city contains real-world referents, including a remarkable number of Chinatowns that surface in otherwise imaginary worlds. He suggests that these ubiquitous Chinatowns are at once the crystallization of age-old notions of ethnicity — especially when they embody the so-called "yellow peril" — and the epitome of the digital itself. Because of the proximity of the premodern and contemporary technology, these films allow us to see how ethnicity is often "remediated" and reproduced through technology, how it endures as a product of the present rather than a relic of the past. The oldest tropes of ethnicity are given a new shell, just as cities are rendered in digital form and anime figures bestow voice and movement on bodies modeled after traditional Japanese dolls, or *karakuri*. Davis suggests that within the narrow lanes and vital bodies of Chinatown, Japanese anime and other science fiction genres condense both the fears that thwart the movements of globalization and the "'pull' of a technologized East Asia." If, as Davis maintains, a dystopic techno-noir has become one of the primary stages for these digital Chinatowns, film noir also resurfaces in the slick, glossy action films discussed by Susie Jie Young Kim. Kim situates these contemporary Korean films within the context of historical studies of the film noir city, but she argues that Seoul's constantly changing architecture and infrastructure interfere with a clear, black-and-white mapping of the city's terrain. She suggests that these films often rely on cinematographic flair and the distinctive personal style of their protagonists to achieve the "flash of transgression," though the transgressive potential of style has been radically diminished in a city where consumption has become the dominant form of self-expression and historical traumas have been paved over or relegated to the outskirts of the city. Despite the stunning cinematography and shimmering surfaces that have contributed to the vibrancy of recent Korean cinema, the possibilities for rebellion are radically diminished when film advertises itself as a mode of self-fashioning that, like the city itself and the images on screen, emerges and disappears in a flash.

The city's edge alludes also to a paradox at the heart of the overstretched metropolis and ever-expanding media: the city is never enough, yet it is a sign of excess. The tension is captured in the two essays concluding the book, by Chris Berry and Akira Mizuta Lippit. Berry juxtaposes Koolhaas's dream of the Generic City, operating within and sustaining the logic of globalization, and *San*

Yuan Li, a cinematic gesture of resistance that gives the lie to the utopian vision of global flows. The urban village of Sanyuanli, and the documentary film *San Yuan Li*, stand for all that Koolhaas has sought to render abject — history, local specificity, and a celebration of the cluttered public realm. Lippit too focuses on the turn to specificity in recent Japanese cinema. Yet Lippit sees in the details of the locale a jumping board for fantastic projections and subjective memories that transform the city into a placeless spaces — an atopia. The city is in the world, but the city also contains entire worlds that escape geographical and historical parameters. Lippit is both exuberant and cautionary: the city's edge is a precarious place.

Over the Edge: Proceed with Caution

The emphasis in this volume on the city and cinema at a point of transition might turn the films into celebrations of the coming new urban vision — or into cautionary tales. It is easy to wax futuristic over the East Asian urban metamorphosis and to become lightheaded at the sight of an architectural feat such as Koolhaas's CCTV Tower, which transformed Beijing's skyline toward the 2008 Olympics. It is also hard to miss the symbolism in the fact that a large part of the CCTV Tower compound was scorched in a spectacular fire on February 9, 2009, on the last day of the Chinese New Year's celebrations. Yet recent works suggest the demise of the city as a filmic fantasy, shaped to comport with a cinematic imagination.

An example of the city that defies both utopian and dystopic scenarios for the future, as well as accepted definitions of cinema, may be found in RMB City, featured on the cover of this volume. An entirely virtual creation, RMB City was "constructed" for the Internet-based space known as Second Life. RMB City, designed by the artist Cao Fei, heaps together Chinese urban landmarks: Tiananmen Gate, which serves as a sluice gate for the Three Gorges Dam; Shanghai's Pearl of the Orient tower, turned into a totem; Koolhaas's CCTV tower, balanced in mid-air against the People's Love Palace (the latter housed in a panda-like structure); and the "Bird's Nest" Olympic stadium, half-submerged in water and already rusting. This "condensed incarnation of contemporary Chinese cities" liberates the visitor from the limitations of urban space as we know it. As Cao Fei notes, without the usual obstructions that hinder the design process — environmental issues, budgetary limits, even gravity — Second Life is an architect's ideal fantasyland. Like the upside-down CCTV Tower, RMB City seems to be hanging by a thread — does it spoof the Disneyfied city? Like the rest of Second Life, RMB City exposes the virtual city as advertising space — is it the continuation of the consumerist construction boom through other

means? Teetering on the brink of accepted notions of space, RMB City confronts us with the unsteady and uncertain condition of the contemporary East Asian city, and forces us to rethink the meaning of urban experience and its visual representation.

Cao Fei's virtual (but very cinematic) visualization, recording a non-material (but highly architectural) metaverse, puts to an extreme test the Kantian space-time continuum. With its most prominent structures suspended in air, sinking under water, or hovering in defiance of the laws of physics, RMB City is a floating mirage that nevertheless highlights the very concrete challenges facing the contemporary urban experiments of East Asia. Cao Fei's work pushes to the extreme the questions posed by many city films and urban theorists from the past half century. The challenge presented by RMB City is more easily understood, given that its foundations are rooted in the hyperurbanized environment of East Asia, with its new forms of global and regional networks, where the horizons of modernity and the adequacy of the cinematic imagination are challenged. How can a city be grounded when its fate tracks the vicissitudes of economic boom and bust cycles, and when even its name derives from a fluctuating (if highly regulated) currency? Is this virtual city merely a new media environment without real-world origins and ends, or does the history of cinema help frame and locate these excursions into cyberspace? How does the viewer navigate through a city perched precariously on the edge of new conceptions of media and space? This book explores the uncharted outskirts of film and the city.

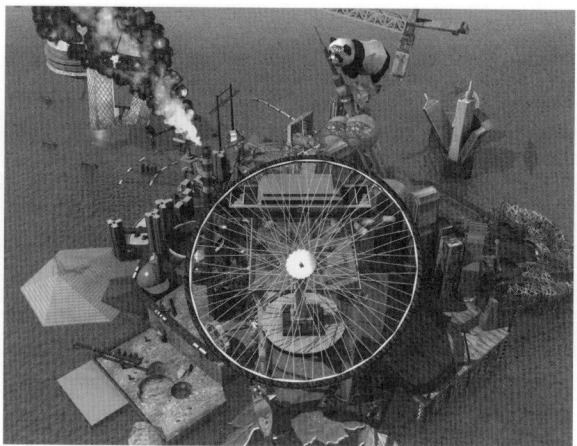

Fig. 1.1 *RMB City* (Cao Fei, 2008)

INTERLUDE *1*

Arriving in the City

Yomi Braester

The film camera is a stranger to the city; to belong, it looks for a surrogate carrier. Much depends on the identity of that carrier, through whose eyes we will see the city. Is she a passerby or a local dweller? A stranger or a returning exile? A vagabond or a savvy traveler? An architect who sticks to blueprints or a jack of all trades who spontaneously creates her own spaces?

Many films begin with a point-of-view shot that tells us as much about the observer as about the city. The city is revealed, often at a distance, from an airplane or a train, before we delve into its streets. The opening sequence of the blockbuster comedy *Crazy Stone* (2006; dir. Ning Hao) shows Chongqing as seen from the cable car that connects the two parts of the world's largest metropolis (32 million inhabitants). The camera hangs by a thread, ready to crash into the city.

Fig. i.1 *Crazy Stone* (Ning Hao, 2006)

The camera can turn into a time bomb, plunging into the urban mass and tearing it to pieces. Caught in the lens, concrete is rendered brittle. Many urban films visualize the downfall of utopia through images of the crumbling city. But if the city is a doomed shrine to modern technology, the cinema is a favorite tool for bringing down the walls made of pure lines of vision.

18 Interlude 1

The opening sequence of *9 Souls* (2003; dir. Toyoda Toshiaki) descends upon Tokyo with visual violence. One by one, the buildings are erased from the natural topography, until only Tokyo Tower remains in place. The city as we know it recedes before the camera. Those landmarks that remain are monuments to destruction. In the post-A-bomb era, we cannot enter the city unharmed.

Fig. i.2 *9 Souls* (Toyoda Toshiaki, 2003)

The camera can accommodate our wish never to touch down but always to observe the city from a distance. Borne on wings woven of memories and dreams, the cinematic gaze is free to reinvent urban existence. The final image in *Tropical Fish* (1995; dir. Yu-Hsun Chen) shows a fish swimming across Taipei's skyline. The wide boulevard and glistening high-rises are rendered as parts of an aquarium habitat.

Fig. i.3 *Tropical Fish* (Yu-Hsun Chen, 1995)

Touring the City

Moving through the urban environment is an exploitative act — stretching the topography, social structure, and individual identity to the limits. The many forms of ambulation — romantic bike rides, car chases, parades, and lonely walks alike — challenge the city to reciprocate by presenting its own spectacle, showing its true face, and subjecting itself to the camera.

Fig. i.4 *Naked Youth* (Oshima Nagisa, 1960)

The two youngsters at the center of *Naked Youth* (1960; dir. Oshima Nagisa) never stop moving around Tokyo. The film starts as Mako catches a ride; when the driver assaults her, she is saved by Kiyoshi. Later, they make their living by repeating the situation — Mako lures those who give her a ride, while Kiyoshi rides a motorbike behind, ready to extort the drivers. Left-wing student demonstrations occupy the city, but Kiyoshi and Mako take to the streets for their private youthful rebellion. At first it seems that they are hurtling toward self-destruction; yet it is when they slow down that the city catches up with them and drags them down.

Fig. i.5 *Naked Youth* (Oshima Nagisa, 1960)

Moving through the urban environment is an exploitative act — first and foremost testing the elasticity of personal boundaries. Space rigidifies around Kiyoshi and Mako, slowing them down to the point of dead immobility. The camera, which has constantly tried to pin down the couple in close-ups, now moves even faster than the characters. Just as looking into a black hole increases its mass, so does the cinematic gaze add to the city's gravitational force and precipitate the couple's demise.

Fig. i.6 *Naked Youth* (Oshima Nagisa, 1960)

Watching the City

The city always provides frames through which to watch it. Every structure is a window that reveals views, blocks others, and situates those who watch as the objects of others' gazes.

The city is the perfect location for intrigue and suspense because it is a maze of intersecting lines and plotlines that corner and frame the protagonists. Every view is a Hitchcockian rear window. The ubiquitous borders outlined by urban architecture add a sense of mystery even when there is little to begin with, whether it is the Seoul overpass in the anti-whodunnit *The City of Violence* (2006; dir. Ryoo Seung-wan), shown here, or the Tokyo train tracks in the slow-paced *Café Lumière* (2003; dir. Hou Hsiao-hsien).

Fig. i.7 *The City of Violence* (Ryoo Seung-wan, 2006)

Some films turn the camera itself into part of the framing urban architecture. In the concluding sequence of *Good Morning, Beijing* (2003; dir. Pan Jianlin), a woman who had been locked up and forced into prostitution tears away the black cardboard off the window in the room that was her prison. The woman watches, from atop a high-rise, Beijing at dawn. A slow zoom-in overlaps the film frame with the window. The sharp slivers protruding from the round-edged cardboard are reminiscent of an open shutter,

placing the woman within a camera obscura through which she watches the city exposed to the morning light. At the same time, the grid of supporting beams functions as a visual barrier between the woman and the city. Being able to look out does not intimate the possibility of going out and solving the crime.

Fig. i.8 *Good Morning, Beijing* (Pan Jianlin, 2003)

The city, with its combination of close quarters and anonymity, encourages peeping toms. The woman in the dark comedy *Barking Dogs Never Bite* (2000; dir. Bong Joon-ho), a self-appointed detective after a pet-dog kidnapping conspiracy, finds out that whatever can happen will happen, in front of her eyes. She stalks a man in her residential Seoul suburb and witnesses him throwing a dog out from a rooftop. In shock, she drops her friend's binoculars from an equally damaging height and rushes to pursue the man. The detective plot advances at the immediate expense of the gaze.

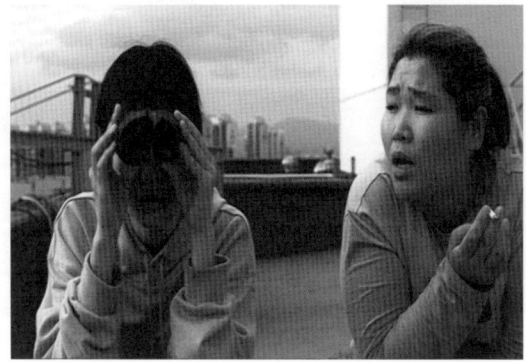

Fig. i.9 *Barking Dogs Never Bite* (Bong Joon-ho, 2000)

PART I
The City Vanishes

1

Affective Spaces in Hong Kong/Chinese Cinema

Ackbar Abbas

Writing about Paris in the early twentieth century, the German poet Rainer Maria Rilke notes that "the city sucks images out of you, without giving you anything definite in return." It is as if a *radical disconnection* between image and city has taken place; the first in a series of other disconnections. Rilke's precocious insight, I would argue, is even more applicable to Asian cities today. More and more, it seems, images of the Asian city, even as they proliferate and become more vivid, tell us less and less about the city. The city can no longer be *represented* through a coherent image or a set of images, but only *presented* or projected through the affective responses of its inhabitants. In other words, the more we fail to hold the city together in an image, the more intensely (even if confusingly) it is felt. The word that Samuel Beckett uses to describe these affective intensities that accompany spatial disconnections and failure is *unhappiness*. In his usage, unhappiness is not just an emotional state of mind, but also describes the structure of a space and time that is out of joint: hence the famous line "nothing is funnier than unhappiness." The unhappy city is the disconnected city, and vice versa; comic and pathetic all at once; the city with an edge or edginess to it. I take the term "the city's edge" to connote therefore not just a spatial extremity, but also the edge of the tolerable, as if a kind of affective instability and sensory malaise were bound to manifest itself when urbanism is taken to the limit; the edge then is both a spatial and affective extremity.

We can approach the unstable relations between space and affectivity through the example of the globalizing Asian city. It is clear that globalization has introduced a space that is new and unfamiliar, through related processes like the restructuring of capital and the creation of integrated economic and informational networks, one mark of which is the proliferation of the newest

kinds of architecture that is transforming the face of cities in China and elsewhere. But it has also introduced something else, more paradoxical, a space that is old and unfamiliar, one example of which is the kind of preservation of historical areas and buildings that follows not so much the logic of saving the past as the logic of global tourism. Thus preserved buildings may look old and familiar, but the grids and coordinates by which we understand them are not, as these too follow rather than go against the logic of globalization. Something has happened to change itself. The situation is no longer one of "the more things change, the more they remain the same," but its parodic double "the more things remain the same (like preserved buildings), the more they change." If it is not just the new that is unfamiliar, but also the old, then we have reached a critical point of crossover, a chiasmus, the X-factor in both urbanism and affectivity.

What I am suggesting is that the problematic nature of affect, one example of which is our confused response to the city, has something to do with the problematic nature of urban space and its confusing transformations. One skews up the other, distorts or discolors the other, but in doing so makes the other signify, the way a litmus test signifies through discoloration. This does not of course lead to a phenomenology of the city, because what we grasp of the city is based not so much on what we see, as on what we wish to see; not so much on what we experience, as on what challenges and even upsets our experience. We see the city not through privileged moments of insight or revelation, i.e., epiphanies; but rather through puzzlement and confusion, i.e., through negative epiphanies; and it is through the negative that we derive an intuition of urban spaces about to be, taking shape at the city's edge. While the city may no longer be directly representable, neither is it entirely ungraspable.

We can follow in some detail these affective spaces and spatial affects in a number of recent films, set in cities like Hong Kong and other Chinese cities where space is being rapidly transformed. I will briefly discuss four such examples of "cinema at the city's edge": Fruit Chan's *Durian, Durian* (Liulian piaopiao, 2000), Zhang Yuan's *Crazy English* (Fengkuang yingyu, 1999), Wong Kar-wai's *2046* (2004), and Alan Mak and Andrew Lau's *Infernal Affairs, Part I* (Wujian dao I/ Mou gaan dou I, 2002). These films embrace a variety of visual styles, ranging from documentary to melodrama. However, what is *cinematic* about this cinema is that in each case, the city escapes capture by the available images, so that a search for other kinds of images has to be made. Equally important is that each film presents — in its own way, and in terms of a different set of circumstances — basically *an affective conundrum*: characters act in strange, sometimes bizarre, and always inexplicable ways. The interest of these films is that they invite us to ask, not what this behavior means, in the sense of what individual psychological explanation can be given for it; but to ask, what social space makes it possible?

Durian, Durian or Virtual Migrancy

Let me begin with Fruit Chan's *Durian, Durian*, which evokes space through a migrant figure of a peculiar kind. We see in China today many different migrant figures: not only the exile and refugee, but also the business traveler, the tourist, and the in-migrant. What all these figures have in common is that they move for a clear reason, in spaces that are clearly recognizable, even if they are new. But what seems to be emerging today are other spaces that we do not yet understand or that we no longer understand. In their wake, a puzzling kind of migrant begins to appear, which I call the virtual migrant. The term refers not to sci-fi figures that travel in virtual reality, but to everyday people in ordinary circumstances who are distinguished by the fact that they seem impelled and compelled to move, but for reasons that are not immediately explicable, even to themselves. There is no true match between motive and movement; one falsifies rather than justifies the other. The trip itself always seems to end in an inconsequential and inconclusive way, as if there were nothing in it at all. It is the distinction of Fruit Chan's film to have given us an adumbration of this as yet not clearly defined type of migrant, and through this figure, a glimpse of a problematic new space.

The film deals with a small-town mainland woman who comes to Hong Kong on a three-month visa, makes her money working illegally as a prostitute and then returns home to a respectable life. But this is not the whole story, because the film divides clearly into two halves that do not quite add up. The first half seems to be a straight document (shot in documentary style) of the quasi-legal existence of migrants: we see Xiao Yan's encounters with clients, the police, and triad gang members, and we notice her social isolation and single-minded determination to make money. She is hardly distinguishable from other kinds of migrants.

It is in the second half of the film, after Yan returns to her hometown, that this document of her life turns puzzling, and her virtual migrancy becomes apparent. We are given a number of quietly surprising details. For example, we learn that her parents are neither poor nor dependent on her support. We learn too that she is one of the privileged few, having been trained at an elite dance academy. Even though she is about to get a divorce, she has relatively cordial relations with her husband and her in-laws dote on her: i.e., even divorce itself is a kind of diversion or divagation, an affective migrancy. Finally, we see that she really has no plans about what to do with the money she has earned. In other words, none of the usual motives for someone to become a migrant or turn to prostitution seems to apply in her case. The whole trip to Hong Kong seems in retrospect to have no purpose and no conclusion. What then does it signify,

Xiao Yan's pattern of departure and return, those journeys — so characteristic of virtual migrancy — that seem to cancel each other out?

Let me hazard the following analysis. Midway through the film, we see a giant poster of Deng Xiaoping, architect of the "socialist market economy," the specific form that globalization in China takes. Some signs of globalization are the new urban spaces like the Special Economic Zones (SEZs), Special Autonomous Regions (SARs), and Metropolitan Interlocking Regions (MIRs), which like the durian both attract and repel; but they draw Xiao Yan — "little swallow" — and other migrants to them. Xiao Yan's trip began as a move from home and the present to Hong Kong and the future, in the sense that for many, Hong Kong is China's urban future. However, the trip to Hong Kong ends in disappointment. "Hong Kong people are cheap," Xiao Yan observes after a few weeks there, like people everywhere. And so begins a journey home, a journey back to the present, but a present now experienced as split between two absences: between a past that is no longer there because it has been so decisively eradicated by the "socialist market economy"; and a future that is *not yet there*, because all the statistics predicting China's place in the new century have no spatial equivalent as yet, no objective correlative. Even the Hong Kong she found is not Hong Kong. It is this gap, this hysteresis, this strange space of a frantic but absent present that produces the desultory movements of virtual migrancy. Neither a hero like the intellectual exile nor a victim like the economic refugee, the virtual migrant is a *symptom*. Her "diaspora of sensation" (Virilio) helps us begin to read the problematic spaces introduced by a globalizing China.

Crazy English or the Generic

My second example is the film *Crazy English*, made by the Sixth Generation Chinese filmmaker Zhang Yuan. If *Durian, Durian* shows the depressive side, *Crazy English* shows the manic side of globalization in China. It is a documentary film about a charismatic and phenomenally successful teacher of English, Li Yang. In interviews, Li Yang proudly tells us that he failed his university exams several times, and that he failed three semesters of English. So failing to *learn* English, what does he do? He decides to teach it, as if he really took to heart the Nike slogan "Just do it." What his program "Crazy English" promises is not merely language efficiency, but worldly success. English is the language of globalization, and "crazy" means, Li Yang tells us, not mad but "100% commitment"; in the new global world only the paranoid succeed. Hence the spectacle of student after student repeating earnestly and diligently the line, "I want to be crazy." Learning Crazy English does not involve linguistics or phonetics or knowledge of any kind. All it involves is the ability to speak

loudly, quickly, and clearly. It consists first of all in *shouting slogans*, a practice reminiscent of the Cultural Revolution, except that the slogans now take on new content. Students practice sentences like:

— Never let your country down.
— I want to be somebody someday.
— I enjoy losing face.

This language course is also changing the course of affective relations to self and society and replacing older Chinese character types with new ones. Students are not so much learning a new subject (English) as learning to become a new kind of subject. The model is no longer the Confucian gentleman, the man of letters, the revolutionary hero, or even Lu Xun's Ah Q, but rather "the man without qualities," the media person, the communication expert, the celebrity; men and women who can "enjoy losing face" because they have discarded traditional identities and affective attitudes.

What space makes such a type possible? One answer in the context of architecture and urbanism might be the space of the Generic City. It is commonly said that in their attempts at going global, Chinese cities are losing their character and identity; they are becoming more generic. Historically interesting cities like Beijing and Shanghai are becoming more and more like Shenzhen or Houston. This is the usual negative sense of the term generic; but there is another, more paradoxical sense that comes out in Rem Koolhaas's intriguing essay "The Generic City," which brings out more clearly the manic quality of *Crazy English*. Koolhaas's argument is not: what a pity cities are becoming more generic, but: how exciting! The generic is seen not as *loss* of identity but as *liberation* from identity: "What if the seemingly accidental — and usually regretted — homogenization were an intentional process, a conscious movement away from difference towards similarity? What if we are witnessing a global movement: 'down with character!'" The Generic City, he goes on to say, is what is left after large sections of urban life crossed over into cyberspace, i.e., as technology, global networks, and so on become increasingly important, real cities do not *need* to have character, because the action has moved elsewhere, into cyberspace. We might add that Koolhaas's "Down with character" recalls the Futurist slogan "Down with moonlight!" which Umberto Eco tells us is the implicit motto of every avant-garde. Thus in Koolhaas's reading, the generic is recoded as the fulfilment of the avant-gardist dream of liberation from character and affect, which is also a liberation from the city as we know it — a fulfilment now aided and abetted by globalization. The question that Koolhaas poses is no longer "What is the city?" but rather, "What *was* the city?" Understood in this way, the generic is the face, and the phase, of the absolutely contemporary. On the one

hand, it sidesteps the awkwardness and messiness, the clumsiness and naiveté, of historical questions — for example, questions of cultural identity and the burden of the colonial past. On the other hand, it distances itself from the facile return to historicism advocated by certain kinds of postmodern architecture, with its ironic play with historical styles and its flirtation with kitsch. The Generic City is therefore also the post-historical city. Following Deng Xiaoping, its motto is a relentless pragmatism, which easily translates into economic pragmatism.

The pragmatism and post-historicism of the generic is seen most poignantly near the end of *Crazy English*, when we see Li Yang teaching English to a group of PLA soldiers at the Great Wall. In this scene, strong historical resonances are evoked, only to be retuned. The Great Wall gives up its historical identity and becomes a tourist site where "foreigners" are welcomed, not repulsed; while the PLA soldiers — who since Tiananmen no longer hold their venerable position as the sworn defenders of the people — are now the enthusiastic disciples of Crazy English, eager to learn the new global language. We see this scene repeated in an uncanny way when the language of global architecture is introduced to Chinese cities. To take just one example, it is none other than Rem Koolhaas who is constructing the new CCTV headquarters in Beijing. CCTV is still an arch-conservative institution, while Koolhaas's design envisages an ultra-contemporary building made up of two inverted and interconnected L-shaped structures. What else but the post-historical would allow such a client to appoint such an architect, and such an architect to propose such a design for this particular client? It seems that in cities like Beijing, Shanghai, and Shenzhen, what we see everywhere we look are examples of "crazy architecture" that, like Crazy English, speaks loudly, quickly, and clearly. Is this China's urban future?

2046 or the Interior

The manic/generic space of *Crazy English* can be contrasted to another kind of affective space, what Walter Benjamin calls "the interior." If the generic focused on the power of the pragmatic to reshape both space and affect, its flipside is the interior, which comes into being partly out of an experience of impotence. The interior, as Benjamin theorized, is not just domestic or private space. Rather, it is the product of two nineteenth-century developments: liberal democracy on the one hand, which gave the citizen a sense of political power and freedom; and industrial capitalism on the other, which proved to him on a daily basis that he was still just a slave to capital. It took this combination of power and impotence to create the European interior. The interior is both a place from where the citizen can reduce the world to an ongoing spectacle, as well as a casing, a protective envelope, that preserves his traces. If "living means leaving

traces," the citizen provides proof that he has lived by filling the interior with objects. The bourgeois interior stuffed with objects is both space and affect, an affective space that has a relationship to the spatial changes being brought about by politics and economics. If so, what changes can we expect to find there when these political and economic factors are being reconstellated by globalization?

One unfailingly accurate guide to this contemporary interior are the films of Wong Kar-wai, particularly two of his latest films, *In the Mood for Love* (Huayang nianhua/Fa yeung nin wa, 2000) and *2046*. In these films, the city as such seems to have disappeared, replaced by an interior. There are very few recognizable "images of the city," since much of the action in these films, the small "capillary action," takes place in enclosed spaces. Even the outdoor shots give a sense of enclosure: they focus on decrepit walls with graffiti-like patterns; walls with the surface concrete peeling off, exposing the brick beneath, like raw human egos. It turns out that in fact the city has not disappeared at all; all that has disappeared is the membrane that separates city and interior, so that the interior is now invaded by and takes on all the puzzling qualities of urban space itself.

How is the city-as-interior produced? One hint is provided by Manuel Castells, who argues that an important characteristic of the global city is that the more connected it is to global networks, the more disconnected it is from its local hinterland. There is a curiously similar pattern of connection and disconnection in Wong Kar-wai's films at the level of affective relations. We find again and again in these films the evocation of some kind of invisible barrier between people, and human relations characteristically take the form of proximity without reciprocity. People are close but apart, connected and disconnected. Even the space of intimacy is not intimate, as something always seems to stand in the way. Take the situation of Tony Leung and Zhang Ziyi in *2046*. One stays in room 2047, the other in room 2046; however, it is not space but memories, or negative traces of the past, that stand between them. "All memories are traces of tears."

Instead of reciprocity, affective relations now take a serial form: A loves B, but B loves C, and C has a previous commitment to D, so cannot reciprocate, while D ... who knows what D's story might be? And so it goes. It is as if we were seeing an inhuman algebra of love at work. The ciphers can be given names and faces: Su Lizhen (Maggie Cheung/Gong Li), Mr Chow (Tony Leung), Bai Ling (Zhang Ziyi), Miss Wong (Faye Wong); but in the end it is the serial structure that dominates and disconnects the characters. The affective series begins because, as Chow says, "feelings can creep up on you unawares"; but he also notes that "love is a matter of timing. It is impossible either too early or too late." But

then, we see again and again that in love it is always either too early or too late, never just on time. In the interior, all appointments are dis-appointments, and unhappy endings are inevitable, even in fiction. Chow cannot change the sad ending of his sci-fi novel *2047*, try as he might, because fiction too follows the stubborn structure of the interior, whose law is disappointment.

However, there is a kind of loophole available: though the unhappy ending cannot be avoided, it can be *delayed*, as Chow says, by never taking no for an answer. This allows the affective series to be continued and to take the form of: A loses B, but finds C, only to lose C and so on. Chow loses Su Lizhen (Maggie Cheung) in Hong Kong (in *In the Mood for Love*), leaves for Singapore and finds another Su Lizhen (Gong Li), and of course loses her. It is as if Wong Kar-wai's characters never learn, or never want to learn, but keep repeating the same pattern and always starting over again; just as *2046* in particular repeats and recalls many scenes and situations from previous films. As the affective series continues, through repetition and memory, something else quite remarkable happens. Not only do we find everywhere an alternation between desire and disappointment, but we find also a curious change in their relationship. We find not how desire is followed by disappointment, which would be banal; but how desire is *generated* by disappointment, how disappointment itself becomes the source and resource of the erotic: an erotics of disappointment.

Nothing characterizes such a strange erotics so much as *the secret*. This is how *In the Mood for Love* ends, and how *2046* begins and ends: with the secret. The secret always revolves around a question of how the other one feels, and an inability to decipher the other one's answer. So characters either end up whispering the secret-as-question into a hole in a tree and give up on the answer; or they take the train to 2046, a place where "nothing changes," in search of an answer — which they never find. The secret therefore is always two things at once. It is firstly a means of hiding away impossible emotions that cannot be shared, a displacement of affect to the hole in the tree, a kind of protection of the ego. But secondly, the need for the secret's protection shows the overwhelming nature of these emotions, and how unequal the characters are to the task of dealing with them. This doubleness of the secret is presented most clearly in the figure of the android (played by Faye Wong) that we encounter in the sci-fi novel written by Chow. The android looks numb and shows no affect; but that is because, we are told, she has worked too hard, so fatigue sets in, and her answer to a proposal like "leave with me" can only come later, so we never know what she feels. It is as if "her answer was like a secret." It is the same kind of secret answer that Gong Li's Su Lizhen, a professional card player, gives to Chow when he asks her to leave Singapore with him: her winning Ace of Spades disappoints all desire, including her own.

Infernal Affairs I or **Information**

The last film I want to discuss, Alan Mak and Andrew Lau's *Infernal Affairs, Part I*, also concerns the secret, but a different kind of secret, the kind in which secret agents or informers deal. The story revolves around two main characters: Yan, a police agent (played by Tony Leung) who infiltrates the triads; Ming, a triad agent played by Andy Lau who infiltrates the police. The film begins with an image of the Buddhist continuous hell, an afterworld of fire and brimstone from which there is no respite, and of twisted human figures being punished for their sins. But this opening image is very quickly overlaid with images of cell phones, computers, coded messages, and so on, i.e., the world of information. The moral/physical world of Buddhist retribution is dissolved into and recoded as the world of information. The two worlds are fused and confused with each other. Just as there is no respite in the Buddhist hell, there is no respite from information. (Note that even though there is still physical violence, the main action involves the passing of information.) Triads and police, like hell and information, are everywhere, and almost indistinguishable from each other. In the confusion, police agents can infiltrate the triads; triad agents can infiltrate the police.

This space of information is a strange new world, with horrible creatures in it, a world considerably more complicated than what Guy Debord called "the society of the spectacle." It cannot be critiqued the way the spectacle was critiqued, as Debord tacitly acknowledged when he penned in 1988 his *Comments on the Society of the Spectacle*, twenty years after the publication of the original text — because every critique of information is organized by and turns into information itself. There is no outside of information, hence no escape. The relatively innocuous forms of the spectacle of the 1960s have mutated into the "integrated spectacle" of the 1990s and today — the more accurate term for which is information. "When the spectacle was concentrated, the greater part of surrounding society escaped it; when diffuse, a small part; today, no part" (9). Debord goes on, in a passage that sounds almost like a commentary on *Infernal Affairs* itself, to say:

> It is in these conditions that a parodic end of the division of labour suddenly appears … A financier can be a singer, a lawyer a police spy, a baker can parade his literary tastes, an actor can be president … Such picturesque examples … go to show that one should never trust someone because of their jobs … Yet the highest ambition of the integrated spectacle is still to turn secret agents into revolutionaries and revolutionaries into secret agents (10–11)

— that is to say, to fuse and confuse what we think of as opposites. For Debord, the only strategy left would seem to be a retreat to silence and *secrecy*; i.e., the strategic withholding of information. Thus the *Comments* practically starts

with the statement "I must take care not to give too much information to just anybody" (1).

But secrecy is not so much an effective *resistance* to information as it is a *reaction* to it. In *Infernal Affairs*, we also see not so much a resistance to information as a reaction at the affective level to it: a reaction split between the two main characters each adopting a diametrically opposite stance towards the space of information. As secret agents, both Yan and Ming live under aliases, but they inhabit their aliases in different ways. Yan wants to hold on to the truth of affect and identity. He wants to maintain that his alias is false, and that his true identity is that he is a cop, but the only proof is in a secret computer file in the police department (i.e., in information) that Ming hacks into and deletes. Yan's belief in a personal identity beyond information makes him capable of friendship, fidelity, and love — we see him develop a genuine camaraderie with some of the triad gang members. But it also introduces the moral issues of divided loyalties and the betrayal of friends. In a final attempt to prove his identity, he forces a meeting with Ming — and gets shot in the head. In contrast to Yan, Ming only acknowledges the truth of information, however arbitrary. He brackets identity, lives his alias, and would kill to preserve it. Eventually, he even kills the triad boss he works for, the only person who knows his identity. Murder is the deleting of information; there is nothing personal to it. For Ming, the kinds of moral and affective concerns still so important for Yan, like love and fidelity, have all but disappeared, and with them all sense of moral ambiguity. Hence he can act with resolution, because resolution has now been transcoded into a mere technological concept — resolution as the degree of pixilation on a TV screen. Perhaps significantly, Ming's one outside interest is an interest in hi-fi equipment, suggesting that the only fidelity that counts is high fidelity. The film ends with him killing Yan and another officer who witnessed the killing, and when the police arrive, he shows his ID card as proof of identity: "I am a cop," and gets away with murder. This ending is a scandalous one for the commercial cinema, and the directors Mak and Lau have provided an alternate ending where Ming is arrested by the police; but it is this first ending that carries the logic of information, because it indicates what a dystopic urban future dominated by information might look like: not a hell situated in an afterlife where sinners are tortured by fire, but a hell situated in this life, where things just go on: a cool hell, an "air-conditioned nightmare" where information is processed.

Conclusion

Films do not provide answers to our problems. All we can ask of them is that they do not gloss over the difficulties. The affective conundrums presented

in these four films at least have the virtue of directing our attention to spaces that we do not yet or that we no longer understand. The relation of space and affectivity in these films is the very opposite of what we find in *Brokeback Mountain*. Ang Lee's film can be criticized, it seems to me, not for its political correctness towards homosexuality but for its optical correctness: all those National Geographic–type shots of lofty mountains and crystal-clear rivers are there to normalize, to correct, to homogenize the homosexual; so that it has led a number of reviewers to say, under the illusion that they are praising the film: "It's not about homosexuality, it's about love." But are we always talking about the same thing when we talk about love?

2

Ghost Towns

Dudley Andrew

Anyone looking into the way Asian cities cooperate with cinema in the representation of the present must start with two unavoidable critical texts: Fredric Jameson's 1989 "Remapping Taipei" and Ackbar Abbas's 1998 *Hong Kong: Culture and the Politics of Disappearance*.[1] Whereas before World War II cinematic modernism was in league with Joyce, Döblin, and Dos Passos in rendering cities visible through "symphonic form," postmodern writers and filmmakers find the city invisible, discordant, and in a fundamental way unrepresentable. Temporal simultaneity and spatial randomness work against this medium of time and space, for in cities today simultaneity could mean being nowhere as well as everywhere at once.

Perhaps the very identity of Asian cities has been evaporating ever since the economy heated up in the 1960s. Heat increases molecular motion, felt in the expansion of imports and exports, in a migrating work force, and in the melting of traditions and customs in the cauldron of global trade. All this became quite visible by the 1990s, when the fuel was used up and the economy cooled, leaving a mass of urban areas that no longer looked as distinct as they had a few decades earlier. Identity is a function of distinctiveness and continuity; without these a phenomenon is only a chimera, a mirage. Yet Asian cities, at least as represented by the most compelling films that take up the conditions after, say, 1980, seem neither distinguishable nor continuous. Haven't we heard that the filmic image of the "Generic City" (Rem Koolhaas's term) has migrated from Hong Kong to Seoul, without anyone really being aware of it? Urban renewal might as well mean "the urban condition," the condition that Edward Yang from *The Terrorizer* (1986) to *Yi Yi* (2000) knew how to lay before our eyes and ears, albeit in different hues. As for persistence, Asian cities may in fact differ significantly from their

west European counterparts in one respect: they pay comparatively little regard to their pasts. Natural disasters (the Kanto earthquake of 1923) and manmade assaults (the firebombing of Tokyo in 1945) leveled some cities; more corrosive to continuity has been the quick refashioning of livable space in every megalopolis coping with the massive immigration of the past few decades. Exodus from the countryside, together with wage-based manufacturing opportunities that have migrated from Japan to Taiwan to Hong Kong to Korea and then to Thailand and the Philippines, have meant that hordes of humans with housing and service needs have literally overrun an architectural past, obliterating much of what made certain cities distinctive. Even if image-conscious chambers of commerce have managed to erect signature buildings, life in the cities themselves, the movies show us, has become homogenous and flat: cities, like airports, are places of anonymous passage and convenient connection.

Look again at the cover of this book and recall Jameson's prophetic 1989 characterization of Edward Yang's *Terrorizer* as a representation of the random simultaneity of urban existence, wherein happenstance rules plot and terror replaces suspense. No one is in control, surely not the authorities whose "rapid response units" merely react to occurrences they can neither predict nor contain. When one character in *Terrorizer* dials a number aimlessly picked from the phone book, she plucks a chord that vibrates the entire network causing unforeseen static, interference, and violence somewhere down the line. Jameson rightly understands this as the horizontal representation of social life, with the adverb "meanwhile" effectively replacing such coordinating temporal conjunctions as "because" or "after," which would establish hierarchical (vertical) relations among events and people. To Yang (and to Jameson) Taipei is the very type of undistinguished urbanity, a flat and timeless present where things happen beyond the ken of an overseer. No character commands Taipei the way Vautrin secretly manipulated Balzac's Paris or the way (to take another 1980s film addressed by Jameson)[2] Gorodish controls the Paris of *Diva*. The narrators of *Terrorizer* and of recent Asian films like *Beijing Bicycle* and *Take Care of My Cat*, may see more than any character, but sight does not lead to insight. Events and people are put into mere conjunction, rather than into explanatory context.

Can a culture develop through purely horizontal relations? The wired-up world of South Korea may soon give us an answer. Meanwhile cinema (not TV) plays its traditional role of reflecting on this state of affairs, doing so either "on the edge of the city" or by carving a hole in the city center, wherever a movie screen awaits the ghostly images that slip across it for a time. Cinema allows images to develop not so much in the city but in relation to the city. The term "reflection" often used to describe this relation ought to give way to "shadow" or, as I plan to show, to "ghost." TV is the medium that reflects the city, along

with billboards, shop windows, and other technologies of image proliferation; cinema, on the other hand, "reflects on" rather than merely reflects the city, by separating itself ever so slightly in distance (at the edge, inside a theater) and in time (the time it takes for film to "develop," the time of composition and editing, the lag time of distribution). Cinema thus accompanies the city like a shadow or specter that is perpetually and productively behind it. What happens when the city looks away from its cell phones, computer screens, and TVs and looks into a movie? What happens, I want to argue, is the coming into consciousness of questions of history, of memory, of identity.

I have addressed this issue in a recent book, enlisting André Breton's peregrinations in *Nadja* and *L'Amour fou* as a way to enliven Paris with a vibrant past and a possible future.[3] In the first paragraph of *Nadja* Breton defines who he is by whom he haunts, "playing a ghostly part" not limited by his current physical presence but by all he has ceased to be in his blind submission to contingencies of time and place. The wayward method of his book takes him close to a mysterious woman whose appearance figures and portends untold encounters he will never register, a woman who "is closer to things" than he is. The things they touch in their wanderings are streets, monuments, and precise locations from which emanate the aroma of the past. Margaret Cohen details Breton's evocation of historical memory and its centrality for Walter Benjamin's "surrealist historiography" in a chapter of her book *Profane Illumination* called "The Ghosts of Paris." Breton cares nothing for official monuments; but his feet are drawn toward distinct crossroads and dilapidated vestiges like the Porte Saint-Denis where, Cohen reminds us, revolutions were started in 1830 and 1848.[4] She cites Breton's expectation of a rendezvous, seeing it as a meeting not just with a woman but with history:

> I do not know why it should be precisely there that my feet take me, that I go almost always without anything decisive but this obscure data, namely that *it* will happen there. I hardly see, in this quick trajectory, what could constitute for me, even without my knowing it, a magnetic pole in either space or time. No: not even the very beautiful and very useless Porte Saint-Denis.[5]

Boiffard's photographs open holes in *Nadja*, through which a wind from the past blows. Benjamin loved this aspect of both Surrealism and photography, thinking that the wind might blow into the future as well.

The spiritual force field around such a site felt by the bohemian Breton makes him quiver with anticipation as the present meets the revolutionary past of Paris. Filmmakers from Feuillade to Olivier Assayas have asked their actors to perform on Parisian locations charged with magnetic energy. Replay *Irma Vep* (1996): not just Maggie Cheung on the city's rooftops, but Jean-Pierre

Léaud, specter of the *nouvelle vague*, disappears at the end and leaves behind only celluloid whose surface has been scratched through.

Assayas personally made the transit from a tired European modernity to the cinematic youthfulness of Asian postmodernity.[6] The hyperkinetic Hong Kong action films, some of them featuring Maggie Cheung, quickly engendered a shadow genre. Let us treat the Asian ghost film as this shadow or underside of the films of urban postmodernity. If Maggie Cheung climbs across the roofs of Paris in *Irma Vep*, it is only because she has emerged from the sewers and anonymous lower depths of Hong Kong. At first blush one might want to pit genres against one another. As opposed to the disco-glitz and mirrored glass of so many postmodern films, ghost stories most frequently rise out of the rural past and, like an abandoned lover, bring terror on anyone who ventures into their space. This pattern dominates the most notorious Asian examples, as if their rural setting compensates for the anomie of statistical existence that has become the future for most immigrants to megacities. *Ringu* (1998), the unavoidable blockbuster and touchstone of the genre, opens in Tokyo, center of information, whose reporters travel to investigate para-rational phenomena occurring on the Izu peninsula: a ghost has bubbled up from a well covered over by tawdry tourist architecture and it terrorizes unsuspecting guests who happen into this sacred space connected to the magma of the past. This follows the pattern established by the most sublime Western example, *Nosferatu* (Murnau, 1922), in which death travels from far-off Transylvania to slip into Bremen's port and contaminates the city with plague. In *Ringu* the cancer spreads more insidiously along a self-activated network that will inevitably reach and destroy its nerve center, Tokyo. As in *Terrorizer*, everything begins when the telephone sounds inside an apartment. A wakeup call sets destiny in motion.

Ringu operates as an allegory, in which an original sin is passed along through viral dissemination. Potentially everyone, including the film's audience, will fall victim in this revenge tale of an innocent female child whose powers and expression were squelched and buried. Her ghost returns not to exact justice from those responsible for her trauma, but indiscriminately to spread an evil that passes through her. Is Sadako the emblem of womanhood so repressed in Japan, or is she a silkie, a sea creature? The origin of this epidemic may be inhuman, may shape itself according to the logic of the simulacrum. *Ringu* spreads its terror through video copies of films just like itself.

Ringu is also the literal origin of a powerful Asian cycle of ghost films. Hou Hsiao-hsien cites it as the example to follow, for it incorporates local material and aesthetic preferences in a manner that thrilled audiences throughout East Asia.[7] It is a model to copy, he said, perhaps ironically. Distinctively Asian ghost films feature pubescent girls and vaguely defined religious practices or beliefs.

I take these to challenge the organization of the metropolis by male interests and male logic. It is, after all, an anarchist female who sets *Terrorizer* in motion with a phone call. Every Asian cult film since seems to feature the unfathomable fury beneath a beguiling female face and body, from *Audition* (Miike Takashi, 1999) right up to Kurosawa Kiyoshi's *Loft* (2005), where a female author copies a manuscript she discovers in an uninhabited rural home, literally ghostwriting her new book and suffering the consequences when a mummy comes to life out of the nearby swamp. From this perspective, Hou was right to pair *Shiri* (Kang Je-gyu, 1999) with *Ringu*,[8] both films jump-starting a wave, by unleashing a female fury that enters the city from an outlying space. *Ringu* remains the more resonant because it evokes local folk myths that infiltrate the city via telephones and televisions, climbing right through the screen uncensored.

Hou's admonition that Asian cinema's health depends on exploiting regional genres (like the ghost film) while grounding them in specific and local material — Korean or Thai, etc. — undoubtedly comes from his having calculated the tremendous success of *Double Vision* (Chen Kuo-fu, 2002), a Taiwanese film whose box office in its home market was astounding and which played very well throughout East Asia. Specific local material in this case means folk beliefs and practices, like *Double Vision*'s Taoism which, far from orthodox, nevertheless comes out of Chen Kuo-fu's sense of the peculiar superstitions that have incubated on an island that still looks to the mainland for its spiritual roots. In this case an entire mainland temple has been imported to sustain cult practices. Crucial to us, the temple is camouflaged within a modern financial building. Within the temple, under its floor, lies the female ghost, hungry for victims who will help her in her quest for immortality. "All my films are about Taipei deep down," said Chen Kuo-fu in a post-screening discussion at Yale. "I see Taipei as foreign, alien. In *Double Vision*, Taipei is a ghost town. The color, the lines, the angles try to give that image."[9] Chen is certain that the Taiwanese anxiously turn to ancient or brand new religions in their perpetual fear of the mainland. He looks at Taipei with "double vision," two pupils but a single lens in the camera's eye, splitting the image while splitting the character of urban life into schizophrenia.

Even when the final dramatic confrontations take place downtown, most of these examples sustain a common opposition that distinguishes the ghost genre with its female instigators coming out of a rural past from urban genres (gangster films, sci-fi) where men contend with one another in the present. In Western cities, one may be lucky enough to stumble across charged spiritual zones as Breton does during his nightwalk with Nadja, or one may unluckily do so, like the couple who inadvertently buy the wrong apartment in *Rosemary's Baby* (Roman Polanski, 1968). At first glance, few Asian cities seem to harbor

such implacable ghosts, their pasts having been leveled in urban renewal. Stanley Kwan made this the very theme of *Rouge* in 1988, whose demoralized ghost must conjure up the pleasure house she inhabited early in the century while she stands in front of what has replaced it: a fast-food outlet.

The Asian city, however, has not yet disappeared entirely into the quicksand of postmodernity. In *Sorum* (Yoon Jong-chan, 2001), a slum building in Seoul became the site of a horrid and inescapable destiny for those living there. The film begins and ends in this dilapidated apartment on the verge of being rebuilt. Thirty years ago, we learn, a woman in room 504 disappeared, and recently a man was found bizarrely burnt to death there. The new tenant will eventually reenact the crime, killing the woman down the hall who had recently killed her husband in self-defense. By the time all is done, three bodies are buried in the nearby hillside and a novelist's account of the original crime circles back on itself like a Moebius strip. That novel is itself ghost-written, it turns out, since the novelist, living next door, snatched the pages from the fire that consumed the earlier tenant, also a writer. The layering of characters and actions pile up like a palimpsest, and literal traces are visible everywhere. The word "mommy" is scratched as graffiti on a wall. The hero's body, seen as he showers, contains inexplicable scarring. The woman down the hall exhibits bruises from the abuse she has received. The trigger of recognition comes, however, from a photographic trace, a seemingly harmless picture hanging above the barbershop where the building's landlord works. It shows the original family before the violence set fate in motion. Chin-yŏng looks cryptically, then knowingly, at this old photo, like Jack Nicholson in *The Shining* (set far from any city, by contrast). Later he and Myŏng-min will take a photo of themselves; later still he will recognize his look to be identical to that of the brutal man in the first photograph. *Sorum* takes its characters down a spiral of Oedipal degradation, as later generations rehearse the original dismemberment of the happy family. There is no escaping fate. Chin-yŏng drives his taxi through Seoul but returns each night to pick up Myŏng-min at the 7-11 store where she works (bright future of the global city); he takes her back to the apartment whose dark past regularly flashes on and off, like neon. The stroboscopic effect paralyzes everyone inside the building, the very image of Korea with its history of national family murder and dismemberment.

Rooted in the inescapable past of its national oedipal trauma, *Sorum* is a somber and regressive film, out of tune with the high-pitched hum of the postmodern global network of expanding megalopolises, like the same city, Seoul, represented the same year in *Take Care of My Cat* (Chŏng Chaeŭn, 2001). Whereas *Sorum* is caught in the bog of history, past alternating with present as in the light of some garish neon sign, Chŏng Chaeŭn represents the continuously

illuminated present of office buildings, shopping malls, and clubs that make up the environment and the lives of most Koreans, oblivious to the past. Seoul is shown stretching toward its new airport in Incheon, along high-speed rail lines. The airport is already beginning to encroach on this old port city, incorporating it into greater Seoul. One character returns to Incheon to find her back alley hovel collapsed, wiping out her parents, keepers of old practices and spirits. All are swept away before the forces of generic modernity. Chŏng Chaeŭn is sensitive to the different speeds at which her four female characters live their lives. The narration, progressive and catlike, nimbly follows them from an initial moment of community (the group photo at graduation) to their accelerating dispersal on trains, across cell phone calls, and finally, for two of them, on an airplane out of the country.

Next to *Take Care of My Cat*, *Sorum* appears heavy, weighed down, actually bound and gagged by a horrible and inescapable past. One can read this ghost film as an allegory of the obsession with national memory that overtook Korean cinema in the 1990s, because, in aiming to unsettle and frighten the spectator the way the genre traditionally does, it introduced a repressed and unbidden revenant. The past that hovers over *Take Care of My Cat*, on the other hand, has no spirit of agency and is not personified. Only figuratively can it be called a ghost film. Yet, without the memories that its urban geography evokes, the film would lose its significance and dramatic verve.

Midway between these two examples — one a classic ghost tale, the other a social critique evoking a lost past — stands one of the signal films of the New Korean cinema, *A Single Spark* (Pak Kwang-su, 1995), a title that announced a new ambition for Korean cinema. This film bravely and deliberately conjured up an historical character and a national trauma so as to reroute the present. It represents the once-well-known Chŏn T'ae-il, a tireless advocate of workers' rights who became a martyr through self-immolation during the failed struggles for progressive social and political change in 1972. But Pak Kwang-su complicates what could have been straightforward hagiography when he mediates the life of Chŏn T'ae-il through his biographer, an intellectual trying to continue his subject's political work in the turbulent years at the end of the 1970s. *A Single Spark* confidently offers a clean moral comparison of past and present, in which heroic black-and-white images of the good ghost, Chŏn T'ae-il, are evoked by the film's main character, this biographer, in a confusion of color. Kyung Hyun Kim argues for a complex understanding of *A Single Spark* by locating inconsistencies in the biographer's idealistic representation of Chŏn T'ae-il. The biographer needs his subject to be a martyr not just to define and inspire his own activism, but to complete and sell his book.[10] Presumably Pak Kwang-su narrates all this in 1995 from the more nuanced perspective afforded

by the democratization achieved in the late 1980s. He can ask contemporary viewers to keep both the past and the way it has been recruited in mind as he represents his two characters (Chŏn T'ae-il and his biographer) as well as the two dramatic moments they lived out (1972, 1979).

A Single Spark, working to render national history multi-dimensional by conjuring a martyr, seems flat, however, when set beside Hou Hsiao-hsien's *Good Men, Good Women*, made the same year. Also treating three periods, Hou works to express a wrenching cultural jet lag, and he does so using several registers. His main character embodies the directionless present. A film actress, when given the role of an actual revolutionary from the war years, cannot help but see her own life and that of Taiwan in relation to a terrible past she struggles to understand. More jarring, the scenes from the 1930s take place on the mainland, a mythical homeland for the Taiwanese patriots who have come to fight the Japanese. Because they are in fact involved in two struggles (a national fight against the Japanese and a civil war) they are returned to Taiwan, where starting in the late 1940s they must endure the White Terror at the hands of those mainland Chinese who followed them to claim Taiwan as a refuge. Our actress, portraying this situation for a TV show in 1995, finds herself simultaneously drawn into her personal past when faxes of pages from a diary she was sure she had lost begin to arrive maliciously and inexplicably in her apartment, forcing her to recall her sordid years in the 1980s with a petty drug dealer. Thus three time zones are intercalated in *Good Men, Good Women*, as the heroine (a symbol of Taiwan itself) is shown to be split between an ego-ideal, a squalid past, and a cheerless present.

Whereas the biographer of *A Single Spark* righteously rebukes his present for its moral malaise by holding up the image of his model subject, Hou's actress would forget the past, but cannot. The faxes that arrive unbidden (as from a cultural unconscious) provoke a confrontation with both her drug-befogged early years and the compromised political history that she replays on screen. Juggling three time periods and responding to internal contradictions in his character, Hou has renewed his modernism and challenged his audience both morally and aesthetically, by delving, as he has done since the 1980s, into the depths of the past, bringing its ghostly voices into dialogue with the present.

Hou Hsiao-hsien reminds us that cinema's specificity, its validity, and often its sublimity lie in the manner in which the visible comes to be questioned, clarified, or rebuked by the invisible. Something *develops* in cinema: characters and story develop in shooting; the exposed film literally develops in a chemical bath; the filmmaker's sense of a subject develops in post-production; and the significance of what is shown at one screening gives way to further significance

as interpretations develop and multiply. All this begins with the unique ontology of the photographic image. Cinema was made for ghostliness, which is why most films, benign though they may be, still have the power to haunt us.

James Tweedie encourages me to see in the ghost genre a compensation for, or response to, the real (and real estate) development of the Asian megalopolis. This is how Ackbar Abbas might be said to link *In the Mood for Love* to Hong Kong, the "City in Disappearance."[11] Postmodern cities are positive "developments" while films, which first come out as negatives, only gradually develop, bringing forward traces of their earlier stages and of film history. TV presents us with the here-and-now of urban immediacy, while cinema represents what is absent and potential, historical or virtual development.

Ghost films may be experienced as two contrapuntal lines of melody, wherein the somber past interweaves with and finally dominates the present. But let's switch keys, to listen to a new strain of Asian urban cinema that takes the form of a fugue in which the present is pursued by its equally present obverse. In the climate of what Garrett Stewart has called post-filmic cinema, signaled by time-travel plots, by characters harboring multiple identities, and by Moebius structures, the Asian films I am thinking of are free of the burden of the past.[12] Their convenient ontological fluidity corresponds to the atmosphere that reigns in twenty-first-century cities which have become post-post-traumatic — for the wounds have been covered over, including those inflicted on cities during twentieth-century wars and those sustained in the "big digs" that leveled the ground for modern development. Postmodern architecture is often defined by its turning history into historical style, only to put such style into ahistorical free play. The architecture and the movies of the twenty-first century aim to include different and even opposing elements, yet to do so without friction. But we are not free from otherness for all that: unexpected apparitions, benign ones perhaps, still lurk, casting a spiritual shadow behind or in front of urban developments.

3-Iron (Kim Ki-duk, 2004) follows such a shadow in and out of a long sequence of Seoul's domestic and public spaces. T'ae-suk fills empty houses like a benevolent and silent sprite. He exists in double-relay, photographing himself before other photographs that he encounters. He comes to desire the abused Sŏn-hwa (played by Yi Sŭng-yŏn) through her nude photos which he ogles while she is in fact actually naked just a few meters away in the bathtub. Shadowing her own image, she catches him aroused by her photos, and initiates an impossible desire that finds these two quasi-beings skipping through urban spaces together. Thus does a benevolent spirit — T'ae-suk — redress the abuse that urban life routinely produces. Cinema shadows the present as an image that repairs rather than terrorizes the city.

I turn finally to the film that sparked these meditations in the first place: *Tropical Malady*. More profoundly than *3-Iron*, *Tropical Malady* (Apichatpong Weerasethakul, 2004) proposes to change the nature of the ghost film. A contemporary gay urban romance that transmutes itself into a haunting jungle tale, *Tropical Malady* does not so much represent the power of imagination as take on that power. Shape-shifting as we watch it, developing before our eyes, and penetrating our dreams, it crosses from one realm to another, from the city to its shadow, the jungle, while its main character, Keng, metamorphoses into a beast.

A prologue in the savannah sets the stakes: a corpse is discovered and carried off screen by a group of soldiers, one of whom is Keng. The camera, now alone, zooms unprovoked and with purpose into the tangle of vegetation, as though it were the eye of a tiger. Next, a nude male figure enters and traverses the entire screen, exiting right. Later, we will assume that this "shape," surely the spirit of the departed corpse, belongs to or has become an avatar of Tong, Keng's urban boyfriend.

When after the credits Keng's unit rests for the evening at Tong's parents place in the forest, they meet and exchange greetings. "You talking about ghosts?" asks the mother as the two men sit near the shrouded corpse. They encounter each other sometime later in the city. It happens this way: Tong is headed to work on the bus routinely one morning. He flirts casually with an attractive girl, who is distracted by a cell phone call but maintains nearly tactile eye contact with him. But Tong is next distracted when someone in a neighboring truck reaches out and literally grabs his elbow at a traffic stop. It is Keng; they strike up a conversation, remind each other of their names and vaguely say they will see each other sometime. Thus random conveyances, carrying unrelated passengers, come into contact in the molecular motion of traffic, setting a love affair in motion. A most gentle, genial, and benign affair, or so it seems in the city, where it grows at a video game parlor, a night club (Tong is invited to join the retro torch singer on stage), and a tawdry movie theater. In the darkness, their eyes fixed on what sounds like a melodrama, Keng and Tong touch each other intimately for the first time, innocent smiles illuminating their transparent faces. Keng follows Tong to his country home beyond the city's edge. There, in this liminal space, they follow an older woman, an entrepreneur and priestess, down into an underground temple, then further on into a tunnel of unknown length through which they crawl, torch in hand, until Keng's courage fails him. Driven deeper by desire, Keng gnaws on, and would seem to devour, Tong's hand in their moment of parting. He passes into obscurity in the jungle where Keng cannot follow. Here at its dead center, the film fades to black and in a real sense it never quite fades in again, for Part II takes place in the blackness of the

jungle as the obverse of Part I's perpetually illuminated city. In the jungle speech degenerates into noises while baboons deliver dialogue; spirits wander from the animals they inhabited, and men become tigers. *Tropical Malady* changes shape before our eyes and *for* our eyes. This film becomes a different animal, or rather it is *the same* but as animal. When the figure that was Keng groans on his knees, tormented with animal desire, and gnaws now at his own hand, and when he (or rather, it, the animal, the figure, the film) looks at us, then we look into this dark screen and recognize our doppelganger. The shape-shifting screen is the tunnel at the city's edge. In the depths of the tunnel the invisible is as real as what can be scarcely made out. Thus the city is inhabited by the spirit of what is at its edge, the spirit of imagination which keeps memories alive. This is the spirit of cinema.

INTERLUDE 2

Workspace

James Tweedie

Slavoj Žižek has written that sites of mass industrial production only appear in Hollywood films during the decisive moment when James Bond is captured and taken on a tour of the villain's lair, with its half-completed tool of world domination on display and legions of uniformed workers scurrying around the shop floor as they build it. Bond then manages to escape and eventually to blow up the factory and its workers, and even the surrounding island, if necessary. Work environments, especially the spaces of large-scale industry, are as rare in East Asian city films as in Hollywood blockbusters, except in documentary or social realist exposés. A brief allusion to work life helps establish a character's identity without commanding too much screen time, unless, of course, the character's occupation is one of the glamorous few consecrated by genre cinema, most notably the gangster or detective. The streets of the city are the equivalent of the factory for the mobster or the hard-boiled detective; and in the movies, the labor of crime and justice, unlike most other jobs, is inseparable from its site of production.

Fig. ii.1 *Infernal Affairs* (Andrew Lau and Alan Mak, 2002)

Fig. ii.2 *Infernal Affairs*

The *Infernal Affairs* trilogy is an unusual gangster and detective story because over the course of three films the locations shift from the familiar haunts of the genre — a relatively mundane police headquarters, the city streets, and the various spaces of concealed criminal activity, ranging from a warehouse to a parking garage — to increasingly rarefied and spectacular spaces, including an expansive, virtually empty office space with floor-to-ceiling windows overlooking the Hong Kong harbor. (The first in the series was in fact filmed in humdrum but authentic locations like a parking lot at the old Kai Tak airport or the roof of the North Point Government Offices Building.)[1] The fundamental conceit of all three films is that a criminal and a police officer can infiltrate the other's organization without being discovered, the crook becoming the ideal and rapidly promoted cop, and vice versa. That basic premise is also inscribed on the spaces of the film. By the end of the trilogy, the more typical locations of the detective film, the streets and underground hideouts that define and distinguish the genre, have merged with the visually stunning but less obviously dramatic milieu of the high-level business services that organize transnational capitalism. The trilogy begins by situating its action in the environments that spawned the genre and concludes in an office suite more appropriate for an investment bank or advertising firm.

In the second and third installments of *Infernal Affairs*, the Andy Lau character returns from his execution after a final shootout (or his arrest, in an alternate ending) to star in two subsequent variations on the same theme, and he remains a member of an elite unit of the Hong Kong Police Department, though his surveillance work involves covering all traces of his criminal past. The trilogy as a whole is also a tale of revenance and infiltration: the gangster's inside man shifts fluidly back and forth between the spaces associated with crime and those controlled by the police; but over the course of three films, and even after his bloody demise, he migrates into another universe entirely, a space connected to the mean streets of the gangster film only by computer networks and surveillance cameras. With a blue glow emanating from the ubiquitous computer monitors and cell

Fig. ii.3 *Infernal Affairs III* (Andrew Lau and Alan Mak, 2003)

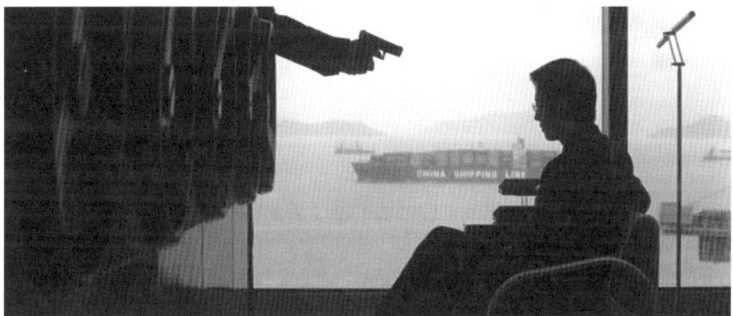

Fig. ii.4 *Infernal Affairs III*

phones, and with cavernous office spaces laid out with an infinitely flexible design, the police headquarters in *Infernal Affairs* has severed its ties with the streets of the city and joined a more ethereal network of globalized spaces linked by virtual flows of images and information. Andy Lau's gangster-turned-detective returns from the dead only to find himself surrounded by an increasingly spectral city where the decaying architecture and infrastructure of Hong Kong, concrete spaces that endure, has given way to the paradigmatic environments of global capitalism defined less by their structures and rootedness than by their adaptability and their links to communication systems. Viewed as a record of Hong Kong environments, *Infernal Affairs* becomes an allegory of the global city: it begins by occupying the parking lots, bureaucratic offices, and service rooftops left over from the previous era of modernization, the locations that Rem Koolhaas calls "junkspace"; and it concludes in a thoroughly globalized atmosphere where Andy Lau's character, a ghostly holdover from that earlier era, a product of the gangster genre and its typical haunts, now attempts to destroy all traces of the past. He sits at his desk, settles into his new role amid costumes and communications equipment, and realizes that his labor must begin with the effacement of the character and the city that used to be.

52 *Interlude 2*

Fig. ii.5 *Infernal Affairs III*

Fig. ii.6 *Infernal Affairs*

Fig. ii.7 *Infernal Affairs III*

PART *II*

A Regional Network of Cities

3

Taipei as Shinjuku's Other

Emilie Yueh-yu Yeh

Japanese cinema since the 1980s was noted for its apparent decline, and only recently was its recovery recorded with the performance of several popular films in the domestic market.¹ Parallel to the recovery was Japanese cinema's artistic achievement by independent filmmakers who emerged from television and video sectors. Miike Takashi is among these directors whose quick, efficient workmanship helped accumulate an impressive repertoire and establish a cult reputation. Like another noted Japanese filmmaker, Kitano Takeshi, Miike pushed a new engagement with the yakuza picture and rendered this genre attractive to fans of Asian popular cinema. But this does not mean that Miike and Kitano share similar views of contemporary Japanese cinema. On the contrary, Miike and Kitano engage differently with the film culture, hybrid identities, and multicultural society in Japan. Miike displays a sometimes morbid fascination with Asia and Asian cinemas. Many of his films are shot in other Asian countries or are diegetically related to Asian cities, notably Taipei and Hong Kong. Kitano, on the other hand, is less preoccupied with the relations between Japan and the rest of Asia. Although Kitano played a Japanese-Korean gangster in *Blood and Bones* (Chi to hone, 2004) directed by Sai Yoichi, a second-generation Korean, as director Kitano maintains a persistent Japanese identity in his portraits of a narcissistic, ultra-masculine Japan.

Compared with Kitano's self-conscious branding and polished workmanship (the *K* trademark opening Kitano's films), Miike's films are erratic, jagged. The messy states of Miike's fictional world have been aptly summarized as "lack and excess."² Miike avoids working with the same organizations or producers, and he does not commit himself to a single genre or style. He moves around and among genres, mixing yakuza, sci-fi, horror, and action at will. Where

Kitano's rich productions are aligned with well-known professionals and media conglomerates (Shochiku, Bandai Visual, TV Asahi, Tokyo FM Broadcasting, etc.), Miike's low-budget films are made by floating crews, with on-the-fly schedules, attached to no specific brand name, apart from that of the director himself. If Kitano's films come out of the calculations of the ubiquitous master K, then films by Miike convey a shifting, small case 'm' standing for messy, and master-less. Kitano's modern *rōnin* are dignified men of action and conviction; Miike's characters are restless mongrels, deranged mobs, and losers. While Kitano's heroes are "big brothers" of physical prowess and romantic angst (Nishi, Zatoichi and *aniki*, the Big Brother), Miike paints his underdogs with wild homosexual perversity.

These brief comparisons reveal the underlying disparity between Miike and Kitano. Miike's reputation as a cult director associated with a trashy, over-the-top, camp style is related to the conditions of his productions. He travels widely and trespasses geographical, financial, and stylistic boundaries. In other words, Miike represents *mukokuseki* (literally, "nation-less"), the practice of crossing, hybridization, and co-production. In contrast, Kitano's prestige is achieved by his *kokuseki* (citizenship), his "re-ignition of Japanese tradition," especially in his 1997 breakthrough *Hanabi*.[3] What is important is not, however, comparison of these two directors but their deployment of non-Japanese criminal elements as devices of style.

It is Miike's transnational, trans-generic consciousness that enables his films to be made quickly and cheaply. Global circulation is here mobilized by the *mukokuseki* style, which, in turn, is a product of the filmmaker's transitory, transnational mode of co-production. Miike's escape from the national style is illustrated in an interview:

> Japanese film people have this very conservative idea of what a film should be — and that's what they make again and again. Everyone is trying to make "film-like films" — they can't do anything else. There are enormously talented people outside the film industry who could challenge that way of thinking …[4]

Miike says that he is not interested in making the kind of cinema that simply repeats and recycles itself, alluding to films by major studio directors such as Yamada Yoji or even the independent Kitano Takeshi and films such as *Poppoya* (aka *Railroad Man*, 1999; dir. Furuhata Yasuo), *Bayside Shakedown* (Odoru daisôsasen, 1998; dir. Motohiro Katsuyuki), *Twilight Samurai* (Tasogare Seibei, 2002; dir. Yamada Yoji), and *Zatoichi* (dir. Kitano Takeshi, 2003). Miike seems to imply that these works, institutionalized as representative of Japanese cinema, no longer satisfy audiences and young creators. The indelible imprints of Japaneseness that these films have have become dead signs, signs with no

energy or vitality. Clearly, Miike wants to break away from the traditions of Japanese cinema or, in his own practice, to create a cinema that keeps its distance from national cinema *à la* Shochiku, Fuji Television, or even Office Kitano. The Asian dimension of Miike dominates his rejuvenation of Japanese film.

This disavowal of Japan in turn takes Miike onto different terrain, both geographically and cinematically. Miike Takashi's films have an obsession with East Asia. Exotic Asian locations, peoples, and cultures give Miike's films a vivid transnationality or statelessness — *mukokuseki*. In *Shinjuku Triad Society* (Shinjuku kuroshakai: Chaina mafia sensō, 1995) and *Rainy Dog* (Gokudō kuroshakai, 1997), Taipei is a refuge for Japanese gangsters and a place for hideous transnational crimes. But this transgressive transnationality is indebted to *mukokuseki akushon*, "borderless action," a 1950s/1960s genre known for its fusion of gangster, western, James Bond, and film noir. Where does Taipei, a capital city of Japan's former colony, stand in the latest rendition of *mukokuseki* in the films of Miike Takashi? Does Taipei function as a mirror of underground society? As postcolonial nostalgia? Or as something else? Given the concerns of the present volume, with Taipei running as an "engine of various desires," can we also find in Taipei potent fears, dread and loathing, as it arises in the fevered mind of Japanese storytellers?

The following discussion revisits the concept of *mukokuseki* in the spatial imagination of Japanese gangster films, with a focus on the representation of Taipei. The essay consists of three parts: *mukokuseki* as a mode of production and urban representation; Taipei as an ambivalent site for *mukokuseki* ventures; and finally, Taiwan New Cinema scenes as desirable locations/edges for the stylistic reorientation of contemporary Japanese cinema.

From *Mukokuseki Akushon* to *Mukokuseki* Asia

In a 1999 Japanese publication entitled *"Made in Japan Cinema": Ways of Reading: 1980–1999,* one of the contributors used *mukokuseki* as a keyword to describe Miike Takashi's works.[5] It is telling that the writer would employ the term *mukokuseki*, stateless or borderless, as if to place gangster films alongside fashionable consumer goods or cuisine, such as *mukokuseki ryōri*, Japanese fusion cuisine. According to Iwabuchi Koichi, the non-Japaneseness of Japanese computer games and animation is a manifestation of *mukokuseki*; by this he means "the erasure of racial or ethnic characteristic or a context."[6] On the other hand, in Japan's daily consumer culture, *mukokuseki* is ubiquitous on signs and refers to inexpensive restaurants where you can enjoy fusion cuisine with spicy Southeast Asian flavors and carouse until late. History does interesting things to popular culture here. *Mukokuseki* is not a recent arrival from the multicultural

fusion of the 1980s nor is it a neologism derived from global consumer markets. In fact, it has an etymological link to the cinema. In the 1950s, when U.S. military censorship was lifted, Japanese studios went full-bore to develop a new type of movie targeting young audiences, who were crucial to the rise of the postwar consumer economy. That new style was called *mukokuseki akushon*, or "borderless action."

Borderless action films were produced by the Nikkatsu studio in the 1950s as a type modeled on a mixture of genres: film noir, gangster pictures, and detective thrillers. For example, Inoue Umetsugu's *Eagle and Hawk* (Washi to taka, 1957) starring Ishihara Yujirō (1934–1987) features this type of borderless blending in terms of style and narrative. The film begins with a film noir setup: a drunken sailor, murdered in a dark alley in a seaport. Low-key lighting for shadowy effects and fragmented views that conceal the crime scene — these techniques recall film noir conventions used in American cinema of the 1940s and 1950s. A vivid marker of *mukokuseki* appears at the end of the opening sequence, just before the sailor is killed. As he becomes aware of his stalker, the victim runs for his life but is stopped by the murderer waiting at the corner. Here we see a large silhouette on the wall, again, a film noir suspense device representing the invisible, fearsome murderer. Above the shadowy image, there are inscribed two words — "NO SMOKING." Even though the second part of "smoking" is kept outside of the frame, the audience has no trouble deciphering this sign — an English phrase now recognized as a universal language for fire prevention. But in the 1950s, the warning's appearance in English rather than in Japanese displaces the scene, making it seem as if it were on a base or in a restricted customs zone. Diegetically, though the space is supposedly in Japan, the signage renders the Japanese setting *mukokuseki*.

After the sensational noir opening with a *mukokuseki* undertone, the film unfolds as a Borderless Action adventure story at sea. This is *mukokuseki* at work: the hero on board sails out into the wide blue Pacific. During the journey, romance crisscrosses action and adventure while the murder mystery is eventually solved.

The film's romance subplot incorporates singing to further advance the mixed but well-matched quality. The music takes place under blue moonlight to enhance the exotic, romantic atmosphere at sea. The male lead, Ishihara Yujirō, sits on the deck, facing the camera while playing a ukulele and singing to a young woman in a tight white dress, similar to Liz Taylor's sultry appearance in *Cat on a Hot Tin Roof* (1958; dir. Richard Brooks). Ishihara Yujirō, Japan's Elvis Presley, was perhaps the biggest crossover star in contemporary Japan. Ishihara began his career as a Nikkatsu actor in the mid-1950s and quickly rose to remarkable stardom. Like Elvis, Ishihara was known as "the King"

in Japan, but he was not just a pop singer crossing over to movies. Before his premature death in 1987, he made forty-five films. Ishihara's star image as a rebellious but romantic heartthrob signified a new breed of Japanese youth during the post-occupation rebirth and resurgence of national awareness. Furthermore, it promoted a new explosion of masculinity that was assertive and pleasure-driven.[7] With the occupation's end, masculine Japanese aggression was domesticated and became symbolized by a stylish, decadent male iconography fashioned by American and French youth culture. Ishihara Yujirō was about six feet tall, with long legs, large eyes, and a wicked, boyish grin. This new youth image was no longer a unifying *Japanese* imagery, but a cosmopolitan look whose Japaneseness was constructed through its "un-Japaneseness" (*Nihon banare*).[8]

Mukokuseki as a stylistic mode might be an allegory for the Cold War political unconscious. It makes little sense to call a mélange of borrowed action genres stateless, because during the Cold War *mukokuseki* as a practice was certainly fantasy. National borders in Japan were jealously guarded, and communist paranoia was used to police internal political conformity, as well as to project a strong outward resolve. In summary, we might say that cultural productions during this period were aimed at fostering and supporting a collective, national identity. The Japanese term should be read as a disguise for, or a displacement of, rampant Westernization, a sensuous carnival of foreign indulgence. The negative term "no-nationality" was used to describe a Japanese culture in the grip of rapid but idiosyncratic Westernization, after the earlier attempt to force pan-Asian cultural and political impositions in the form of *Dai Tōwa kyōeiken*, the Greater East Asian Co-prosperity Sphere.

So, *mukokuseki* did not really embrace borderlessness at this time. It meant instead the postwar domestication or synthesizing of foreign ingredients within a Japanese framework. "Borderless" here suggests a Japan confidently receiving and adapting exotic materials for its own use. More specifically, confronted by powerful institutions such as Hollywood and European cinema, Japanese film had to be inventive in order to compete. Borderless action was a rational choice to produce popular culture through differentiation from a Western other. These genre pictures seem cosmopolitan in characteristically Japanese ways, mixing and mismatching imported generic styles. They express mastery and insecurity, acknowledging the popularity of American (or Italian) westerns, James Bond films, or films about juvenile delinquency, while also refashioning these ingredients in ways often improbable or incongruous (as in the "funny English" on Japanese clothing). Postwar cosmopolitanism through Borderless Action appears fragmented, caught between gestures of admiration and ridicule. It is difficult to know how serious these vehicles of postwar cosmopolitanism

were, given the historical interval between Borderless Action and contemporary *mukokuseki* consumption.

If Borderless Action is now consigned to film history, Miike Takashi's low-budget yakuza films revive borderless ventures with new versions and representations. Unlike Borderless Action, synthesizing Western or faux-Western genres, Miike's *mukokuseki* yakuza films move from generic, artificial sets to spaces with class, ethnic, and geographical specificities. *Rainy Dog* (Gokudô kuroshakai, 1997), *The Bird People of China* (Chûgoku no chôjin, 1998), *The City of Lost Souls* (Hyôryû-gai, 2000), *DOA 2* (2000), and *DOA Final* (2002) can all be called neo-*mukokuseki* in terms of a shift from pseudo-Western settings to specific, East Asian geographies and ethnicities. The story of *Rainy Dog* takes place entirely in Taiwan. The encounter between Japanese gangsters and Chinese ethnic minorities in *The Bird People of China* was shot in China's remote Yunnan Province. In *DOA Final*, Hong Kong locations are supposed to pass for a futuristic Yokohoma populated with cyborgs and Chinese-speaking rebels. Yakuza characters in these films virtually fall into identity limbo, baffled by who they are and what they might become. Lost in some kind of stateless, trans-generic space, they lack identity papers (*Rainy Dog* and *City of Lost Souls*), go native in a Third World utopia (*Bird People*), or simply turn into androids (*DOA Final*).

As Yomota Inuhiko suggests, Miike rewrites Borderless Action in undermining the unequivocal Japanese ethnicity and exclusion of women as in the old-fashioned Japanese chivalry pictures. Yomota argues that Miike's inclusion of hybrids, homosexuals, and foreigners gives *mukokuseki* a distinct, contemporary currency and allows Japanese cinema to break the boundaries once policed by the Cold War mentality.[9]

In her "The Break-up of the National Body: Cosmetic Multiculturalism and Films of Miike Takashi," Mika Ko makes the link between the prominence of non-Japanese characters and the breakdown of the homogeneous Japanese national identity in Miike's films of the late 1990s. Ko argues that to depict a broken and fragmented "national body" in contemporary Japan, Miike has mobilized tropes of multiculturalism as a narrative strategy for his gangster films. But in the end, this strategy remains no more than a trope, a cosmetic device. This is because Miike merely notes the disruption that multiculturalism has brought to Japanese society, and fails to question the dominant structure of racial discourse in Japan.[10]

Ko's essay provides insight into Miike's inclusion of non-Japanese ethnicities, especially mixed-blood Japanese, and their awkwardness in mainstream society. Informed by critiques of multiculturalism, her reading is useful in understanding the rising interest in representing Asia as a cluster of

criminalized scenes, echoing the dystopic sentiment of post-bubble economy Japan. Does this mean that Miike's films represent an important diversification (or fragmentation) of Japanese cinema prompted by multiculturalism? Is cosmetic multicultural discourse useful in examining his fluid, borderless film style? Given Japan's ambivalence towards other Asian cultures and nations, do Miike's pictures represent Asia and, specifically, Taipei, in a new light?

In addition to specific locales in East Asia, Miike depicts *mukokuseki* within Japan by presenting Taiwanese, Brazilian, African, Filipino, and Chinese outlaws residing in Tokyo, reminiscent of the standard association of *mukokuseki* fusion cuisine with Southeast Asia, Africa, and the Middle East. Here, the notorious Kabukicho of Shinjuku is presented as an intra-Asian interior, nurturing varieties of transnational enterprise and crime. Miike's contemporary rendering of *mukokuseki* by way of the yakuza genre is a forceful representation of borderless Asia, a new regional imaginary precipitated, and enabled, by globalization. Fusion chef Miike cooks his *mukokuseki* pictures by using scenes (flavors) and ingredients (sites, locations) from other Asian cinemas. Unlike the Cold War Borderless Action, which domesticated Western genres within images of postwar Japanese cosmopolitanism, Miike's *mukokuseki* Asia serves as a placeless stage where Japanese potency and purity is confronted and undermined.

Moreover, *mukokuseki* Asia allows immersion in the canons of East Asian art cinema and boldly exhibits cinematic debts to neighboring film styles. In *The Bird People of China*, Miike incorporates visual tropes from China's Fifth Generation, such as leading directors Chen Kaige and Zhang Yimou, to depict China's enthralling landscape and peasantry. When he made *Rainy Dog* in Taiwan, he paid tribute to Taiwan New Cinema by citing Hou Hsiao-hsien and Edward Yang, two major internationally renowned Taiwan directors. These canonical styles from Chinese-language films occupy potent sites in Miike's making of the neo-*mukokuseki* action pictures. The following section focuses on Taipei, a frequent destination in Miike's borderless adventures.

Mukokuseki Asia in Taipei

Primitivist Taipei

One critic proclaimed that there is little connection between *Shinjuku Triad Society* and *Rainy Dog*, the first two installments of Miike Takashi's Triad Trilogy.[11] The critic forgets, however, that locales can forge a narrative link, just as characters and plots do. Moreover, locales, especially border crossings and shifting spaces, are core to the *mukokuseki* imagination. The locale that connects these two films is Taipei, one of the key spaces in Miike's evocation of *mukokuseki* Asia.

Taipei plays an important narrative and spatial transition in *Shinjuku Triad Society*. It is the homeland of Wang Chi-ming (Tomoro Taguchi), the head of the Taiwanese Dragon's Claw gang in Shinjuku. Wang is a psychopath, deviant and unpredictable. In the middle of a war between Dragon's Claw and another gang, a Shinjuku policeman travels to Taiwan to investigate Wang's background and discovers his trade: trafficking in human organs. An abandoned hospital from the colonial days is used to "harvest" local drug addicts and poor Filipinos who have been smuggled onto the island. Their kidneys are removed and sold on the black market in Japan. More importantly, inspector Kiriya (Kippei Shiina) is able to understand Wang's dark psyche because he sees his origins: a typical Third World backwater with colonial ruins, poverty, and widespread drug addiction.

In fact, *Shinjuku Triad Society* opens with images related to Taipei. The opening scene depicts a naked man in bed babbling in garbled Taiwanese. The film then cuts to a murder scene in Shinjuku alternating with a Taipei montage: a village boy, a pig's head being chopped off, a bloody washbasin, and a disfigured beggar sprawled on a wet market floor. It is not clear initially how these images relate to the story, but later they re-emerge as narrative links to the ferocious Taiwanese-Japanese mobster Wang. Even though Wang speaks fluent Japanese and moves around Shinjuku as a native, his unconscious remains with the primitive, drug-addled Taipei. In this connection, it is not far-fetched for *Rainy Dog*, the sequel to *Shinjuku Triad Society*, to use Taipei as its only setting, given its criminalized representation in the earlier film.

Rainy Dog opens with two medium shots of slaughtered pigs crammed inside a moving truck. Inside the truck, the gutted pigs are photographed as if they are corpses — naked, raw, and hanging grotesquely from both sides of the frame. Another medium shot introduces Yūji (Aikawa Sho), the protagonist, as he walks through these body parts to reach the end of the truck. These packed-in carcasses foreground the squalid environment. This is our introduction to the film's setting — Taipei — so powerfully encoded as a primitive refuge for a lone Japanese gangster.

Taipei as a filthy hideout appears again in the next scene, in which Yūji drags a pig on his back, staggering inside the meat section of an old wet market. A butcher is in the background, chopping pig parts while Yūji and his mates continue to discharge their cargo. There is a cutaway to a black cat, a regular scavenger at the scene, enjoying raw meat.

What does the opening of *Rainy Dog* signify, in terms of the relationship between the protagonist and his space? Yūji is a runaway yakuza, hiding in Taipei after the breakout of gang warfare in Shinjuku. His Taipei sojourn is hardly glamorous. Unlike typical depictions of a runaway gangster enjoying

a "vacation" in pleasure spots such as Spain or Okinawa, Yūji is in exile. He works for a local boss (Li Li-ch'ün) in exchange for protection while he awaits a passport to get home. The opening sequence sets the stage for exile — an area of slaughterhouses, brutality, crime, and decrepitude. Shadowy photography extends this primitive locale where the ex-yakuza makes his living as both a laborer and hitman, blindly following orders like a dog. The second sequence takes us to Yūji's temporary home, a tiny upstairs room in a dismal city with substandard infrastructure and lots of rain.

Yūji is not the only wandering yakuza in Taipei. There is another Japanese man, a nameless hitman (Tomorowo Taguchi) camped out in the city and waiting for the best opportunity to nail his target — Yūji. This assassin, too, is prohibited from returning home. To go home, he must complete his assignment to kill his fellow Japanese gangster. To these two exiles from Shinjuku, Taipei functions more like a doghouse than a holiday paradise, although they concede that Taipei has "good food and kind women," the postcolonial attraction marketed towards Japanese tourists. A typical morning for Taguchi's character: after he gets out of his sleeping bag on an anonymous rooftop, he stands, spits, and urinates straight down from where he stands on the edge of the roof. The interesting thing about this scene is the deliberate shot of the man's penis in medium close-up as he urinates. Relieved, he shouts, "I love it, Taipei." To this homeless Japanese man, Taipei is an open toilet, a filthy but relaxed place in which a man can undo his pants and piss on the world. Following this logic, the rest of the film shows Yūji and Taguchi's character both trotting around Taipei with their outrageous acts as if the city were a silent, impassive backdrop in which the criminal presence of Japanese gangsters appears routine, rather than as an annoyance. In this sense, Yūji and his assassin are likened to stray dogs wandering in the rain, just like Yūji's illegitimate son whom he refuses to acknowledge and tolerates as a stray pup.

Rainy Dog shares with Miike's other works similar characters, plots, and gags; stylized action choreography; and cynical representations of heroism and homosexuality. But the Taipei setting makes the hero's conundrum even less predictable. Taipei is not a refugee paradise, nor a safe shelter. It is full of deceit and false promises, aside from offering cheap food and sex. It double-crosses the Japanese man, manipulating his vulnerability and exploiting his expertise. On the other hand, Taipei seems to be a natural choice, because its colonial history allows a somewhat comfortable familiarity and serves as a site for nostalgia. Thus, it is not surprising to see Yūji solicited by a pimp — in Japanese — even in a rural area. Taiwan nativist writers Huang Chun-ming and Wang Chen-ho have written remarkable works on Japanese sex tours to Taiwan, an indelible, bitter memory in Taiwan's postcolonial literature.

Here we see Taipei's double alterity, combining for Japan both horror and nostalgia. Taipei underlines Japan's continuing fear and loathing of Chinese-speaking society and serves as a deprived and ludicrous location for eccentric Shinjuku outcasts. Yûji's white raincoat works like a visual gag: a foreign hitman calling attention to himself and the ridiculous mismatch with his surroundings. Meanwhile, the same primitive setting mobilizes nostalgia on behalf of highly modernized, efficient, and technocentric Japan. As envisioned by Japanese filmmakers, Taipei's duality makes it an alternative space for proscribed activity — border-crossing, rusticity, alternative cuisine and sex, lawlessness, and drugs — and a convenient place to vanish. Taipei is *mukokuseki*'s perfect terrain.

Cinema Taiwan

The shooting of *Rainy Dog* was a strange experience for the director from Tokyo. Miike was alone, in that his production crew consisted mostly of Taiwanese. The only Japanese crew members were the two actors, a soundman, and Miike himself.[12] Chang Hua-kun, of City Film Company, was brought in to assist on location shooting in Taipei. Chang is a well-known producer, having produced Hou Hsiao-hsien's films in the early 1980s. Does Chang's production background have an effect on the style of the film? Aaron Gerow says that in *Rainy Dog*, Miike used actors who were "prominent in Hou's work,"[13] which is not entirely wrong, but it may be based on misinformation circulated by the film's publicists. Chang Shih, the actor who plays the local gang member chasing Yûji, and Niu Cheng-tse, who plays a flamboyant but untrustworthy gay artist, are the two leads in *The Boys from Fenggui* (Fenggui lai de ren, 1983), but they have virtually disappeared from Hou's films since then. Only until recently was Niu seen to play a minor role in Hou's *Millennium Mambo* (Qianxi manbo, 2001). Gerow also indicates that Miike uses Li Yi-hsu, Edward Yang's cameraman for *Mahjong* (Majiang, 1996), as the cinematographer for *Rainy Dog*. But the cinematography in *Rainy Dog* is nothing like the brisk and upbeat photography of the booming, yuppie Taipei presented by Yang. To use these names to prove a link between *Rainy Dog* and Taiwan New Cinema would be difficult. But if we turn our attention to style, then we may find more tangible connections.

Bringing us back to the opening sequence of the film, the shot that follows the wet market scene is a tunnel vision setup showing Yûji being paid. Meanwhile, a fight breaks out nearby, as indicated by the off-screen sounds. Yûji checks it out, but keeps his distance. Like Edward Yang's *A Brighter Summer Day*

(Gulingjie shaonian sharen shijian, 1991), this setup pushes violent confrontation to the edges or even off the screen altogether.[14] Hou Hsiao-hsien also uses this technique in City of Sadness (Beiqing chengshi, 1989) and Puppetmaster (Ximeng rensheng, 1993) to create a sense of cosmic *distanciation* and "geometrization of the space." According to Abe-Nornes and Yeh, Taiwan New Cinema is conscious of staging conflicts and violence as an integral part of the entire setting, not merely as a dramatic focus.[15] It is important to note that such setups are rarely seen in Miike's other work, in which he avoids the use of establishing wide shots in scenes depicting explicit violence and sexual expression. Instead, he favors medium close-ups to create the effect of an abrupt, motional intensity. Miike's deviation here could be explained by the director's deliberate tribute to Taiwan New Cinema.

In the following sequence, a bird's eye view is employed to reveal the neighborhood where Yûji lives. Recall Wan Ren's *Super Citizen* (Chaoji shimin, 1985), a film that exposes Taipei's moral corruption. Even Yûji's tiny upstairs room is similar to the temporary housing in the notorious, red-light district occupied by the protagonist of *Super Citizen*. Immediately after the shot of the neighborhood, there is a wide-angle shot of a narrow alleyway, into which an old man shambles against a yellowish, relaxing backlight. Here we see Yûji easily riding his bike into the alleyway, passing the old man, and arriving at his shelter in Taipei. This comforting composition is intended not merely as a transitional shot, but as a depiction of the daily routine of the Japanese exile. We could argue that such a depiction comes from outside the regular, generic staging of gangster pictures in which a calming, slow moment is often followed by a shocking dramatic effect. It is worth noting that Miike's staging is known for its shock value and, sometimes, cheap thrills. Hence this staging, so alien to Miike's work, can only be interpreted as something borrowed, cited from outside his own repertoire. Early Hou Hsiao-hsien films, particularly *The Boys from Fenggui*, *A Time to Live and a Time to Die* (Tongnian wangshi, 1985), and *Dust in the Wind* (Lian lian feng chen, 1986), which were all embraced by Japanese critics,[16] are pregnant with this kind of staging device in order to reveal a continuous space and a correspondingly wholesome way of life.

All of these examples appear to be citations of or homage to the more established places and space of Taiwan cinema. Not only are Miike's heroes displaced from their home turf, but it also seems that his film style is dislocated and reoriented, taking cues from echoes of East Asian cinematic voices. These voices haunt the *mise-en-scène* and cinematography of contemporary yakuza pictures such as Miike's, lending nostalgia, discovery, and an East Asian reconfiguration of Tokyo stories.

Conclusion

From Nikkatsu studio's Borderless Action to Miike Takashi's *mukokuseki* yakuza, a major change occurred in content, style, and mode of production, in response to a rise in the "pluralization of ethnicity" in Japan and to scattered film cultures, as Yomota Inuhiko pointed out in the late 1990s.[17] Multiculturalism and its critiques are useful as an entry to comprehending the counter-cultural world and its heteroglossia in the gangster films of Miike Takashi. But multiculturalism falls short as an account of the complexity of Japan's relations with Asia, especially the ways in which Asia is imagined as a post-bubble-economy dystopia and as a land for adventure and nostalgia. Here we find film language and its construction of city space a useful, alternate entry to answering our question about *mukokuseki* cinema and its borrowed, mixed surroundings.

Not only must we consider the passage of nearly fifty years of film and social history: the idea of borderlessness itself has traversed different phases, from post-occupation synthesis of Western genres, to counter-cultural appropriations of Southeast Asian fashion, to a diffuse bohemian sensibility that may or may not connect with contemporary Japanese forms of multiculturalism. A more popularized, tantalizing version of *mukokuseki* yakuza is Iwai Shunji's *Swallowtail* (Suwarōteiru, 2000), synthesizing cosmopolitan youth cultures with fantasies of urban homesteading and criminal syndication. The fictional city of Yen Town is a cowboy haven for refugees and third-culture people, where one's (white) color is belied by linguistic facility (in Japanese), which points to a carnivalesque pan-Asian fantasy, a melting pot for Japanese disillusion, as well as for non-Japanese settlement. This has less to do with real multiculturalism in Japan and more with an appreciation of other Asian film and popular cultures, imported to Japan from Taiwan, Korea, and China.[18] Young Japanese directors were aware of the rising aesthetic status of films from these areas, as well as their sensational cult values of explosive energy.

More relevant is the new spatial imaginaries of contemporary filmmaking and its attempts to challenge the conventional binarism of spatial imagination. Here Edward Soja's "thirding-as-othering" offers a theory of disjuncture between Taipei as a primitive Third World city and Taiwan cinema as desiring "*spaces* of representations" (my emphasis):

> Thirding introduces a critical "other-than" choice that speaks and critiques through its otherness. That is to say, it does not derive simply from an additive combination of its binary antecedents but rather from a disordering, deconstruction, and tentative reconstitution of their resumed totalization producing an open alternative that is both similar and strikingly different ... open to additional otherness, to a continuing expansion of spatial knowledge.[19]

Thematically, Miike copies tropes of Orientalism by depicting Taipei as Japan's destined, "other" space, a playground to generate *mukokuseki* fantasies. Hence Taipei remains exoticized, trivialized, and most often criminalized. But beyond the thematic level, Taipei as a primitive space is complicated by the insertion of familiar scenes from Taiwan cinema, a decisive contribution to world cinema from Japan's former colony. Not since the work of Akira Kurosawa and Kenji Mizoguchi has Japanese cinema made such an impact on world filmmakers. The flow of cultural influence seems to have reversed in these Taipei images. These Taipei scenes virtually transform Miike's visual style into something strange, something other than Miike. It seems at this point that *mukokuseki* has gone beyond a mere geographical crossing and entered a new, third terrain, an unpredicted and not entirely resolved synthetic space. Because of its place in Japanese colonial history, Taipei's figuration as Shinjuku's other remains tenaciously problematic and vividly attractive.

4

City of Youth, Ocean of Death: Taiyōzoku on the Edge of an Island

Yiman Wang

The relationship between the city and cinema has been an important topic in studies of cinematic modernity. Regarding the increased significance of the city due to the inception of the sound era, Anthony Sutcliffe writes, "[T]he definitive arrival of sound in 1929 confirmed the credentials of the big city, as par excellence the home of noise, as a neutral or even positive setting for feature films."[1] This is amply manifested in the outpouring of a series of American musicals extolling the excitement of New York, the Chaplinesque comedy containing mild social criticism, and a new genre called the gangster film.[2] Sutcliffe's reference to the city-musical connection suggests that the ways and the extent to which the city is deployed vary with cinema technologies and historical periods.

Another significant moment when the city assumes a symbiotic relationship with cinema was the postwar era, which witnessed the emergence of film noir and urban youth problem films in America, the iconoclastic Taiyōzoku (Sun Tribe) literature and cinema in Japan, and the "Teddy Boy" and "Teddy Girl" film imagery in Hong Kong.[3] The postwar concatenation between these national/regional films highlights the transnational operation of urban culture as refracted through marginal figures such as the shady characters in film noir and juvenile delinquents in urban youth problem films. Such transnational linkage becomes more conspicuous and better documented, in the late twentieth century, due to the escalation of worldwide urbanization and globalization. An important conception of the contemporary city is put forward by Rem Koolhaas, an architect and writer, whose notion of the "Generic City" has been frequently cited in analyses of contemporary filmic representation of city. In this chapter, I contemplate the implications of the Generic City through the lens of two urban youth films from postwar Japan and Hong Kong respectively. My study of the

Generic City in the postwar era may seem anachronistic, because what Koolhaas calls the "Generic City" did not exist then. Nevertheless, as shall become clear in the following pages, my study not only underscores an early phase of imaging the Generic City triggered by the postwar dissemination of Western urban youth culture in East Asia (often via the mediation of Japan); I also examine the political and cultural implications of "genericity" in relation to the commonly emphasized specificity. I demonstrate that genericity actually inscribes the inability to address the specificity, which in turn constitutes the very content of the specificity. In other words, genericity should be understood not as a factual existence antithetical to specificity, but rather as the manifestation of specific socio-political conditions and representations. The global "genericity" and the local specificity intersect in ways that make them mutually constitutive, rather than subsuming the local to the global. Georg Simmel's study of early modernity and spatiality usefully highlights the politics of the global/local space. According to Simmel, the metropolis necessarily "overflows by waves into a far-flung international area" so that a "single city has broadened into the totality of cultural production."[4] To understand such a space, one must follow Iain Borden's reading of Simmel and see space "in the realm of *the ideological*, the representational, the structuring and the more mental dimensions of the *phenomenological*; it is a space that alludes, extends, permeates and envelops."[5]

In this chapter, my goal is precisely to study the ideological register of (urban) spatiality at the interwoven global and local levels. I base my argument on two films: the Japanese Taiyōzoku film *Crazed Fruit* (dir. Nakahira Kō, 1956), based on Ishihara Shintarō's fiction of the same title, and its Hong Kong remake *Summer Heat* (Kuang Lianshi), again directed by Nakahira Kō (aka Yang Shuxi) in 1968.

I choose to focus on this remaking practice for two reasons. The first has to do with a theoretical concern. That is, the generic turn manifested in these (and other 1960s remakes directed by Japanese directors contracted by the Shaw Bros. Studio) provides an optimal opportunity for discussing the dialectic of specificity and genericity (especially the Generic City) in a concrete context. Secondly, my attention to film remaking practices responds to an important phenomenon in Hong Kong film industry from the 1950s to the 1970s, namely, the collaboration with Japan, initiated by the Shaw Bros. Studio and its rival, MP & GI (later renamed Cathay). Such collaboration took the form of using Japanese landscapes and contracting Japanese directors, composers, cameramen, and choreographers. Japanese directors contracted by Shaw Bros. and MP & GI during this period included Inoue Umetsugu, Wakasugi Mitsuo, Shima Kōji, Murayama Mitsuo, Matsuo Akinori, and Nakahira Kō.[6] The two Japanese directors noted for remaking a number of their Japanese films for Shaw Bros.

were Inoue Umetsugu and Nakahira Kō. It is on the latter, Nakahira Kō, and his two films that I focus in this chapter.

It has been argued that many of these directors tended to recycle their Japanese productions without showing explicit interest in localizing them in Hong Kong. Consequently, their remakes in Hong Kong bear few identifiable traces of Hong Kong specificity. Chua Lam, Shaw Bros.'s 1960s representative in Japan who was responsible for inviting Japanese filmmakers, for instance, holds that the Japanese directors' self-remakes in Mandarin Chinese were inferior to their Japanese originals because their purpose was "not to surpass … but to copy."[7] Similarly, Emilie Yue-yu Yeh and Darrell William Davis argue that Inoue Umetsugu's Mandarin self-remakes represent uncomplicated transplantation of the 1950s Japanese Taiyōzoku cinema to 1960s Hong Kong. As a result, what started as iconoclastic youth films became stale and dissociated from the 1960s youth culture in Hong Kong. Inoue's Hong Kong productions followed the "fast food recipe of 'pop art à la Shaws'," and hence were no more than mass-produced toys, rather than hand-carved playthings.[8]

Lam, and Yeh and Davis, are not simply echoing the clichéd idea that the remake inevitably lives in the shadow of the original, even when both come from the same director. Rather, by pointing out that the Japanese directors' Hong Kong remakes failed to be local or up-to-date, they implicitly raise an important question regarding the definition or identification of what counts as up-to-date Hong Kong specificity. It remains debatable whether the Japanese directors' Hong Kong remakes are indeed irrelevant to Hong Kong — or how one may determine what Hong Kong is or is not. Nevertheless, if we accept the argument that Nakahira's Hong Kong remake and other similar cases are no more than a Hong Kong cast pasted onto existent Japanese film ideas, then we need to ask: why it is useful to study what is seen as the generic and *non*-Hong Kong in the remake(s); what this implies for building a Hong Kong movie empire in an era prior to Hong Kong's economic takeoff; and most importantly, how this helps us to better understand the cultural and political import of the Generic City as well as the generic as a concept.

By comparing Nakahira Kō's two films, I analyze how he failed to localize and indigenize a postwar Japanese Taiyōzoku film in late 1960s Hong Kong. Specifically, if we accept that he (along with other contracted Japanese directors) did fail to localize the remakes, then we should ask what made them be perceived as foreign, or Japanese in this case? Does the failure to indigenize serve any purposes? How does the very foreignness of the films contribute to the formation of the postwar Hong Kong movie industry and pop cultural ideology in general? My discussion of the foreign and the non-local genericity is inspired by what Lawrence Venuti, in a different context, calls the "foreignizing

translation," as opposed to "domesticating translation."[9] To galvanize these questions, I focus on the differing *spatial* configurations of the two Nakahira Kō films. My goal is to provide a new angle on two interrelated issues: 1) the phenomenon of Japanese directors' self-remakes encouraged by the 1960s and 70s Hong Kong film industry, and 2) the formation of generic urban cinema and its relationship to the postwar Hong Kong's geopolitics. These two aspects combine to underscore the ways local specificity and global genericity mutually constitute each other. They suggest that Hong Kong cinema's attempt to align with the Western and the Japanese youth film was actually closely connected with the postwar political condition, even when such a condition exists as structural absence in the film narrative per se. The last part of the essay will focus on why it is important to understand geopolitics as the structural absence.

Now I turn to my case study of Nakahira Kō's *Crazed Fruit* and *Summer Heat*. An outline of the two films is in order here. Over ten years apart, the two films are amazingly close in terms of the narrative *and* dialogue. Adapted from Ishihara Shintarō's fiction of the same title, *Crazed Fruit* relates two brothers' struggle for a married young woman (Eri in one case, Judy in the other), who is not just a film noir femme fatale, but also an ambivalent child-woman, who starts out as an innocent good girl only to be eventually revealed as a woman married to an elderly American and constantly engaged in extramarital affairs. This sibling rivalry culminates in the film's disastrous ending. The initially innocent younger brother, Haruji, learns that Eri, whom he has believed to be "a good girl," has been sleeping with his elder brother, Natsuhisa (played by Ishihara Shintarō's younger brother, Ishihara Yojirō, an actor–pop singer and youth idol). Overwhelmed with this realization, which leads him to see the whole world as a pack of lies, Haruji takes revenge by running his motorboat first into Eri, who is swimming toward him, and then into his elder brother's sail boat, killing both. The post-destruction sequence begins with an aerial shot of the wreckage — the floating pieces of the broken sailboat, no human bodies visible. It then cuts to a close-up of Haruji driving his motorboat toward the camera, tears trickling down his stern and spiteful face. Finally, the camera cuts to a long back shot of Haruji speeding into the distant background, gradually disappearing on the horizon, while the non-diegetic music (which has previously accompanied the romantic moments) crescendos.

In his Hong Kong reprisal, *Summer Heat*, shot over ten years later, Nakahira follows the plot closely, and even reproduces some of the camera angles, framings, and body language. The pre-destruction sequence, for instance, restages the famous bird's-eye-view shot of the furious younger brother circling and rocking the sailboat on which his brother and girlfriend stand, like a hunter circling his prey before the ultimate strike, or the tightening of the screw. Likewise, the post-

destruction sequence shows the younger brother disappearing on the horizon in a long back shot — again, an ending free from any attempt at moralization.

The close resemblances between the films lead to what Jeremy Butler calls "putative synonymy." That is, the "original" film and the remake share ostensibly the same denotation, except that it is "rendered in a different style."[10] One important factor that contributes to the differing styles is technological innovation. Whereas the 1956 *Crazed Fruit* was shot in black and white with standard aspect ratio, *Summer Heat* flaunted its Eastman Color, Shawscope (widescreen) format, and new sound-mixing technique. Technological improvement, after all, was one important reason for the Shaws' invitation of the more tech-savvy Japanese filmmakers. As I shall argue in due time, technological and stylistic shifts work to produce implications that need to be grasped in concrete geopolitical terms. In the following pages, I shall consider the two films' mapping, figuration, and framing of the *space* and *place* in connection with the issue of *specificity* and *globality*. The space I deal with contains four dimensions: the spatial setting of the narrative; the characters' experiential space as mapped out by their everyday living and transportation; the construction of perspective and space within specific shots and sequences; and finally the geopolitical space that provided the conditions of the films. My discussion below follows this four-part structure.

Siting/Sighting Postwar Youth Culture

In both films, the narrative of postwar youth problems takes place in a setting that registers both the social reality of postwar nihilism and the social fantasy of transnational capitalism. Given the fact that the geopolitical setting in both films seems to enable anti-social nihilism on the one hand and social fantasy on the other, we should first and foremost consider what the setting is and how it functions. In *Crazed Fruit*, the major site is Hayama Bay near Yokohama, a resort where wealthy people go yachting and water skiing, which has since developed into a well-known tourist spot. In *Summer Heat*, the diegetic site is Chizhu (literally meaning the red pillar), also known as Stanley; but the film's exterior scenes were partially shot in Hayama. In an interview, Jenny Hu, the female lead, described the experiences of swimming and yachting in the foreign weather at Hayama.[11] What is interesting for my purpose here is that the location of Hayama is meshed with the Hong Kong exterior shots in Stanley. Unlike a number of other Shaw productions in this period that flaunt the kaleidoscopic East and Southeast Asian scenic spots as exotic local color, thereby aspiring to take the audience on a virtual, quasi-roller-coaster tour, *Summer Heat* passes Hayama as Stanley, rendering them undistinguishable. This operation, as I

argue below, ultimately hinges upon the very lack of specificity of Stanley, and of narrative space in general.

Stanley, named in memory of the British prime minister Lord Stanley, is situated at the southern tip of Hong Kong Island, verging on the South China sea. It used to be a flourishing fishing village and an important fort where Chinese soldiers were stationed prior to Hong Kong Island's concession to Britain in 1842. Since its concession, Stanley had served as the British colonial government's administrative center until the establishment of Victoria City in 1903. In 1941, the Japanese invading army defeated the defending British army at Stanley. After the war, a scenic cemetery was built in memory of soldiers killed in the war, which has also become an important filming location. Unsurprisingly, today's Stanley is most known for its tourism and commercial value.

One significant common feature of Hayama and Stanley is that both are scenic coastal sites that provide an appropriate setting for youth outings, explorations, and ultimately violence. The fact that both Japan and Hong Kong sit on the edge of the Asian landmass makes the decision to remake the island-and-ocean-based film in Hong Kong a felicitous and natural move. The geographical resemblance contributes to optimizing the visual resemblance between the two films. Furthermore, Hong Kong's littoral geography conveniently continues the island and oceanic fascination that motivates the youth energy in *Crazed Fruit*. This is amply manifested in the extensive skiing and yachting sequences, the waterfront nightclubs, the younger brother's romantic beach rendezvous with Eri, the ocean glittering in the background, the metaphorical association of fish and women, and finally, the disastrous ending in the middle of the ocean. In both films, the obsession with littoral geography ultimately blurs the line between land and sea, so much so that the ocean gradually erupts into the foreground as the very motivation for action, rather than just a passive location or background.

The similar fascination with the ocean, however, takes very different forms in the two films. In *Crazed Fruit*, place names surrounding Hayama Bay are frequently referenced in street signs and dialogue, the most important allusion being the Kamakura train station, where the brothers board the train bound for Hayama at the beginning of the film. These concrete geographical references conjure a tangible map that allows the audience to trace these young people's terrain of activity. The only important place left unnamed is the beach where Haruji and Eri go for their night rendezvous. Yet even there, she provides the audience a sense of location by saying, "I live here, yet I don't know this place." The unnamed yet lived place helps to confirm her dwelling in a specific locale, while leaving the audience room for imagining the mysteries of everyday life (i.e., details unnoticed previously).

The meticulous geographical mapping in *Crazed Fruit* delivers a concrete time-place, which presumes or encourages a certain degree of familiarity on the part of the audience. In comparison, the geographical mapping in *Summer Heat* is far less specific. The only named place is Stanley, where Judy claims to live. Another place to which she refers is the golf course, which may be the one at Deep Water Bay, built in 1889. Yet its historical and geographical specificity are less important than its function as a status symbol. The lack of specific naming and charting is also reflected in two other instances. When the younger brother, Xiao Chun, drives Jodi to the beach for their first rendezvous, she says, "Wow, I've lived in Hong Kong for so long, yet I didn't know there was place as beautiful as this." What is emphasized is the label of "Hong Kong," which is hastily provided to gloss over the lack of concrete locality. Consequently, what constitutes Hong Kong remains mystifying, and Hong Kong becomes an abstract appellation. The second instance is when Xiao Chun tries to track down his elder brother, David, who has sailed out with Judy. Nobody can offer him any information, let alone tell him where that sailboat is headed (contrary to the variegated local names offered by the informants in *Crazed Fruit*).

Due to the differing modes of spatial mapping and figuration in the remake, the land of Hong Kong, its surrounding ocean and everyday lived space, come across as unidentified imagery and labels, as if experienced from a tourist's perspective. In this light, the selection of Stanley as a key spot may have been motivated by the simple fact that it would provide the best site for water skiing and yachting, while its military and economic significance during the pre-colonial and colonial eras was left untapped, even though it may be evoked by viewers familiar with Hong Kong history.

Now the question is: why did Nakahira pay so much attention to detailing and signposting each small location in *Crazed Fruit*, but stop doing so in *Summer Heat*? One explanation could be that those locations were clearly marked in Ishihara Shintarō's fiction from which *Crazed Fruit* was adapted, so it was simply a matter of filming what was already written in. The situation of shooting *Summer Heat* in Hong Kong was drastically different. Firstly, Nakahira had no literary script to refer to. Furthermore, as a foreigner invited by the Shaw Bros. on the basis of his technological sophistication and his ability to handle a wide range of genre films (including the Taiyōzoku youth film), Nakahira was not familiar or required to familiarize himself with the Hong Kong landscape. After all, from the Hong Kong producer's perspective, a film like *Crazed Fruit* could be distilled into just an entertaining film about the luxurious, wild life of a group of nihilist and self-destructive young people — a sensational story that could be set in any postwar "modern" city. As a result, the temporal-geographical specificity of Japan was inadvertently or deliberately dropped, without being

replaced by or transferred into certain Hong Kong–specific qualities. What is foregrounded in the remake, then, is a drama of youth cruelty dissociated from its historical and geopolitical setting. Since Taiyōzoku, or Sun Tribe, designates a mode of postwar youth culture that was both Japan-specific and internationally connected, to remake a Taiyōzoku film could potentially enhance either of these aspects. The Hong Kong remake, unsurprisingly, adopts the universalizing strategy that emphasizes the generic and thereby dissociates *Crazed Fruit* from its Taiyōzoku origin and cashes in on the postwar transnational appeal of the youth film.

If the space of the setting is mapped differently in the two films, one being concrete, the other being generic, how then is such a setting related to the characters, or how do the characters experience and embody the space? With this question, we segue to the experiential dimension of space.

Experiencing the Space of Youth

Space can be experienced in two fundamental ways: dwelling and traveling, the first having to do with the youth's occupation of their home space, the second related to their ways of exploring exterior space. In *Crazed Fruit*, the two brothers' home is shown as traditionally Japanese, with the enclosed corridor that runs along linked rooms. In three similarly composed sequences, the camera is positioned outside the windows of the enclosed corridor, tracking Haruji laterally as he navigates through the corridor (left to right or right to left) between the house entrance and his bedroom. By repeating the similarly composed tracking sequences, the camerawork foregrounds the continuous layout of the house and its semi-transparent relationship with the environment, which evoke the traditional Japanese residential structure. The brothers' residential space and the way it is embodied and experienced sharply contrast with the Westernized home of Frank, a parentless Japanese-American, who generously turns his luxurious house into his buddies' party place. In *Summer Heat*, the Western model characteristic of Frank's house becomes the standard. All interior spaces are now unanimously strewn with Western furnishings and segmented into discrete rooms. The characters are shown in different rooms, rather than finding their way around the house. Consequently, the audience is not asked to map out how the characters occupy and relate to their home environment.

Beyond this interior space, the exteriors are also Westernized to a greater degree in the remake. To the extent that modernization is assumed to be a universal process that overcomes and transcends local specificity, and is therefore transportable, adaptable, and teleological, it is aligned with the developmental

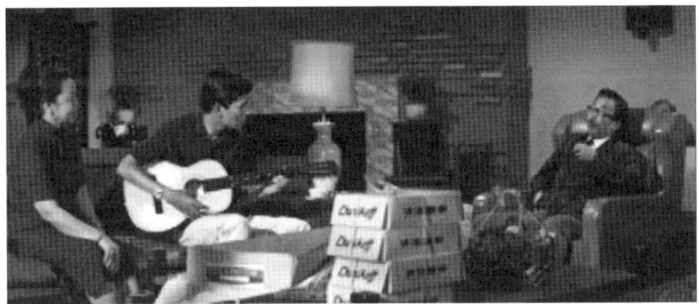

Fig. 4.1 *Summer Heat* (Nakahira Kō, 1968)

discourse that presumes progress along with temporal progression. Since the remake comes after the "original," it is not surprising that *Summer Heat* seeks to improve its over-ten-year-old predecessor by updating its now outdated vision of modernity. This improvement is manifest in the gamut of vehicles that the young characters use to navigate the exterior space, including the ocean. A key vehicle shared by both films is the motorboat. Its association with power, social status, and unbridled youth energy — that can easily become (self-) destructive, as manifested in the disastrous strike — undoubtedly makes it a most apt metaphor of modernity and the related youth culture as well as youth problems. Furthermore, to modernize *Summer Heat*, the number of automobiles present is increased from three cars (belonging to Frank, Eri's American husband and the brothers' absentee parents) to a pageant of race cars. The elder brother now has a car; Judy/Eri has also upgraded from a bicycle (in *Crazed Fruit*) to a race car. As a result, transportation becomes privatized, accelerated, and closely linked with pleasure trips of the privileged social group (youth from wealthy families in this case). Modernization, in the style of the remake, means increasing private ownership and exclusive leisure activities.

This trend of privatization leads to the demotion of public transportation in the remake. In *Crazed Fruit*, the train is featured as a paradigmatic means of public transportation, and the train station as an important public space. The film shows the brothers rushing to board the train at Kamakura station to get to Hayama right after the opening sequence. It is at the train station that Haruji runs into Eri twice, amid the flux of passengers. The train system thus serves practical and narrative purposes. In addition to providing scheduled transportation en masse, it conveys a concrete geography by providing actual location names, functioning as the nodal point where people gather and disperse, causing chance encounters and misrecognitions. The significance of the train accrues with its rhythmic recurrence throughout the film.[12] In *Summer*

Heat, on the contrary, public transportation is marginalized and comes up briefly only once, in the form of the Star Ferry. On the surface, the Star Ferry serves a similar function as the train in that it provides the crucial meeting point for Xiao Chun and Judy. One could even argue that the ferry's replacement of the train suggests an urge to incorporate certain Hong Kong specificity in allowing the film to showcase Hong Kong's Victoria Harbour as well as being a major means of public transportation. Furthermore, it inadvertently inscribes a historical era in Hong Kong, one that predated the metro system (MTR), the construction of which started in 1975. Nevertheless, due to its very brief appearance and the tight framing that isolates the two main characters while excluding the local crowd, the ferry sequence fails to offer a sense of location, making the ferry ride more picturesque and touristy than utilitarian or thematically important.

The upgraded vehicle of transportation and leisure activities showcases how modernity in *Crazed Fruit* is subjected to further modernization in the remake ten years later, in accordance with what the Shaw Bros. Studio felt to be the young audience's desire in the late 1960s. If *Crazed Fruit*, as a representative of the Japanese Taiyōzoku film, inflects Japan's postwar socio-political circumstances by depicting youth angst and boredom staged in a meticulously mapped locale, *Summer Heat* refocuses on the panoramic vision of the location-nonspecific modern façade. To explicate the ideological implications of the generic turn, or the lack of socio-historical specificity, let us move onto the third dimension of space, namely, the use of perspective and the resultant relationship between foreground and background within specific shots.

Background, Foreground, Perspective

The conventional understanding of the relationship between background and foreground is that the background is static, and that its purpose is to set off the foreground — the dynamic center of the audience's attention. *Crazed Fruit*, however, intermittently challenges that normative relationship through two devices, namely back projection and the impressionist extreme close-up.

One instance of back projection occurs when Haruji drives Eri from the party to the beach at night. During the driving sequence, the background that recedes from the moving vehicle is back projected. This back projection shot of night cruising is repeated twice, charting out the advancing intimacy between Haruji and Eri. Traditionally, back projection has been used in exigency. When location shooting is not possible, the pre-shot exterior backdrop is projected onto the background in front of which drama is enacted and filmed in the studio or the back lot. However, given the prevalent location shooting throughout *Crazed Fruit*, as manifested in the yachting and water skiing sequences, the use

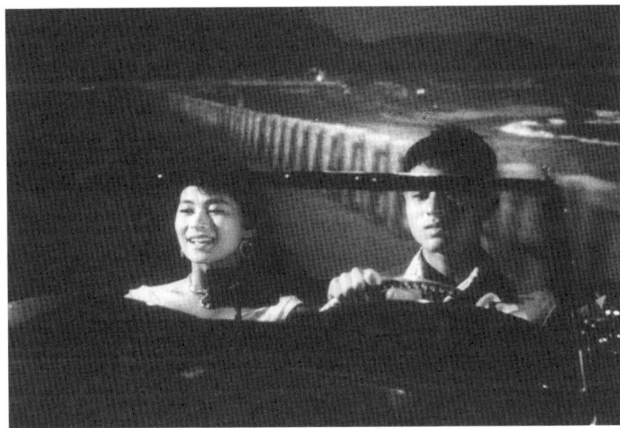

Fig. 4.2 *Crazed Fruit* (Nakahira Kō, 1956)

of back projection seems unnecessarily anomalous. How do we explain this? In his audio commentary included in the Criterion edition of the film DVD, Donald Richie describes the repeated camerawork as a form of "parallelism" that draws the audience's attention to the constructed quality of the film. It invites the audience to perceive the film narrative as an effect of editing and construction, rather than a naturalistic happening.

Whereas these observations are helpful for our understanding of the practical and aesthetic considerations of this technique, they stop short of eliciting its ideological ramifications. What I would like to emphasize is the ways the background encroaches upon the foreground. Or, if we relate the background to the social space and context, the foreground to the drama, then my concern is how the social space and context seep into the drama. This operation becomes clearer in comparison with the prevalent use of location shooting in *Summer Heat*.

As if to redeem the technical flaw of *Crazed Fruit*, the road, beach, and ocean shots are done entirely at actual locations. The two night cruising sequences that otherwise echo the corresponding sequences in *Crazed Fruit* now boast the background of the real road, complete with a pedestrian passing by into the background while staring back at the cruising couple — a telltale moment of contingency and actuality. This shot is set up in such a way that the foreground is prioritized over the barely noticeable background. Even though the inclusion of the pedestrian can potentially draw the audience's attention toward the background, his stare toward the foreground restores the central importance of the cruising couple. The naturalistic cohesion and hierarchy between

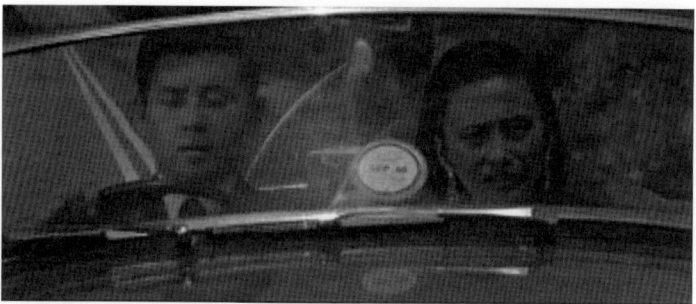

Fig. 4.3 *Summer Heat*

background and foreground are further enhanced by an additional detail that again unmistakably points toward the foreground of drama. In this additional detail, Judy first comments on the moths that fly to light and death, then turns on her radio — an object that does not appear in *Crazed Fruit* almost until the end of the film.

The apparently trivial technical change can be seen as symptomatic of the ideological operation in the remake. To analyze the ideological implications of technology, let us first briefly review Jean-Louis Comolli's argument, which remains salutary, albeit controversial. Disagreeing with André Bazin, who sees deep focus and depth of field as a close cinematic approximation of reality, Comolli considers the depth illusion as indicative of "the extent to which an ideological way of representation is embedded in a mass medium."[13] In his discussion of the ideological determinants of film techniques, he challenges the historical approach invested in amassing the "firsts" of film techniques, which assumes neutrality of teleological and unidirectional technical "advance" and treats film techniques as a reservoir from which the filmmaker can always make a *free* choice.[14] Instead, Comolli posits a "stratified history" characterized by recursive, dialectical, and discontinuous temporality.[15] With this, he urges us to scrutinize the ways in which any technical choice is always implicated in a network of economic and ideological determinants — that is, a chosen technique is always part of "the signifying practice where it is not just a factor but an *effect* (i.e., not just a "form" which "takes on" or "gives" a meaning, but itself already a meaning, a signifier activated as a signified on the other scene of the film, its outside: history, economy, ideology)."[16] Taking, for instance, the absence of deep focus between 1925 and 1940 (according to Jean Mitry), Comolli argues that the absence did not simply result from shifting technologies (replacing orthochromatic film with panchromatic film); rather, it was determined by the ideology of *studio shooting*, which reduced the background to a mere "décor"

effect, often conjured with the "painted canvas inherited from the theater and convenient for the cutting-up/assemblage operations of the psychological drama."[17] That is, the lack of deep focus during that period had to do with "the *transformation of the conditions of this credibility* — the displacement of the codes of cinematic verisimilitude, the levels of fictional logic (narrative codes), psychological verisimilitude, and the impression of homogeneity and continuity (the consistent space-time relations of classical drama)."[18]

Comolli's strategy of inscribing film technique in the socio-political context is instructive for my comparison of the back projection in *Crazed Fruit* and location shooting in *Summer Heat*. Following Comolli, I suggest that the use of location shooting in *Summer Heat* does not simply reflect a technical improvement, i.e., the ability to shoot a moving vehicle on location at night. Rather, it produces a perceptual effect that has ideological implications. Or, one may reverse this by arguing that the use of location shooting (as opposed to back projection in *Summer Heat*) is symptomatic of a specific ideological conceptualization of the relationship between the background and the foreground, between the specific space/location and the portable drama/diegesis.

Whereas I subscribe to Comolli's standpoint, my interpretation of the depth of field (or lack thereof) is significantly different from his. Comolli implicitly privileges location shooting over studio shooting on the ground that the latter reduces the background into mere decor. The decorative use of the background may certainly suggest conservative studio shooting ideology, yet its specific implications vary from case to case. In *Crazed Fruit*, when the road is back-projected, the action seems to be pasted onto it; the natural perspective and depth of the field are disrupted, as is the taken-for-granted cohesion between the background and the foreground. The cut-and-paste effect becomes so conspicuous that the background is actually drawn into the foreground, whereas the act of cruising itself recedes from the viewer's attention. In other words, the back-projected backdrop foreshortens the perspective, thereby producing a disrupting alienation effect. It works to accentuate the process through which screen space (especially the background) is constructed.

Contrary to this, location shooting in *Summer Heat* reproduces normal perspective (if not exactly normal depth of field), and thereby proffers maximum verisimilitude. This reordering of space reconfirms the conventional belief that what really matters is the narrative (of the young people in the cruising car), while the background should be consigned to its "naturally" inconspicuous and subordinate position.

What does the formal difference tell us about the divergent modes of ideological operation in the two films? To address this question, I turn to the last section and the fourth dimension of space.

Social and Geopolitical Space

My previous analysis has shown that both the larger geographic setting of the narrative and the more intimate experiential space are figured differently in the two films. In *Crazed Fruit*, the geography is specifically defined and signposted, whereas in *Summer Heat*, it looks vague, uncharted and hastily labeled as "Hong Kong." In terms of the experiential space, *Crazed Fruit* offers a range of architectural styles and types of transportation as well as leisure activities, while *Summer Heat* upgrades all props and makes them generically modern. To understand what specific conditions necessitate the generic turn, or how the social space and geopolitics of the late 1960s Hong Kong find their way into the apparently generic screenscape, I examine the two films' different ways of constructing the relationship between foreground and background. Back projection, as a visual device, provides a vivid metaphor for me to discuss how a specific geopolitics erupts into the foreground. As suggested in the previous section, back projection in *Crazed Fruit* creates disjuncture between the background and the foreground, cuing the audience to the existence of the background. Contrary to this, *Summer Heat* reifies the order of foreground and background and relegates the background to the invisible domain within the frame. What then is the geopolitical background that erupts into the foreground in one case, but gets elided in the other?

The answer may be elicited from the sequence of encounters between the younger brother (Haruji/Xiao Chun) and his elder brother's delinquent cohort. In *Crazed Fruit*, once again, formal defamiliarization is used, this time through impressionist cinematography. Unlike the foreshortened perspective in the back projection sequences, the confrontation sequence utilizes skewed angles and extreme close-up framing so that the background is completely *eliminated*. Exclusive framing casts into relief each character's iconoclastic statement, such as: we live in a boring time; we make boredom our credo and eventually something will come out of it. Given Japan's adjacency to the socialist bloc, the professor's upbeat capitalist "drivel" is as nonsensical as the narration that accompanies the silent film; intellectual ideas are as flimsy as tropical fish and easily succumb to a changed environment.[19] These characters' punch line, slogan-like responses regarding their political stance are provoked by Haruji's criticism that they are Taiyōzoku. The moment of tension in the narrative is visually replicated through the impressionist, tight close-up shots that push the subtext to an exploding point by excluding the background and flattening the frame into a single layer of image. Indeed, one may argue that the youths are able to articulate the quasi-slogans precisely because Haruji's criticism pushes them to defend their position, in the same manner that the tight close-up flattens

Fig. 4.4 *Crazed Fruit*

the frame and compresses all layers into a single stratum of the foreground. In other words, by eliminating the visual background, the close-ups paradoxically allow the socio-political background to erupt into the foreground and to be formulated through the characters' self-diagnosis in terms of youthful angst and boredom.

By intermittently violating the code of verisimilitude and drawing attention to the visual background, be it fake (as in back projection) or missing (as in the tight close-ups), *Crazed Fruit* implies a political effect, i.e., the reinsertion of the postwar Japan's socio-political space into the drama, a space characterized by its awkward in-between, neither-nor situation in the Cold War world politics. As evidenced by the disaffected punch lines, Taiyōzoku youths see themselves in an antagonistic relationship with three forces: the socialist brainwashing in the neighboring Soviet and China, the upbeat yet delusory Japanese education, and American usurpation of Japanese sovereignty. The fact that the wealthy Frank, who is also the only character with an English name due to his mixed heritage (an allusion to the American occupation of the postwar Japan), lends his house as the Taiyōzoku gathering place crystallizes the ambivalent U.S.-Japan relationship in the Cold War era. On the one hand, America's material abundance made possible Japan's economic development and popular culture, which in turn enabled the luxurious ennui of the Taiyōzoku.[20] On the other hand, as iconoclasts, the Taiyōzoku have to disavow their reliance on American resources, for example when the elder brother openly despises Eri's American sugar daddy and when the cohort half jokingly yell at Frank, "Yankee, go home!" The slogan vents the youths' angst yet remains a joke with no real political effect

because Frank, after all, is virtually abandoned by his American mother, hence not quite the Yankee. Furthermore, the Taiyōzoku youth can make Frank's house into a party place precisely because it is first materialized, then abandoned by American as well as Japanese adults and thus neither American nor Japanese, although it would not have existed without them. In a sense, the biracial Frank and his luxurious yet abandoned house stand as the allegorical figure for the postwar Japanese youth and Japan as a whole. Circumscribed by and dependent upon variant forces, yet antagonistic toward all of them, they have to make their awkward in-between situation into the very basis and credo. The devices of defamiliarizing framing and composition thus function as a formal correlative that allows the geopolitical specificity of Japan's Taiyōzoku culture to erupt into the public consciousness.

Summer Heat presents a different operation. The focus is less on articulating socio-political reasons for postwar youth ennui as on presenting an entertaining youth film that might appeal to as wide an audience as possible.[21] The similar verbal confrontation between the younger brother and his elder brother's cohort is shot differently, and serves quite different purposes. Most of the sequence is done in medium shots, with the bored young people gambling at a table, while the younger brother stands behind the table. The debate ostensibly reproduces its counterpart in *Crazed Fruit* — the group that insists on their boredom (hence their indulgence in gambling) against the younger brother who accuses them of escapism. However, boredom is never attributed to specific socio-political causes, let alone philosophized into a life credo. The lack of distinctive social background for the youths' ennui is encoded in the framing and use of lighting. Contrary to the extreme close-up in *Crazed Fruit* that metaphorically forces the social subtext and background into verbal statements, the medium-range framing of the group as a whole in *Summer Heat* makes it hard to tell who says what and how. The flat lighting that shows neither shadow nor depth, combined with the symmetrical framing, renders the setting more balanced than confrontational. The only two close-ups come at the end of the sequence, the first showing the elder brother summarizing the debate by re-emphasizing their boredom, and the second showing a woman confirming this sense of world-weariness and abruptly shifting to the topic of eating.

By altering the cinematography and dialogue, the sequence in the remake reiterates the youth ennui without contextualizing it. As a result, youth ennui is figured as a categorical concept independent of socio-cultural and political conditions, which implies that young people indulge in boredom out of inexplicable compulsion. The generic turn and depoliticization are thus closely correlated to the formal design, especially normalizing use of location shooting, realistic perspective, and medium-range framing. As indicated earlier,

what underlies the generic turn is the assumption of universal modernity. Arguably, the generic turn manifested in the late 1960s remake has something in common with what Rem Koolhaas calls the "Generic City," a city that has shed its identity and consciously moves toward homogenization. As Ackbar Abbas elaborates, the "Generic City" differs from a postcolonial city in that the latter seeks to rediscover or reinvent an identity eradicated by colonialism, whereas the former aspires to the condition of a city without history, one that is superficial like a Hollywood studio set, capable of producing a new identity constantly.[22] Understandably, Abbas mainly sees the post-1997 Hong Kong as a "Generic City" integrated into the global "network society."[23] Nevertheless, the idea of generic modernity and urbanity was already apparent in the Shaw Bros.'s formula and other border-crossing strategies that sought to facilitate the universal appeal of Hong Kong cinema.

Such a "generic" emphasis becomes problematic, however, once we consider that the film was shot in 1968, when Hong Kong was experiencing intense political turbulence due to the expansion of the Cultural Revolution in mainland China. What is the connection, if any, between the invisible historical and political background and the apparently apolitical film? How did the film manage to occlude that significant background? How do we understand the *negative* inscription of politics? First, it is important to note that depoliticization was not an exception, but a norm in Hong Kong cinema from that era. In this sense, *Summer Heat*'s omission of political turmoil in its immediate context is exemplary of the overall cultural politics of filmmaking in the late 1960s Hong Kong. As the Hong Kong cultural critic Lo Wai-lok suggests, the three left-leaning film companies — Great Wall, Phoenix, and Xin Lian — were established in Hong Kong in the 1950s, then merged into Sil-Metropole Organisation Ltd. (Ying Du) in 1982. Their production totaled 379 films during the three decades, 262 of which were shot before the Cultural Revolution. Significantly, the rise of the Cultural Revolution and the resultant severe ideological control caused a drastic atrophy of leftist filmmaking. Shen Jianzhi, the chief editor of *Xin Bao*, observes, "The progressive filmmaking tradition inaugurated in the 1930s was nailed into its coffin during the Cultural Revolution."[24] As a result, in the social realist films produced during the late 1960s after the radical disruption in Hong Kong, the issue of leftist class ideology becomes taboo and is transcoded into communal concerns, namely, concerns with establishing a positive community that helps social underdogs overcome local, everyday difficulties, such as hurricanes and impoverished living conditions, rather than explicitly mobilizing class struggle.[25] The mechanism of transcoding allows these social realist films to posit an avant-garde social community with an implicit ideology and vision without being explicitly political. By so doing, early 1970s leftist filmmaking

in Hong Kong sought to survive in colonial Hong Kong without alienating the mainland Chinese government.[26]

If leftist ideology had to be transcoded, and in a sense, muted, even in early-1970s left-leaning filmmaking, then it is not surprising that the Shaw Bros.'s productions, as well as a large number of other Hong Kong film companies, avoided politics altogether. The collective silence and blindness suggest the unrepresentability of radical movements that were unfolding in local as well as international arenas. Radical politics was unrepresentable because its purpose was to instill the discourse of class struggle into the popular consciousness to instigate social resistance against capitalism and Western materialism. This agenda went against the premise of the colonial governance *and* the film companies' goal of appealing to the widest possible spectrum of audience, both local and transnational.

In this light, the criticism of "escaping from reality," which the younger brother in *Summer Heat* levels at the bored youths, seems an appropriate diagnosis of the general film industry. Or, more accurately, it indicates the film's attempt to allude to its own "political unconscious" so as to interiorize and preempt the ideological critique of mass entertainment. That is, the reference to escapism allows the film to execute self-criticism *and* self-defense, all at once. By flaunting escapism and boredom without spelling out (and without the ability to spell out) what exactly the bored youth escape from, the film gestures toward the industry's own representational dilemma. That is, a certain sociopolitical stratum subtends the surface escapism and ennui, without which the film would not be possible. However, the film takes its current form because it cannot provide adequate terms of representing or addressing the substratum. In other words, whereas the film undoubtedly emphasizes modern window-dressing to produce a wide-ranging a-national appeal, we should understand this business consideration in connection with the historical conjuncture. It omits politics not simply as an active decision to exclude it in order to maximize the generic appeal. Moreover, it is the impossibility of representing the local politics that necessitated the transferred emphasis on the "generic" look. As such, the film registers self-conscious escapism, a self-aware escapism that is nevertheless unable to articulate what it escapes from or why it has to escape.

Local politics and generic modernity thus become yoked together as the two sides of one coin. The latter becomes hyper-visible and occupies the absolute foreground precisely because the former has to be invisible or rendered invisible, just as the layer of background in the frame is naturalized as the receding point that is left out the viewer's attention. In this light, film direction, as Jean-François Lyotard argues, is a political activity par excellence, in that the fundamental problem for both consists not in the representational arrangement, but rather

in the "*exclusion and foreclosure* of all that is judged *unrepresentable* because *nonrecurrent*."[27] By comparing the two films' differing spatial configurations on four levels, I have identified some formal "symptoms" that allow us to discern the unfigurable and excluded political subtext that exceeds and is transcoded into the generic look of the Hong Kong remake. The generic modernity is thus by no means a transnational surface devoid of historicity and politics. Rather, it must be understood as resulting from the dynamic economic, cultural, and political tension between the transnational, regional, and local arenas. In these terms, Koolhaas's "Generic City" underscores an important postmodern cultural phenomenon. Yet the real significance of the concept consists in its potential of inviting us to deepen our understanding of the mutually constitutive relationship between the generic and the specific, between aesthetics and politics, and finally between the transnational and the local/regional cultural formations.

INTERLUDE 3

Neon

James Tweedie

Neon lights beckon us toward a future city seen from another era. In films like *Tokyo Drifter* (Seijun Suzuki, 1966) the neon sign, multilingual and cosmopolitan, uprooted and floating above the banalities of the street, presents a vision of the city to come, a spectacular space where light is dedicated to the cause of commerce. Littered with brand names, it speaks a commercial lingua franca founded on a handful of keywords like "shopping" and "new." Glimpsed in close-up, these neon signs are more than the backdrop for the tale of a vagabond gangster; they are worthy of attention in their own right, as portents bearing as much significance as the close-up of a face or a gun. Viewed in a montage sequence, the city made of brick, concrete, and steel recedes for a moment, to be replaced on screen by a world constructed of language and light, of gas-filled tubes twisted into the shape of words or symbols, charged with electricity, and set aglow. The neon sign is where the city begins to assume the form of cinema. More than a dash of ambiance, this montage sequence envisions a moment when the city of enduring monuments and eternal truths has been replaced by an ever-changing landscape of signs and momentary flashes of attention. Suzuki has learned from Las Vegas even before Robert Venturi pointed toward this classroom for a new lesson in architecture and urbanity.

If Suzuki embraces this future and develops an aesthetic of ubiquitous and often uniform color, with images that look as though they were lit entirely by these same neon lamps, Wang Haowei's montage sequence of neon signs is a vision of youthful energy run amuck. In *What a Family* (1979), Wang presents a Beijing catching its first glimpse of Reform-era economics and consumer culture. With few actual manifestations of that future visible in the city itself, the neon sign occupies the full screen in close-up, to be followed by another and another in succession, alternating with images of young people dancing furiously and downing food and drinks. These images demonstrate the modernity and dynamism of the new reform generation, and Wang's tightly framed shots momentarily make cinema a conduit for the energy of the neon sign and a city consisting almost entirely of lights and language. But if, in Marx's famous formulation, capitalist modernity constructs a world in which "all that is solid melts

Fig. iii.1 *Tokyo Drifter* (Seijun Suzuki, 1966)

Fig. iii.2 *Tokyo Drifter*

Fig. iii.3 *Tokyo Drifter*

Fig. iii.4 *What a Family* (Wang Haowei, 1979)

Fig. iii.5 *What a Family*

into air," what better manifestation of a successor and perhaps an existential threat to the socialist project than the neon sign, whose source of pyrotechnics is already an inert gas, light as air.

Viewed from the present moment, the neon sign in cinema appears to display a future seen from the past, because on the streets of major cities in East Asia neon is no longer the sign of the times. The cutting edge cityscape pulsates with constantly flashing and refreshing LED displays, massive billboards that harness the latest screen technology and collapse cinema and advertising and the city onto the same pulsating surface. If neon once

embodied the utopian promise or dystopian threat of a city devoid of substance, a city of spectacle, a city tantalizingly or threateningly close to cinema, it now seems passé because the city has veered even closer to a pure form of cinema. The archaic armature of the sign, visible behind and around the radiant forms or characters, marks them as relics of another era, like the gilt lettering of an illuminated manuscript. Both voids and solids, these signs beckon toward an era when information emanating from projectors or backlit screens will be the dominant form of public communication, but they are also burdened by their archaic materiality. Although these dancing lights once constructed urban space from the stuff of cinema, the future of the city is no longer written in neon. Nor, in the contemporary media environment, is it captured on celluloid, which nowadays appears as outdated as the neon sign, a throwback to an earlier conception of modernity. But few objects capture the faded but still enticing dream of the future city better than the blinking neon sign.

PART III
The City of Media Networks

5

Transfiguring the Postsocialist City: Experimental Image-Making in Contemporary China

*Zhang Zhen**

Shanghai in Sixty Years (Liushi nianhou Shanghai tan) is a long forgotten futuristic comedy made in the besieged Shanghai of 1938. According to an extant synopsis, at the beginning of the film two men find themselves suddenly in a Shanghai of 1998, following an evening out in the dancehall cut short by their annoyed wives, who promptly placed them "in the doghouse," in the attic. They fall into a long sleep. In the dreamscape they find themselves in a future Shanghai stranger than paradise, with flying cars and apartments where interior design is instantaneously changeable by remote control. The most shocking change is that people no longer have names but are identified by numbers.

This popular science-fiction comedy from old Shanghai is not my main concern here. But the surprisingly accurate prophecy on the ubiquity of remote

* Earlier versions of the essay were presented at the symposium, "Urban Trauma and the Metropolitan Imagination," at Stanford University, the conference on "Chinese and Asian Cinema in the Context of Globalization," co-organized by Beijing University and Shanghai University, both in 2005; Center for Chinese Studies at the University of Michigan, Ann Arbor, and the symposium, in 2006. I thank Scott Bukatman and Pavle Levi for giving me a wonderful opportunity to start this project in a global comparative context, as well as to Shanghai University and C. K. Lee, for their invitations to develop and bring the essay to other engaging audiences. My thanks also go to my research assistants Shi-yan Chao and Ying Xiao at NYU, and particularly to Wen Hui, Wu Wenguang, and Chen Yusu for our lively conversations on dance, film, and the nature of contemporary urban life.

controls and digitalized personal identity provides a unique entry point for "traveling" to the present-day postsocialist Chinese city. Indeed, the universal adoption of ID numbers for Chinese citizens is recent, coinciding with the erosion of the socialist structure (in particular the strict city residence registration, or *hukou*, system) and of rural-urban boundaries. Hence the adoption of IDs parallels the unprecedented physical and social mobility of millions of Chinese, forming a gigantic "floating population" (*liudong renkou*). That the two men taken for dead by their families emerge intact from a futuristic construction site, along with the prescient references to digitalization and virtuality, inspire reflections on the changing nature of temporality and body in the context of frenzied urbanization in China today, especially in Shanghai — where the film unfolds in the "present" as well as "future" tenses. The film's interest in both the utopic and dystopic potential of technology and its impact on the human body is also relevant to the place of cinema in the so-called "post-material" and "post-human" condition today.[1]

In the last decade of the twentieth century — the ambivalent locus of desire for the 1930s film — an art movement traversing experimental and documentary film, video art, photography, and performance has emerged with much creative energy in metropolitan centers such as Shanghai, Beijing, and Guangzhou. This new generation of artists place themselves right "on the scene" (*xianchang*) to record the momentous shifts in the physical and mental topography of China in the country's headlong rush toward a quasi-capitalist economy and culture.

What are the distinctive features of the metropolitan imagination created by this nascent movement deploying, or rather blending, old and new media? In what manners do these image-makers, who grew up in the socialist period, engage with memories of the past and the post-revolutionary conditions while fashioning provisional designs for living the seismically shifting realities? More crucially, how do these experiments exploit the changing nature of the photographic or cinematic image for alternative social and cultural visions, as China is propelled onto the information highway and the full-speed lane of globalization? This tentative study aims to make sense of an array of still and moving images about performing (in) the city and explore ways for understanding their producers' obsessive experimentation between stasis and motion, between real and virtual time, and between the documentary and the fantastical registers of time and image. I call this performative play with both image and body, in a variety of cinematic and paracinematic forms, a "transcinematic passage" cutting through the postsocialist and post-cinematic landscape.

Postsocialism Mummified

The time span within which two dandies from the semi-colonial Shanghai of the 1930s are incarnated into the postsocialist metropolis of the 1990s roughly fits a popular periodization of the modern city from its "exorbitant" or "invisible" state to the "Generic City."[2] Ackbar Abbas uses this pair of concepts — borrowed from the Italian writer Italo Calvino and the Dutch architect Rem Koolhaas respectively — to trace recent changes in cinema's relationship to the city. The exorbitant city — its kaleidoscopic melange of splendor and misery, gigantic scale, and inexhaustible details — and the identity of its inhabitants could only be adequately grasped or made visible through the cinematic image that thrives on reassembling a fragmented modern world. The Generic City, for which identity is less important, corresponds with the transformation of cinema in a time saturated with electronic information that encodes or recodes lived experience in a different logic. The epistemological status of the body once again mutates during this paradigm shift. In a postmodern martial arts film like *Crouching Tiger, Hidden Dragon*, whose success had much to do with computer-aided special effects, the Generic City is not so much visibly shown as conceptually and digitally embedded in its very texture. When "every sword move is like a click of the mouse," the body becomes weightless, or gracefully vacuous.[3] When both the body and the city are subject to accelerated disappearance or ruination in our age, as Celeste Olalquiaga observes in her book on the megalopolis, the techniques of visualization that give them representation are also quickly turning into sky-high metal scraps as they become ubiquitous and disposable.[4]

These meditations on the postmodern state of image and body are certainly relevant to today's Chinese cities. However, the historical context and particularly the socialist legacy in China call for special attention to the nature and impact of this sea change on the structures of perception, feeling, and everyday life. China logged on to the global Internet in 1994 and is now boasting more than 20 percent of the world's telecommunications market. (The year 1994, incidentally, also saw the first Chinese video show.)[5] An exuberant commercial and mass culture, enhanced by the popularization of personal computers and then the World Wide Web, has yielded an avalanche of images — big and small, still or moving. They literally engulf the city inside out: from building façades to the interiors, from the subway to the highways, from KTV rooms to Internet cafes. Meanwhile, this startlingly new and fast image culture is surreally contrasted with the uneven, often scarred, urban geography dotted with architectural and life ruins or traces from different epochs including the pre-communist and the socialist times. Concomitantly, the emergence of the impeccably dressed white-collar young urban professional class, or the "new humans" (*xin renlei*),

is paralleled by the transient movements of migrant laborers, who build or assemble, among other things, soaring skyscrapers. Meanwhile, artists and intellectuals seem to have withdrawn, albeit reluctantly, from their traditionally consecrated positions as spiritual leaders of the nation, drifting instead in the border zone of simultaneous cultivation and renunciation of the self. All of these have been fastidiously recorded and transfigured by an increasing number of artists working with reproducible images, especially digitized images, in the last decade or so. My examples drawn from serial photography and video art are mainly culled from two recent major exhibitions that tried to offer a historical overview of this experimental movement,[6] although later in the chapter I will analyze a few longer works that may be categorized as performative documentary. At the center of the shared aesthetic and social concerns that unite these visual practices is, at varying degrees, the retooling of photographic realism and cinematic time during the strikingly parallel digital and capitalist turn in China.

The term "turn," with its reference to traffic, is used instead of the triumphalist "[new] age" because it underscores a process that is not only still unfolding but also riddled with risks and anxieties: a process suspended between past and future, as well as different directions. Ambivalently linked to the state-sanctioned project of globalization since the early 1990s, captured by the mantra "connecting with the tracks of the world" (*yu shijie jiegui*, meaning to catch up with the modernized West), the "turning" as manifested in the new image-making practice is a bold experiment with new media. Its radicalism is paradoxically manifested in taking time to absorb the shock of the new, by emphasis on duration rather than speed, on the present rather than a utopian future (as promised by either the gurus of the new media or the Chinese status quo), on re-embodiment rather than simulation or immersion. I was struck by how such new image-making, in yoking together the analog and the digital, realism and fantasy, representation and performance, opens new domains in which different art forms and media commingle to give shape to urban transformation and social life.

Obviously, the social and political valence of such image-making practice can hardly be disengaged from the question of postsocialism. The socialist legacy and the digital turn share the same convoluted historical moment, in a period that has alternately been called "postmodern," "postsocialist," "postrevolutionary," and "post-New Era." While some argue for the interchangeability of these terms in the Chinese context,[7] others have objected to the relevance of "the postmodern," citing its provenance in the late-capitalist West.[8] Indeed, the discursive skirmishes on periodization suggest only the muddy nature of the so-called "socialist market economy."[9] In his book explicitly engaged

with postsocialist cinema, Chris Berry traces its origins in the immediate aftermath (1976–1981) of the Cultural Revolution and defines postsocialism as a "disaggregated phenomenon that emerges gradually in fits and starts in different parts of the socio-cultural formation in different ways and at different times."[10]

Rather than viewing postsocialism as a blanket condition or symptom, the uneven temporality of "fits and starts" adequately accounts for a complex social and political experience. The films that Berry examines were popular melodramatic fare of the day, through which the audiences come to terms with the "wounds" of the past. In terms of narrative, this cinema exhibits the classical "slowness" of Chinese cinematic tradition, including the socialist period. Cinematically, many of these films, made in a time when China was opening up to Western influences, as Leo Ou-fan Lee observed, showcases an array of framing (e.g., zoom) and editing (e.g., montage and split screens) techniques for a modern look and faster tempo.[11] The mixture of the old and new sensibility and vocabulary that resulted in a body of films with indeterminate social and aesthetic make-up, in a time when cinema seemed to be undergoing a reinvention in China, is instructive for today, though with a crucial difference. Cinema is faced once again with an opportunity for rebirth, while the warning signs of its extinction — at least on the big screen — are everywhere in China, due to the proliferation of both new media and piracy.[12]

It would seem that we are now treading along in what theorists have termed the "post-cinema" terrain, in which cinema is rapidly "losing its hard-won privileged status as 'king' of the popular arts," "the cinema must now compete with television, video games, computers, and virtual reality."[13] The spasmodic mode of the postsocialist condition in China corresponds to the film industry's painful transformation in the past decade, moving forward and backward periodically between freewheeling commercialism and regulation and censorship. While an "independent" film scene is rapidly emerging and converging with an alternative public sphere clustered around digital video, state-sponsored cinema, propagandist or commercial, along with Hollywood, has continued to occupy the center stage of the big-screen cinema.[14]

While professional and amateur filmmakers alike are eagerly searching for theatrical release or public exhibition, not to mention commercial success, a particular post-cinematic practice has been flourishing in experimental visual production and small screen or non-theatrical exhibition. The latter quickly gained a foothold in the transnational public space of the museums, galleries, and other art or film/video festivals — a site less directly controlled by the heavy hand of central film policymaking and censoring bodies. Peripheral to both mainstream cinema and its ostensible alternative (like the Sixth Generation

or the new indies), the engagement with post-cinema in this realm is largely a quiet revolution — borrowing from but not necessarily becoming narrative cinema. Karen Smith reports that the Guangdong artist Zheng Guogu began to experiment with narrative rhythm by placing negative-sized contact prints together as sort of a storyboard for film when he was working on the docudrama series *The Life and Dreams of Youth in Yangjiang* (1996–98).[15] Other artists explicitly stage or manipulate images to create effects of mixed media, traversing photojournalism and lyricism, prints and installation.

Such post-cinematic practices and effects could alternately be seen as "para-cinematic," since they are at once independent of and parallel to the cinema as an established institution. In so far as these effects are achieved through post-production (less now in the darkroom than at the computer desktop), techniques of editing or manipulation import cinematic time into the captured images in various forms. Chief among them are duration, seriality, and sequentiality, which have been, as Philip Rosen eloquently argues, at the core of classical film theory and modern historiography.[16] Many view the ascendance of digital technologies and post-cinema as the funeral rite for the epoch of indexicality, ushered in by photography and cinema, or for the "de-ontologization of the Bazinian image," meaning the erasure of origin and the media's rapport to physical reality.[17] Rosen stresses on the contrary that the digital practice and discourse are in fact highly hybrid and operate within modern historicity, by virtue of its claim to radical novelty and its deployment of the rhetoric of conquest. Far from being a brave new world outside of history, the digital turn is the blending, and multi-channel translation, of the old and new, utopia and dystopia, real time and virtual time. The digital camera, which uses an optical lens but not the photochemical process, is the embodiment of such a hybrid machine through which indexicality is not banished but retooled. These observations inspired Rosen to mobilize seemingly oxymoronic terms such as "digital indexicality" and "digital mimicry," reflecting how digital technology is actually used and embedded in everyday practice.[18] The history of digital imaging that has striven for cinematic realism and effects of perspectivism is further evidence of the impact of pre-existing mediated image-making practices on the digital. Understood as a social and material process, the digital turn has the capacity to redeem physicality — and body and gender — that the conceptual digital discourse disavows by privileging the utopic potential over the historicity of the new media.[19]

Rosen's critique of the digital utopia, anchored in what he calls a radical historicity,[20] is useful for critically aligning the post-cinematic and postsocialist trends in arts and society of contemporary China. It is noteworthy that very few artists resort to abstract art forms deploying digital tools. What we find instead is a profusion of hybrid images that stockpile the indexical and the digital,

two-dimensional art and (live or virtual) performance, tinged with a persistent desire to simultaneously document and transfigure the present. At the outset, a large bulk of these works features the changing city and presents a particular form of commentary on urbanism, architecture, and spatial representation. Closer examinations of the formats and details of many works reveal a cultural critique mobilized by an investment in time and body. Experimental photography often appears in serial or scroll format (Yang Fudong, Wang Jingsong, Rong Rong, Zhang Dali, Hong Hao, Xing Danwen, Luo Yongjin, Wang Wei, to name just a few), as though a single snapshot, portrait, or landscape can no longer convey the scale and complexity of change. These efforts to capture the durational, dense, mosaic, and layering qualities of time, place, and people in a time saturated with ephemerality and contingency are also visible in the various uses of contact sheet and celluloid strips as form. Such techniques expose both the fragmentary and mass-produced nature as well as narrative potential of the (moving) photographic image, despite or because of digital manipulation.

Wang Jingsong's *City Wall* (2002) is representative in many regards. It is a gigantic work made of five chromogenic prints each measuring 127 x 91 cm, consisting of hundreds of black-and-white snapshots of generic new concrete buildings, sprinkled with fewer color images of traditional architecture, everyday life, and tokens of organic life (vegetable and handicraft). Architectural styles and lifestyles of different periods and inflected by different ideologies are laid on top of and next to each other, as though a team of masons has assembled a wall with countless bricks. These images, or building blocks, are shown to share the same present, the same social totality shot through with historical memories. Although this is an imagined wall, since the real city wall of Beijing was torn down by the Communist regime in the 1960s, there is no escape from its water-tightness. Some color images suggest violence (boxing), surveillance (police accosting a young man), and natural or ecological disaster (Red Cross volunteers on disaster scenes). Yet far more color images of gates, trees, parks, weddings, and theatrical performances seem to open up spaces for breathing and imagination, showing the tenacity of life. This large canvass of a city in transformation, which seems to have neither beginning nor end, crystallizes the "disaggregated" postsocialist temporality that does not index a specific time but a host of experiences and their memory images. The work conveys the iconic monumentality and inertia of an old city wall on the one hand, and the breakneck speed at which this new walled-in urban environment is built, on the other. This dense image captures, on an immense scale, the tension between stasis and motion, and between witnessing and intervention that energizes many similar works.

Wang's work presents a compressed post-revolutionary Beijing made of steel, concrete, and glass as a monstrous protagonist, and bemoans the diminishing presence and size of human figures and other life forms. Many artists seek, however, to reinsert the body of various gestalts — bruised or naked — on the scene, as victim, witness, and a feeble yet possible agent of change. They do so by adding a dramatic, often surreal, element to the indifferent cityscape, forcing a dialogue with the city. *Dialogue* (1998), Zhang Dali's serial photographs of his "headshot" graffiti (numerous heads drawn on demolished walls around Beijing) is an obvious example. Here I will focus on a few photo works that enact surreal or spectral "live performances" on the often indifferent city scenes: Yang Fudong's triptych *The First Intellectual* (2000), Li Wei's pair of *Mirroring* images (2000), and Chen Lingyang's panoramic tableau *25:00* (2002). These works build into their dense visual narrative the interplay between conceptuality and realism, foregrounding the body's uneasy position in the postsocialist landscape.

The First Intellectual — with its poster-style bright red title on the top of the images — features a man in a dark suit and with a briefcase standing in the middle of a road in Shanghai, surreally empty for the bustling city. He seems to have just been attacked. The skyline in the far background is unmistakably Pudong, boasting some of the tallest buildings in the world. The bespectacled man's slacks are torn, blood streaming down his face and shirt. He holds a brick as if trying to seek revenge for his injury. Yet his target is nowhere to be seen, and he seems unsure at whom or what his anger is directed. This awkward figure, out of place in the new market economy, recalls the pickpocket Xiao Wu, the "last intellectual" in a dusty town, in Jia Zhangke's eponymous film, whose humiliated position and anachronism in a society that has outpaced him is shared by a large number of Chinese intellectuals (or broadly educated people in non-menial professions). The three images vary slightly, as if they are still enlargements taken out of a sequence. In one image, the man's tie is gone, and his frustration seems as overflowing as his belongings spilling out of his roll-on suitcase. The "intellectual" has turned into an agitated solo protester at the indifference that surrounds him. The art critic Charles Merewether agrees with the artist that this "amnesiac body," though inevitably originating in the "empty homogenous time" of consumerism and political apathy, is not entirely devoid of potential. He appears to be holding on to a sense of dignity and justice, a "persistent idealism," a utopian yearning that, in the form of nostalgia and romance, permeates Yang's other series such as *Don't Worry, It'll be Better* (2000) as well.[21]

Chen Lingyang's *25:00, No. 2* (56 x 173 cm), exhibited as a rear-illuminated transparency, is spellbinding and engages the postsocialist city in a unique

way. For a woman artist who previously photographed her own menstrual blood for an early series that confronts the structure of patriarchal gaze,[22] it is hardly surprising that she places a female body (her own, in fact) at the center of the frame. Digitally inserted into an otherwise-generic urban landscape of concrete residential buildings seen everywhere in China, the naked artist, asleep facedown on the rooftop of a building, is out of proportion and place. It endows the slumbering, or shall we say lifeless, city with a meditative sensuousness. Here the sense of duration or stretched time and its fragmentation is not shown in the mosaic or serial format; rather, it is condensed into one thick hybrid time-image. *25.00* readily reminds one of Spike Lee's film *25th Hour*, also released in 2002, which features Edward Norton's character saying goodbye to friends and relatives before going to jail on his last day as a free man. Chen's ominous nocturnal city, a postsocialist ruin of sorts, is eerily reminiscent of the apocalyptic ruins of the World Trade Center that gives Lee's film a contemporary poignancy. Yet just as Lee's antihero, on the verge of being banished from his beloved city, finds redemption in the extra hour of the night, the female body in Chen's work, inactive and fragile it may seem, is the embodiment of an alternative order of time. The new urban planning may be homogeneous and lifeless, but the indigo night sky is pristine and expansive, especially since the energy of daytime production and consumption is momentarily suspended or diminished. This spectral woman (the artist's alter-ego) is reclaiming the city, one building and a block at a time. She is dreaming of and for the city. Her porcelain skin is in direct contrast to the hardness and coldness of the concrete jungle. But her body temperature warms up the buildings; extended like a tree, she also seems to be taking root in the landscape, breathing life force into this built environment.

Evidently, one chief characteristic that unites many such experiments in narrative photography is the play with cinematic time — its dual capacity for recording "universal" capitalist modern time and for reordering and transcending it. One way they achieve the latter is through transfiguration, or bodily performance as a vehicle or medium for retemporalizing the present. Theatrical staging is crucial for this *mise-en-scène* of heterotopia, which Michel Foucault calls the alternative social ordering of space.[23] The use of real or virtual props and backdrops, such as a briefcase and other white-collar paraphernalia, the mirrors, and the skylines, invokes early studio photography before the medium became what Bourdieu calls a ubiquitous "middle-brow art" in the industrialized world.[24]

Whereas the works by Wang and Yang discussed above insert gestures of intervention into the city and the prevailing time and ideology that governs it, Chen's photographic imagination gives wings to the profane and the spectral.

The body in her image is not a victimized intellectual or the migrant worker — prevalent in too many male avant-garde artists' works — but rather a new entity that defies subject-object, organic-cybernetic boundaries. If her early work with menstrual blood is a feminist critique of patriarchal linear time by looking inside the body through an emphasis on cyclical time, this work flips the temporal coin to make a macroscopic statement. The body here carries an additional hour: a liminal chronotope for dream and sleepwalking, and for stretching time and making a crevice or difference in history.

The postsocialist city as portrayed by these new experiments with a now-antiquated medium, as I have shown, is not one single city, imagined or lived. The manifestations of adjacency or overlap between different sensibilities and possibilities suggest that the two modalities of city and image — encapsulated by the paradigm of the exorbitant versus the generic, or the modern versus the postmodern, the analog versus the digital — are not mutually exclusive. By virtue of its combination of residual premodern and modern elements, socialist statism (though no longer perceived as apparent totalitarianism), and global capitalism, the urban landscape in which the artists find themselves and which they transfigure is in fact a complex chronotope of temporal-spatial coordinates. Its density and fluidity, and its seeming superficiality and hybridity, are precisely both the ready-at-hand material for a new breed of artists and the touchstone for their own relevance when culture and art have resolutely marched into shop windows and personal computers. Their searing images embalm the changing present through their very instability, a spasmodic temporality on the threshold of stasis and motion, of entropy and revivification.

Xianchang: Under Construction

For a number of other visual artists attracted to the moving images, the impulse to bear witness to the troubled present and a lingering desire to intervene readily find expression in the form of video (especially DV) that thrives on immediacy and accessibility. The quick spread of the medium over the last decade has confounded conventional distinctions between different types of moving image production, especially in China where filmmaking until recently was under tight state control. The ascendance of television and, along with it, the non-fiction genres in the 1980s, followed by the popularization of home video, prepared a stage for an alternative cinema intended for the small screen. Narrative film made on celluloid and for theatrical exhibition after passing censorship is no longer the privileged *modus operandi* in a mass culture suffused with a wide spectrum of offerings. Here I again concentrate on how artists give an experimental spin to the medium, conjoining the documentary and the performative in an explicit

way so as to anatomize and reconstruct the here and now. As I will discuss below, *xianchang*, a concept that writer and documentarist Wu Wenguang has sought to articulate through a number of video and writing projects, is indeed a theory of practice akin to the Situationist International (hereafter SI) movement in postwar Europe.

How is this "present scene" staged and visualized in experimental video? In what ways is this spatial practice implicated in or re-inscribed in cinematic time? In some instances the aesthetic strategies foreground the durational power of the long take and slow panning, as in the Guangzhou artist Lin Yilin's video *Safely Crossing Linhe Road* (1995). This early analog video work is ninety minutes long, appropriating the feature length of narrative film for a visceral live performance of the artist moving a wall of breeze-blocks from one side of Linhe Road to the other, one block at a time. The concrete skeleton of two skyscrapers under construction is the backdrop "construction site" for the act. While building projects are often carried out at a frenzied pace in the overhaul of the socialist infrastructure, the artisan-style building and moving of a miniature wall across a busy street amount to a solo demonstration. The art critic Hou Hanru observes,

> Not only did he turn a "solid" into a moving entity but invoked a sense of speechless surprise in passersby as this bizarre form disrupted the traffic, leading to one jam to another. In this dense, intense portion of the city, through this work, Lin Yilin created his own new space within the chaos.[25]

The crucial point to note here is that this idiosyncratic new space takes place in time. The painful slowness of the act carves out a new temporal regime in the midst of the urban traffic flow. The patience and concentration the performance requires produce a meditative effect, in stark contrast to the surroundings (especially the huge billboard showing a digitally enhanced utopian image of the finished building). By forcing the traffic to slow down (lawfully, as Lin with his mobile wall crosses the street on the zebra lines) and turning the passersby, including the construction workers on the scene, into spectators, the work creates a spectacle in motion by revealing the materiality of urban construction and human labor imbued in it. The artist-cum-builder here is not simply the disgruntled intellectual who strikes a defiant pose in Yang's *The First Intellectual*. Rather, his low-key but no less dramatic act conjoins the two construction sites and their respective time zones — the giant one inside the homogeneous "progress" and his makeshift one on the (fading) safety island — precisely by contrasting their distinct scale and style.

This work and other similar ones strike me as replays of the SI's engagement with the city in the contemporary Chinese and global context.[26] A brief

movement that peaked in the 1960s, the SI project as described by Peter Wollen was "relaunching surrealism on a new foundation, ... within the framework of cultural revolution." "Artists set to break down the divisions between individual art forms, to create 'situations,' constructed encounters and creatively lived moments in specific urban settings, instances of critically transformed everyday life." These "situations" are aimed at confronting oppressive urban and social forms and the "ruling economic and political system" that supports them.[27] Its urban-centered or target-specific artistic and theoretical enterprise was largely inspired by its predecessor movement, the Letterist International's *urbanisme unitaire* (unitary urbanism), which envisioned a "utopian city with changing zones for free play, whose nomadic inhabitants could collectively choose their own climate, sensory environment, organization of space and so on."[28]

Influenced by Lukács, and especially his contemporaries Sartre and Lefebvre who gave alienation new, "situated" meanings, Guy Debord imported their ideas into the movement's second, more theoretically charged phase. He advocated vociferously in his famous *Society of the Spectacle* and other writings the imperative to connect politics and art, especially in a cold-war climate in which Marxism was being reevaluated and revised following the rise of Stalinism. Without going into the deeper history of the SI and its internal rifts and shifts, I find in the resonance of the SI urban-oriented theory and practice in contemporary Chinese experimental art yet another proof of the periodical revival of the historical avant-garde spirit on the international horizon. Avant-garde movements arise usually most forcefully at the epicenters of the global spread of capitalism, now inside the previous socialist fortress once held in high esteem by the fashionable French and other European Marxists. The emergence of experimental art, in particular the strand directly addressing urbanization and globalization, paralleled China's (and the Communist Party's) turn to a capitalist mode of production and consumption. This art movement is in fact part of a broader cultural phenomenon. It is a historically overdetermined new edition of the SI, whose very name designates the global scope of the project although as a movement in postwar Europe it concluded in the early 1970s, just as the Cold War was beginning to thaw and capitalist seeds were again sown in China.

The Chinese "situationist" artists find the flexibility and anonymity of video extremely conducive to a direct critique of everyday life, resorting to elements of cinéma verité and on-scene reportage. While *Safely Cross Linhe Street* explores the long take and slow pan, many other works exploit the short format, tracking shot, and jump-cut, especially when involving the artist treading the thin line between subject and object. Tong Biao's *Touch* (1996, 5 min. 30 sec) has the camera mounted on the back of the artist as he runs around the city with

his assistant pursuing him at a frantic pace, often managing to bump and touch him. The city revealed is one of intense pulse and uneasy intimacy.

Woman artist Kan Xuan in her video work *Kan Xuan, Yes* (1999; 5 min.) also stages a scenario on the run in a Beijing subway station. She calls her own name while running through the crowd and then answers to her self. Her bizarre performance not only cancels out the distance between the hailer and the hailed (an interesting though perhaps unwitting comment on Althusser's theory of ideological interpellation), but also between performing shouting and shooting a film. Through this self-splitting act enabled by clever use of editing and the setting of a subway passage looking the same on both ends, the artist cancels out her uniqueness as cultural elite and reasserts her voice through a new self-recognition in the crowd, who is hailed to acknowledge her as well.[29]

The 2004 *Between Past and Future* show in New York exhibited two video works by Song Dong that also place the artist right "on location" and at the boundary between the city and its alternative representation. The veteran installation artist adds some props characteristic of his work to underscore the three-dimensionality of the urban experience as well as its fragility. *Crumpling Shanghai* (2000; 8:19) projects the footage of Shanghai street scenes onto a sheet of paper held in Song's hands. Like a showman of early cinema playing with light and shadow and the ephemeral temporality of "cinema of attractions" ("now you see it, now you don't"),[30] the artist abruptly crumples the paper so that the images vanish into darkness as if they were a mirage to begin with. In *My Motherland Made the Scene for Me* (1999; 16 min.), shot in Beijing during the fiftieth anniversary celebration of the founding of PRC, Song Dong experiments with this temporality more explicitly by using a mirrored clipboard to foreground the internal fragmentation (rather than continuity) and ideological artificiality of his locations. The doubled-up real in its mirrored representation is thus stripped of its naturalness or ontological certitude through overexposure.

Video may be the quintessential medium for a new generation of Situationists. Its flexibility and anonymity allow them to readily place themselves in the midst of urban transformation for remapping the city and rewriting a history of the contemporary. It also compels the artist in unprecedented ways to examine the distance and ethical relations between the subject and object, the intellectual and the masses, when the ascendance of mass culture and new media are rapidly rendering such divisions dubious and even irrelevant. Within this context, the concept and practice of *xianchang* take on added urgency and importance. Just as the relationship between art and politics was the touchstone for divergent tendencies with the SI, the question of social relevance has increasingly become a hallmark of the experimental photo and video. What is different, however, is the absence of a utopian urban vision projected into the future. Instead, we find

an intense investment in the present, as if trying to instigate some form of change in perception and social relations while the present is under construction.

Xianchang is a multivalent term. It became a popular idiom during the 1990s, obviously with the mushrooming of construction sites (*shigong xianchang*) all over China. But it also appeared with the proliferation of non-fiction television programming and the attendant deluge of new style "on-scene" journalistic practice including live news reporting and talk shows that had previously been largely absent under tight state control. Not surprisingly, television became one of the earliest forums where the new documentary sprouted.[31] The more daring visual practices of *xianchang*, however, were carried out by underground (and often migrant) artists who lived and worked at the edge of Beijing, in the Yuanmingyuan area and the "East Village." Hardly surprising then, that some of the earliest independent documentaries and Sixth Generation films were about this group of artists, including Wu Wenguang's *Bumming in Beijing,* Jiang Yue's *The Other Bank*, Zhang Yuan's *Beijing Bastards*, and Wang Xiaoshuai's *Days* and *Frozen*. (The fiction films also had an ostensible documentary and performative streak as characters often played themselves.)

Wu Wenguang emerged as the most vocal spokesperson for the concept when he published a series of anthologies under the rubric of *xianchang*. The books are an interesting blend of production log of his works, such as *Jianghu*, interviews with other independent filmmakers, film scripts, and reviews. Wu's conceptualization derives from these practices — both fiction film and documentary film — that share a passion for confronting reality and getting under its skin, while consciously examining their methods of documentation. He stresses that *xianchang* constructs a particular temporality of "present tense" by virtue of being on the scene.[32] As such it is as much a space as a time for acting out. Subjects featuring artists and performers, who often know each other well, lend *xianchang* a reflexive force as the filmed are as much, if not more, intensely aware of their act as the filmmaker. His own films have consistently been preoccupied with marginal characters who aspire to play a part in history, from the poor migrant artists in *Bumming in Beijing* to the peasant performers of a traveling singing and dancing troupe in *Jianghu*. What these "artists" have in common is their rejection by the city and mainstream culture (elite or popular). They live in shantytowns or simply in ambulatory tents. This type of films may be called "performative documentary" through which, as Charles Leary has noted with regards to *The Other Bank*, the "documented — the subject of the film — [is] being created as the film unfolds, to the point where the documentary form and the dance/performance form are inseparable."[33]

Wu's examination of what it means to be an artist or performer in the shift to market economy and mass culture quickly turned to the figure of the migrant

worker who hovers in the ambiguous region between the city and the country: the vast construction site of urbanization. Unlike the treatment of the migrant work as a cipher for cheap labor and social inequity or simply as a *mise-en-scène* element in many Urban Generation films, Wu with his portable DV camera — whose close-to-the-body quality he discovered in the process — lived with the migrant peasant performers for long periods of time during the making of *Jianghu*. The film portrays them as embodied transient subjects with social and cultural aspirations, while also showing the ambivalent relationship that their subjectivity-in-the-making has toward the process of filming.

With his involvement in the independent Living Dance Studio founded by his partner Wen Hui, Wu found an ideal staging area for his performative documentary that at once documents and constructs experimental spatial and social practice. In a number of multimedia dance projects in which Wu and Wen collaborated, he plays a number of roles: producer, co-choreographer, performer, and video artist, albeit often out of necessity within a cottage industry enterprise. *Dance with Farm Workers* (2001), a film that records the rehearsals and the final performance of an experimental work involving migrant workers at a construction site, encapsulates Wu's attempt to close the gap between subject and object. Rather than posing as a disembodied voyeur, the filmmaker and his cameras here literally dance with the workers. The project tries to reconnect the intellectual and the masses, art and life, for the purpose of forming a new alliance between these "opposites" to counter the hegemonic forces of globalization.

Dance was conceived and evolved as the city of Beijing rapidly transformed. Initially Wen Hui thought of staging a show on a huge lot of demolished residential area near where they lived. She envisioned farm workers standing on the ruined walls under dim streetlights or glaring construction lights. But the lot was soon turned into an off-limits construction zone.[34] In August 2001, an incipient vision was quickly materialized as Wu and Wen gained permission from a real estate developer to "do something" in an old textile factory on the eve of its makeover into an arts center designed by Zhang Yonghe, the U.S.-trained figurehead of postmodern Chinese architecture. They employed thirty migrant construction workers temporarily out of work to dance along several professional and amateur dancers. The film is not a record of the final performance but rather a (well-edited) production log that documents the process of recruiting, training, and finally staging the show. Though masterminded by Wen and Wu, the performance is meant to be a collaborative work between the workers and the artists. Yet, one finds that tension and ambivalence persisted throughout the entire process.

It is plain to see that the final performance in front of a group of cosmopolitan artists, journalists, and Western curators, who are in turn incorporated into the

show as in *The Other Bank*, is hardly the end object. The filmmakers (in the form of Wu's direction and multiple digital camera operators) document the process, edit it, but also literally insert themselves into the project. Put differently, the filming process created a fifteen-day-long multimedia event. The participation of several Beijing-based experimental artists including Song Dong and Yin Xiuzhen, another well-known artistic couple in Beijing, further turned the film into a work of mixed media with multiple artistic visions.

This emphatically situated performance-on-camera is a meditation on a layered *xianchang* branded with vestiges of the socialist era (such as the holes on the floor where machines were anchored, and workers' scribbling on the wall), and of the changing nature of labor and ownership of urban space. All the artists involved were excited by the opportunity to do something beyond the confines of conventional walled galleries, museums, and theaters. Wen Hui first toyed with the idea of reenacting the textile factory's memories with women workers dancing in the space, then decided that filling the space with the migrant workers omnipresent on construction sites would give the project direct contemporary relevance:

> These farm workers appear in our sight everywhere but are completely overlooked. Urban dwellers often detest them and their smell on buses and subway trains. But in a city that is constantly being revamped, they represent the most basic condition of existence in real life …[35]

Rather than using these laborers' bodies as mere props as would have been in the earlier vision about the ruined walls, they were mobilized to play the protagonist — in their collective form — in the space and in the show. Their vital energy would be channeled into the remodeling of the factory into an arts center.

The film records the intense collaborative process, amply drawing on the "primitive" forces embodied in the worker's gestures, movement, games, and singing. At the same time, the cameras register the subtle tension between the avant-gardist impulse to bridge art and life and the workers' practical concerns for living. On the very first day, the workers demand a clarification of their pay and who pays for lunch boxes and transportation before they begin to understand what exactly are expected of them in this art project. Somewhat awkwardly, Wu Wenguang spells out the terms of the contract. Two days later, another discussion pushes the question of pay into an unexpected area, when a worker asks Wen Hui whether or not the show would help them recover unpaid wages, and obtain city residence permits. The choreographer was unable to give a satisfying answer.

The question was in fact directed at the nature of the project itself: what is it for? If it is yet another show and movie, which they vaguely associate with those that play in theaters and on TV screens, would it bring them some form of concrete social recognition, not to speak of wealth and fame? As "untouchables," the figure of the migrant worker enacts the collapsed boundary between the pre-1980s socialist city and the countryside, a boundary which prevented citizens from moving freely. Moreover, the figure also embodies the new great divide between the rich and the poor, the globalizing cities and the vast hinterland of underdevelopment. The performance brought both this figure and the contradictions inscribed on his body momentarily into the purview of a limited number of cosmopolitan spectators, whose patronizing interest was confronted when the workers passed bricks to them as though demanding a direct contact or dialogue. The brick is the metonym of their body. But what would happen to them after they get their wages and disappear into the muggy August night of Beijing? What memories would they bring back to their shantytowns and villages as mementos of their brief encounter with an equally floating art world?

The film, with its linear flow and ad-hoc quality, does not seem to have included these considerations at the outset. There is an unsettling sense that the surfacing of all the practical issues and ethical questions, while surprising or embarrassing the artists somewhat, became quickly assimilated into the avant-gardist disjunctive vocabularies and reflexive open-ended framework. The project seems to have succeeded in endowing the old factory with a new life, turning a space without qualities into a space of potential. The performance momentarily emancipated the productive force of the farm workers and allowed them to engage in work as play, although many still saw it as work pure and simple for the 30 yuan (less than 4 dollars) per half-day wages. The opportunity itself of being commissioned by a real estate developer (who uses the show for pre-sales publicity) is but one of the many instances today of culture producers' unwitting or tactical "dance" with the nascent quasi-capitalist economy in China.[36]

Dance with Farm Workers exemplifies the promise and ambivalence of *xianchang* in vivid ways. It underscores the urgency of documenting the dramatic and sometimes horrific transformations in Chinese society as well as the awareness of the limits of representation through either dance or video alone. The combination of the two produces a larger range of possibilities but also challenges. By linking the past and the present, the embodied and cinematic motion on a haunted site of labor history, the project creates, to borrow architecture critic Marcos Novak's term, a miniature "transphysical city" by returning time and memory, hence life, back to architecture.[37]

Wu's involvement in the Living Dance projects as both filmmaker and performer (the couple collaborated also on *Report on Giving Birth* and *Report on the Body*) indicates his further intersubjective movement across the camera lens and indeed his efforts at diffusing the sanctity of the filmmaker in general and the documentarist in particular. The filmic image is no longer a mirror reflection of a scientific investigation, or an artistic treatment, but rather the site for a new rite of passage, as crystallized by the end of *Dance* where the performers seem to pass through a big screen on which Song Dong's video work *Broken Mirror* (1999) is projected. The various city scenes appear to be refracted from a mirror, which is being smashed by a giant hammer, coming directly toward the onlookers.[38] The workers disappear into the screened mirror only to re-emerge triumphantly, waving at the audience largely composed of artists, critics, and curators.

With this collaborative project, filmmaking becomes for Wu more consciously process-oriented and a by-product of performance and other hybrid forms of creative work, accompanied by a heightened awareness of the ethical implications of the documentary form. Such a practice frankly shows the film as a form of labor, not giving birth to artistic intention, but to an unscripted experience, an encounter. Wu seems poised on entering the post-Griersonian stage, where the classical documentary form that more or less postulates an external reality is ready to be dissolved.[39] Instead of filming victims, the filmmaker will play the role of facilitator for social change, as manifested in his recent "Village Election" project (2005), in which *xianchang* is relocated further, into the farmer-filmmakers' viewfinders.

DV Shanghai as Negative Utopia

Beijing as the political and cultural center of China is the hub of avant-garde artists and intellectuals who have retained much of their "primitive passions," a term coined by Rey Chow to describe Chinese intellectuals' obsession with the symbolic meaning of the subalterns (peasants, women, and children) for China's modernity.[40] It is hardly a coincidence that the new documentary film emerged in Beijing around the 1989 democracy movement, which appeared as a "structural absence" in early works of the movement.[41] Despite the spread of independent documentary across the nation in the past decade, documentary production in Shanghai has resided largely within the state-sponsored system. Overall, the once-vibrant cradle of Chinese cinema has lacked favorable conditions for the revival of a cosmopolitan film culture. In this rather bleak context, ironically, an incipient independent filmmaking began to sprout between the crevices of various neighboring art forms and media.

Artists in Shanghai tend to engage with the divide between the high- and the low-brow, the political and the aesthetic, in markedly different ways. This difference may be attributed to the downplayed role of the intellectual in an urban culture historically thoroughly embedded in trade and commerce, which fostered a form of a worldly cosmopolitanism, as embodied in early Shanghai cinema.[42] Instead of the romanticist "go to the people" approach in *Dance with Farm Workers* (albeit in a more reflexive and mediated form), we find Shanghai-based video artists and filmmakers such as Yang Fudong and Cheng Yusu (Andrew Chen) training their cameras squarely on the homeboys and homegirls of the city. This is the post–Cultural Revolution generation, growing into the white-collar class or, alternatively, into "white trash" (to borrow the American vernacular, minus the race inflection).

Yang's prolific and complex film and video work deserves a fuller treatment, a project to be done for another occasion. I will touch only briefly on some features relevant to my concerns here. Originally from Beijing, Yang decided to work and live in Shanghai after graduating from the Oil Painting Department at the renowned China Academy of Fine Arts in Hangzhou and a brief, disappointing experience in Beijing in 1997, when China's largest metropolis was embroiled in its full-speed project of "(re)cosmopolitanism."[43] While working as a video game creator for a joint-venture company, he began experimenting with film and video.[44] If his photo series, which I mentioned earlier, plays with filmic elements such as sequenciality and tableau framing, his works made on film demonstrate a penchant for evocative stillness and meditativeness drawn from Chinese classical portraiture, ink and brush landscape scrolls, and early photography and silent film. These features are most pronounced in his *Estranged Paradise* (1997/2002; 76 min.), *Liu Lan* (2003; 14 min.), and *Seven Intellectuals in a Bamboo Forest* (Part 1, 2003, 30 min.; Part 2, 2004, 46 min.), all shot on (sometimes cheap, expired) black-and-white film stock,[45] then transferred onto DVD for exhibition mainly as video art in galleries and museums. Yang's subject matter seems to have derived, in eschewed forms, from distinct sources of inspiration, ranging from fables of premodern intellectual dissent (Wei and Jin dynasties of the third century AD) and its pictorial representation (e.g., literati painting), to revolutionary myth (e.g., Liu Hulan's martyrdom), and a corrosive contemporary Chinese society. Yang admits that his overarching interest, which he attempts to encapsulate in his pentalogy *Seven Intellectuals*, is "to articulate several temporalities together":

> One that is really ancient … another set during the '50s and '60s, when there was a profound questioning of the status and role of intellectuals (and so the films will have a clear '50s, '60s kind of New Cinema flavor); and, ultimately, one dealing with the concerns and ideals of today.[46]

This multi-layered temporality is embodied in the nonprofessional actors (mostly his friends), who first appear in nude sitting on a scenic mountain and then slip into costumes of the 1920s borrowed from a Shanghai movie studio. They talk and walk while not much else happens. The sophisticated countenance and lifestyle of the new Shanghai youth uncannily blend into layers of China's history and landscape in which even the trite division between the premodern and the modern is questioned. As a whole, Yang's films plays with narrativity, but the stories ultimately are not driven by psychological motivation and plot construction. Time unfolds, but it is neither linear nor teleological, because it unravels in the matrix of multiple epochs, points of view, and aesthetic and historical experiences. Yang aptly calls the ambience of his films a "kind of dreamscape" — "very calm, very beautiful, but with a strange, disturbing aspect."[47]

One encounters this uncanny dreamscape in a harsher and darker tone in Cheng Yusu's DV films about Shanghai, *Shanghai Panic* (2001) and *Destination Shanghai* (2003). What distinguishes Cheng from other artists who dally with film or video as a new canvass or medium for their art is his wholehearted embrace of digital video for alternative filmmaking and counter-culture storytelling, in a way more radical than any of the independent narrative filmmakers before him. What he has done in his debut *Shanghai Panic* is something defying facile categorization, neither fictional nor documentary. It is reality DV of sort. It shares with Yang's *Estranged Paradise* the central conceit of hypochondria and a pervasive sense of purposelessness among the new urban generation, as well as the use of non-professional actors. However, while Yang still clings nostalgically to the beauty of black-and-white celluloid and a lyrical or "literati" mode that he inherits from both classical Chinese painting and early Shanghai film masters such as Fei Mu,[48] Cheng's aesthetic sensibility and sense of social urgency are edgier. The strange beauty of Shanghai captured and retouched through DV camera and software stems from the city's underbelly that deflates the glamorous surface of the metropolis — China's dressing window of globalization. The inhabitants of the badlands of postmodernity here are neither disaffected bumming artists nor exploited migrant laborers, but rather a host of voluntary misfits or hybrids with ambiguous social and sexual orientations, self-exiled from the respectable mainstream.

After studying film in Australia, Cheng returned to his native Shanghai to pursue his visions for digital film. Lacking any connections to either big studios or big capital, Cheng concocted his shoestring project with the help of Mianmian, Shanghai's notorious party organizer and the voice of the "wasted," siblingless generation. She provided the script based on her eponymous autobiographical novel and played the semi-autobiographic Kika in the movie. Kika, a divorced

young mother, is part of a gang of young loafers, which includes Casper, Feifei, Bei, and Jie. The film follows their alternately collective or solo wanderings in the maze of the city, club-hopping, experimenting with drugs, and looking for intimacy or simply a faint purpose for wanting to live.

The film offers interesting points of contrast to *Dance with Farm Workers*.[49] Both toy with the docudramatic mode, although they come from the opposite ends in the spectrum. Each film has a lot to do with bodily performance and image-making. But the body in Cheng's film is not related (back) to production but rather to consumption. The ex-ballet dancer Bei suddenly finds that he has AIDS-like symptoms. His cohort is alarmed because they have heard the rumor that the government is putting away HIV-positive people on some remote island. The crisis brings them even closer, spending hours together in KTV rooms, where they dance, embrace, and share stories about love, suicides, and betrayal. With the shadow of disease hanging over him, Bei makes a move to explore his same-sex interest in Jie, a childhood friend who is also dancer, only to get more confused and agitated.

This extended sequence with a video-within-video clip of a friend who has just attempted suicide is one of the instances when the Dogma-style shooting and performance digress from the script, which Cheng hardly followed in any case. Such a confrontation with shocking images of death and other uncouth or abject conditions is at the heart of a number of other "documentaries of cruelty" as well, such as Yang Lina's *Old Men*.[50] The "cruel" effect is largely made possible by the portable DV camera and its seeming unintrusiveness. What is peculiar here is that the home video footage is not filmed or planned for insertion in the film by the director. It surfaced spontaneously during the shooting, which further complicates *Shanghai Panic*'s genre status, lying between fiction and documentary.

Cheng insists that DV's portability and lack of professional pretense make it possible to reduce the distance between the actor and filmmaker, so that the latter becomes part of the film, not least through the shadows of himself and his camera on the floor or on the wall. What would have been perceived as evidence of amateurish crudeness is here consciously incorporated into a DV aesthetic that renders the filmmaker a "dispersed body/self."[51] He recalls in an interview, "Until the end, we didn't know whether we were making a movie or showing our own stories, because we were crying all the time, and there was so much unhappiness around us. This kind of DV filmmaking is non-repeatable."[52] Relying less on preproduction and script and more on the contingency of shooting process and post-production software such as Digital Fusion/Maya Fusion, Combustion, and After Effects, Cheng sees his experiment as part of a revolution comparable to the invention of the cinema a century ago. Indeed,

his mode of production — a one-man company or cottage-industry style, along with the trademark improvisation — is reminiscent of the early years of the medium. Cheng claims that he would not trade his DV camera for a 35-mm remake of *Shanghai Panic* even for a million dollars.[53]

Unbounded by the walled studio and the rules made for old institutions of cinema in China, and not set out to make an ostensibly narrative or documentary film, filmmakers like Yang Fudong and Cheng Yusu are charting new territories for the medium and its perceptual, social, and ethical bearings. Their experimentation does not begin with the distinction between Lumière and Méliès, non-fiction and fiction, but rather with the possibilities afforded by new technology while fastidiously trying to represent a society in turmoil. The digital camera and camcorder are close to the body (not just the eyes), its haptic movement is like that of a dancer's, which lends itself well to "digital mimesis," or the "capacity of the digital to imitate preexisting compositional *forms* of imagery," as defined by Rosen.[54] The economy and freedom of the DV camera are also well suited for evading censorship and regulation, which have not caught up with small-gauge film, DV, and mixed media. So far, no permissions are needed to shoot a "home video" on the street, in the subway, in restaurants, supermarkets, or KTV rooms.[55] In short, almost the entire city is a ready-at-hand inexhaustible set that experimental photographers and filmmakers discover and claim as their borderless studio or backlot.

This new form of image-making and storytelling is premised on the overlapping of the "exorbitant" and "generic" cities, as well as the preindustrial, industrial, and postindustrial urban histories in China. It engages simultaneously real and virtual time, which gives the postsocialist city its exuberant visage as well as a schizophrenic character. The laboratory for the experimental visual production is located in the interfacing dimension between the vast physical *xianchang* (construction sites or the like) and the countless computer desktop workstations in homes, offices, and Internet bars. The layered and intermeshing urban and socio-political experiences are turning the contemporary Chinese city into what the Shanghai-based architect Ma Qingyun calls the "laminate city."[56] All the while, the implosive cyberspace in densely populated Chinese cities is making the city even more overexposed and inside out. In his description of the overexposed city, Paul Virilio sees the highway tollbooths and close-circuit TV overseeing the security of residences as a replacement for ancient city gates: "The rite of passage was no longer intermittent. It had become permanent."[57] In a sense, post-cinema is everywhere now.

This dystopic "big brother" vision of the electronically wired city needs not to be applicable to all image-making work. The de-monumentalization of architecture, urban space, and public culture resultant from this process also

inadvertently created conditions for a diffused, vernacular (*Shanghai Panic* uses exclusively the Shanghai dialect), personal, and communal form of image-making that does not care for the intramural studio system and the patronage of the state. Cinema is becoming an open city, via the millions of home videos, desktops, notebooks, and cell phones. *Shanghai Panic* presents a dystopic vision of Shanghai but not of cinema (or for that matter Shanghai DV), as both Yang and Cheng seem to find a strange beauty" and its possible cinematic redemption precisely in the profane thicket of the city's commercial phantasmagoria. Cheng has even predicted that "the dawn of a new era in Chinese film will start with a new way of making urban movies about Shanghai."[58]

This nearly utopian vision invites us to take another look at the function of a DV image — especially the video-within-video image in *Shanghai Panic*. While a paranoid or entropic temporality and medicalized body (allusion to drugs, HIV, and suicide) are dominant in the film, another body and image in the form of Mianmian's baby daughter frequently enter the picture. We learn, somewhat haphazardly, that Kika/Mianmian is embroiled in a custody battle over the biracial baby (whose father is British). Home video now serves almost as a prosthetic umbilical cord between her and her child. Images of this hybrid child on the small screen, as sublime light from a parallel universe, illuminate the room and add a contrapuntal, hopeful tone to a film about a generation's ennui and a city's impending doom. The hybrid child and her image are the product and embodiment of the postsocialist Shanghai, which belongs to many past and future worlds at the same time. At the end of *Shanghai Panic*, Mianmian again watches a video of her holding the child, shot in an indeterminate recent past. In the video, the child reaches out to touch a cartoon image of a tropical fish. Like the earlier footage of a friend's suicide, the DV image here substitutes for memory and is the medium for holding onto the departed, but unlike the image of (near) death, here the medium breathes life back into a community and a city on the verge of a nervous breakdown.

Conclusion

Above I have attempted to construct a critical postsocialist urban landscape by drawing on and linking together a number of experimental visual and "situationist" practices in the past decade (ca. 1995–2005). The artists and filmmakers concerned here deploy different media, aesthetic strategies, and historical lenses for representing the transformation of the Chinese city and its inhabitants. Together they form a loosely connected creative community engaged in mobilizing the imaginative power of the mechanically reproducible image, especially in the advent of the digital turn. They work with old and new

technologies and formats ranging from photography, video art, installation, performance, documentary, and narrative film. The innovative mixing of these tools and forms, with an eye for probing the confusing yet fragile surface of reality, has led them to explore the border regions of overlapping perceptual and historical temporalities, as well as the changing status of the body and self. Formally this kind of filmmaking may be called docu-narration or performance-on-camera in its actualization. In a larger cultural context, the energetic retooling of cinematic time and image by bridging old and new media, performance and film, fiction and non-fiction, intimates a collective desire of reinventing cinema by revisiting its childhood, that is, its intermedia heterogeneity and democratic promise offered by early cinema as an alternative public sphere. I see this post-cinematic or para-cinematic practice as a new trans-cinematic passage where audiovisual production becomes cross-purposeful, multi-directional, and socially engaging.

6

Noir Looks and the Flash of Transgression: Trauma and the City's Edge(s) in *A Bittersweet Life*

Susie Jie Young Kim

> One late autumn night, the disciple woke up crying. Finding this odd, the master asked him, "Did you have a nightmare?" "No." "Did you have a sad dream?" "No, I had a sweet dream." "Then why are you crying so sadly?" The disciple answered quietly while wiping away his tears, "It's because the dream I had cannot come true." (*A Bittersweet Life*)

When we talk about the city in terms of the edge, do we imagine a physical demarcation separating the inside from a periphery outside and beyond? Or is the edge simultaneously "out there" and contained within the city itself? Such ambiguity circumscribes Seoul, which appears to possess the guise of what Rem Koolhaas calls a "Generic City" but whose patina is redolent of something different.[1] This apparent a-historicity is deceptive insofar as its complex history in the last century is marked by traumas encompassing Japanese colonization, the Korean War, Cold War imbroglios, postwar recovery, rapid economic development, authoritarian regimes, and pro-democratic movements. Aporias plague teleological narratives of modern Korean history that are monolithically construed. The memories of these traumas hover over the cityscape, as they wait to be unraveled while Korea surges forward, occupying a privileged position on the global stage and amid the transnational network of Asian centers of cultural production. Although a recent wave of what I call "remembering films" has attempted to reconstruct the memories of past traumas, the complexity of this process should be pondered, as "the disaster is related to forgetfulness — forgetfulness without memory, the motionless retreat of what has not been treated."[2] Trauma has a life of its own. It debilitates, but it also affects our ability to remember and to recall. Trauma is the response, always delayed and thereby forgotten, to an overwhelming event that is not only incapacitating

for the cataclysmic vestige left in its wake but likewise for its repeated effect that comes back in literal form to haunt at its discretion.[3] The city in the grips of the traumatic, which eludes neat compartmentalization, cannot readily be contained at its edge(s).

Although historical trauma in the mode delineated above does not holistically assert itself in *A Bittersweet Life* (Talkomhan insaeng, 2005), this absence has to do with the "forgetfulness" that Maurice Blanchot attributes to disaster, that is to say trauma.[4] Trauma repudiates any semblance of a normative modus operandi in favor of rearing its head in another manner. For the "memory of the immemorable" inevitably returns in silence, a repetition perforce not desired, while forgetfulness remains staunchly immovable.[5] *A Bittersweet Life*, by the master chameleon Kim Chiun (Kim Jee-woon), whose previous endeavor tackled the psychological horror genre in his critically acclaimed *A Tale of Two Sisters* (Changhwa hongnyŏn, 2003), explores the multifaceted edges of the city in his treatment of the gangster genre. On the surface, it looks to be yet another articulation of the *chop'ok*, or gangster genre, celebrating male bonding and fraternal loyalty in Korean cinema. However, the hallmarks of this genre lie dormant in this film. Indeed, there is no emphasis on the family, no male friendship in crisis, no heroine that requires rescue, much less fraternization through gradual mutual respect between a criminal and the detective in his pursuit. *A Bittersweet Life* diverges from gangster films' conventional fixation with honor codes and sentimental displays of staunch masculinist camaraderie and offers, in their stead, a highly stylized cinematic poetics centered on a solitary city wandering. The cinematic city as the site of trauma — trauma *in* the city, trauma *of* the city — lends itself to this equivocal identity drifting toward the verge, which penetrates, divides, and intersects. Trauma's haunting of this noir odyssey approaches the edge of transgression.

The City, the Look, and Enigmatic Spaces

In Kim Chiun's stylistically disposed fantasy world, its hero stands alone, linking this film more with classic noir than the gangster genre, which is often premised on affirming collectivities and communities. *A Bittersweet Life* deviates from the obligatory validation of a masculinist sphere of influence governed by *ŭiri*, that absolute sense of loyalty held up so highly among male characters in these films as well as their Korean male audience.[6] Films such as Yu Ha's *A Dirty Carnival* (Piyŏrhan gŏri, 2006), Ryu Sŭnghwan's (Ryoo Seung-hwan) *The City of Violence* (Jjak'pae, 2006), Yi Myŏngse's (Lee Myung Se) *Nowhere to Hide* (Injŏng sajŏng bolgŏt ŏpda, 1999), and Kwak Kyŏngt'aek's (Kwak Kyung-taek) *Friend* (Ch'ingu, 2001), explore the inner sanctum of a violent, hyper-masculinist

(and misogynistic) world, in which thugs hold up its principles by wielding bats and knives, often against a melodramatic enterprise. Unlike *chop'ok*'s consecration of complete fraternal devotion, the buddy system's usual task remains extraneous in this film, as the city no longer serves as a setting for such sentimental declarations. The film charts an urban topography that, instead of reiterating a city of sentimentality, devises one earmarked by an impassive figure navigating the terrain of anonymity and disconnectedness. The cityscape where such nostalgic modes predominated becomes the province of the (albeit dandy) ascetic, articulated through the genre-bending film's use of the lexicon of trauma set amid a noir landscape. What is more, this self-proclaimed "action noir" plays to the register of fantasy. The fantasy factor is particularly evident in its appropriation of John Woo's hyperbolic style of bullet-ridden choreography in the final sequence, as gun violence is far removed from the reality of this low-crime city, where strict gun control is in place. The film, in effect, is a flight of fancy centering on the mythical space of the hotel sky lounge, La Dolce Vita, that allows for musings upon indulging the self.

Kim Chiun has described his film as an odyssey masquerading as an "internalized road movie."[7] This cinematic odyssey does not, however, cover a wide geographical expanse, navigating hinterlands out there beyond the scope of home. On the contrary, it maps out a trajectory that takes the hero into the depths of the city at once familiar and alien, intimating a mélange of Jean-Pierre Melville's detached coolness and John Woo's emotive gangster world. Like all good noir films, *A Bittersweet Life* assumes an investigative mode, with the city as a suitable backdrop. However, although crime usually fills the film noir canvas and crime abounds, there is a blatant absence of law. The film's hero Sŏnu (Sunwoo) inhabits a world established on a highly stratified sense of order that is riddled with crises, the swift resolution of which is his charge. His actions demand histrionic responses incorporating a mixture of executive judgment, well-placed punches, and swiftly executed acrobatic maneuvers, yet he does not represent unmitigated "good." A wistful soundtrack orchestrates the use of heightened emotions that provides momentum for his cause. Nevertheless, the hero does not pivot around a moralistic center. Indeed, at stake here is not an aphoristic pronouncement of "good and evil." At the crux of this film is not a question of morality but rather a journey of introspection with ontological ramifications, instigated by Sŏnu's attempt to recover an identity that comes brutally undone.

What is more, this cinematic odyssey assumes a particular "look" of the city, which invariably informs the look of the film. The film posits Seoul as a noir city by constructing a space of posh indifference steeped in what James Naremore terms "the aura of noir."[8] However, this is not the city of decay of American film

noir, but rather it evokes a noir mood that is not readily dystopic. Kim Chiun's reinterpretation, which may be deemed neo-noir, aspires to a "cool" look by way of a cinematic façade comprising a subdued color palette and stark modernist lines, but more significantly as embodied in an unflappable, self-contained hero. Yi Pyŏnghŏn is über-cool incarnated as Sŏnu, the number two man in a crime syndicate, evoking more Alain Delon's loner Jef (in Jean-Pierre Melville's *Le Samourai*) sans his signature Burberry trench coat than Chow Yun Fat's morally tormented Jeff (in *The Killer*, which bears the mark of John Woo's own reverence for Jean-Pierre Melville). Handling problems without so much as a flinch, Sŏnu is a well-oiled machine, a product of seven years of serving under a fastidious boss who runs his crime operation from a swanky hotel. He meets the ever-continuing string of predicaments that inevitably plagues his profession with remarkable ease, requiring no deliberation or afterthought on his part.

James Naremore reminds us that noir is a discursive construct the meaning of which is transformed over time and necessitates historical and cultural contextualization.[9] In *A Bittersweet Life*, noir becomes the vernacular of fantasy encompassing a somber individualist topography that lends itself to this personal indulgence. The *mise-en-scène* informs Sŏnu's detachment and precludes the film from the onus of affirming the collective and community, national or otherwise. While Chow Yun Fat's killers for hire (like Jeff) can always count on a mate for backup, Sŏnu is more reminiscent of another Jef — that of Jean-Pierre Melville (who occupies a prominent position in the cinematic experience of Korean audiences past, including Kim Chiun) — alone and pitted against a city of clandestine spaces and subterranean layers, hostile and otherwise, that lie behind and beneath its nonchalant surface. Imbued with the rigidity of his self-imposed personal code, Sŏnu's detachment from community is particularly salient. Whether the inevitable unit of family and home, an unavoidable obligation to a male chum in need of uncompromising proof of his obdurate loyalty, or a paramour's stalwart faithfulness swaying his cause, the inactive condition of such binding links is especially apparent when Sŏnu is forced off his perch high atop the city to suffer a steep fall below. The disorientation inevitably produced by noir to disrupt the moral climate disentangles recognizable and expected communal bonds in this film.[10] The city once seemingly familiar and intimate becomes unknown and enigmatic, as Sŏnu investigates his betrayal by his boss Kang and his subsequent downfall, which sets the protagonist along an inexorable path toward his own destruction.

A Bittersweet Life eschews any representation of the city as a site of nostalgia, making it devoid of Korean cinema's recent preoccupation with remembering that endeavors to recuperate lost memory filaments and address the lacunae found in official histories. Films such as *Taegukgi: The Brotherhood of*

Fig. 6.1 *A Bittersweet Life* (Kim Chiun, 2005)

War (T'aegŭkgi hwinallimyŏ, Kang Chegyu [Kang Je-gyu], 2004), *The President's Barber* (Hyoja-dong ibarsa, Im Ch'ansang [Lim Chan-sang], 2004), *The President's Last Bang* (Gŭttae gŭsaramdŭl, Im Sangsu [Im Sang-soo], 2005), and *Welcome to Dongmakgol* (Welkom t'u dongmakgol, Pak Kwanghyŏn [Park Kwang-hyun], 2005) attempt in their respective ways to carve out a locus for historical memory, whether in revisiting the Korean War or in satirizing the postwar authoritarian era's political theater. *A Bittersweet Life*, however, bears little of the historical weight of embodied pastness undertaken by this mnemonic inclination. Instead, what is presented here is a sleek, stylized urban space that shows off Seoul as an opulent city in line with Korea's stature as an economic stronghold in the global arena, speaking to the "sweet life" (as indicated by the original Korean title) enjoyed by its citizens, at least some of them. Seoul has never looked better and, more significantly, it has not been so prominently featured in recent cinematic memory.[11] At times indiscernible or uninviting in previous films, the city is presented against a nocturnal tableau, which takes on an air of refinement when viewed through Sŏnu's eyes. While the harsh glare of daylight exposes the downsides of living in such a vast metropolis, night draws a veil over the city to contrive a soft glow of intermittent lights outlining an austere silhouette. The palliating effect is such that in the road rage scene on the bridge, the familiar sight of high-rise apartments becomes transfigured, as even those uninspired concrete structures appear less unsightly by night. Because night reigns over this film, there are no urban crowds or traffic jams to be found. Empty roads subtly illuminated by street lamps lend a quiet texture to Sŏnu's nighttime wandering, as night gives the city a soft radiance and imparts a still ambience that is ruptured during the day when the city's streets are overflowing with people and automobiles.

Fig. 6.2 *A Bittersweet Life*

We are not inundated with long shots of the cityscape or a visual cataloguing of the city's landmarks. There is no extensive panning of skylines, but instead the focus rests on the ground, through the myriad shots of bridges spanning the north and south ends of the city, tunnels that traverse the centrally located Namsan Mountain, the Namdaemun Gate roundabout, and other recognizable downtown intersections. These are not landmarks targeted at the pedestrian on her walkabout but urban markers more relevant for a driver navigating the city by car. The camera remains steadfastly at street level proffering what Edward Dimendberg calls "automobile-framed views."[12] In his discussion of *Murder My Sweet* (Edward Dmytryk, 1944), adapted from a Raymond Chandler novel, Dimendberg describes how each view of Los Angeles seems to be "seen from the window of a moving car, a discrete snapshot carried away from a scene."[13] The implied movement of an automobile city dissuades the ossification of imprints that are interposed by city-dwellers writing an "urban text," which is the city by virtue of walking it. Seoul is a walking city that, in effect, has been infiltrated by an automobile culture.[14] This urban "automobility" constituting the mobility promoted by the influx of cars, highways, and other available modes of transportation, determines Sŏnu's experience of the actual city, insofar as his experience of the outside takes place within the enclosure of his car.[15] For Gilles Deleuze, "movement is a translation in space," as fragments are transformed within the process of change, with each instant influencing the whole.[16] The preponderance of driving scenes implies that the constant motion of being in the city ultimately affects one's view, with such locomotion having expurgatorial consequences. City images in *A Bittersweet Life* exude a synecdochic presence, as high-rises in particular offer up their parts for an urban montage that is continually transforming. In this vein, Sŏnu is successively subjected to an

edited outlook of the city by virtue of being in a car, which produces what I call "driving views," mobile images randomly accumulated during this process. However, ambivalence marks such moving images. As he drives through various parts of town, the windshield screens him from the city outside, submitting new yet distorted views. In the sequence in which he is tracking his boss's mistress Hŭisu's movements, Sŏnu passes by City Hall and the Sejong Performance Center (among other architectural landmarks), the reflections of which float by on his windshield. The specter of the physical city is always apparent yet inconspicuous. However, the cityscape is not to be fully digested for enjoyment or forging connections, but rather, it is meant to be passed by — driven by — just like nameless pedestrians or anonymous cars on the street. Seen in this sequence as a blur in the background, the cityscape is perceived not as stationary and fixed but as comprised of fleeting images drifting by and in constant flux.

The driving scenes at night and the posh interiors composing Sŏnu's world of the sky lounge high above the city provide a cinematic articulation of Seoul predicated on a vocabulary of sophisticated chic. Indeed, the city's look has withstood major alterations, as it has become more mindful of its appearance. Part of Seoul's latest makeover has emerged out of former mayor Yi Myŏngbak's (Lee Myong Bak) ambitious "green revolution," encapsulated in his 350-million-dollar project restoring the Ch'ŏnggyech'ŏn Stream, which had been paved over during the Park Chung Hee era for a highway, symbolizing postwar Korea's traumatic hyper-modernization. Other highly visible projects have added their own flourish to the city's physical transfiguration, as new architectural signposts have been erected amid antiquated palimpsests. Notably, the Samsung Foundation's Leeum Museum, which commissioned architects Rem Koolhaas, Mario Botta (who also designed the new Kyobo Building in Gangnan), and Jean Nouvel, has infused a global architectonic parlance onto the city. New aesthetic precepts are variegating this aspect of urban identity, which for too long has been neglected in the name of compressed modernization best embodied by the boxy utilitarian high-rise apartments dotting Seoul's landscape.

It is not just about the outside, however. Interior shots in this film surpass the exterior ones in importance. The hotel where Sŏnu works is the nondescript Crown Hotel, an older building in the Itaewon district, the development of which has been shaped by its proximity to one of the many U.S. military bases still in Korea. As in many buildings in Seoul, one cannot tell from the unremarkable exterior what lies past its doors. Our first preview of the hotel is not through a conventional establishing shot of its exterior, which appears only later in the form of awkwardly angled external shots, but of a tasteful interior space. The focus on interior spaces ostensibly represents the city's penchant for luxury, one touted by glossy magazines with titles such as *Haute*, *Luxury*, and

Fig. 6.3 *A Bittersweet Life*

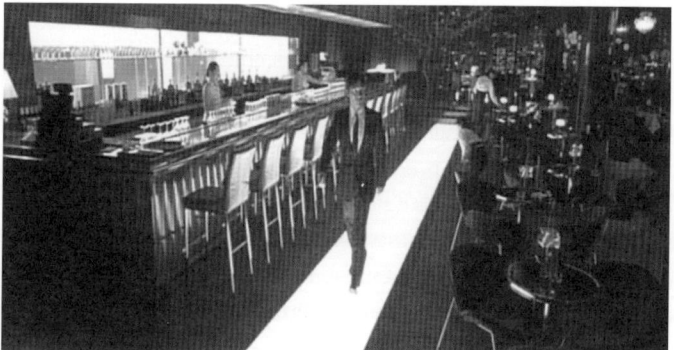

Fig. 6.4 *A Bittersweet Life*

Neighbor, whose primary objective is to disseminate the intricate workings of extravagant living and minister to a growing number of eager devotees. These publications invariably function as manuals on how to live a luxurious lifestyle by detailing what to wear, eat, and drive, and how to decorate one's home. Their appeal reaches to a fast-growing number of Koreans with the level of disposable income for the purchase of multimillion dollar penthouses in newly erected skyscrapers, which are eclipsing the outdated high-rise apartments of old.

 The hotel reflects this taste for luxury that speaks to a certain Seoul sensibility. Consequently, the film's *mise-en-scène* creates an atmospheric underworld, central to which is the hotel operating as a space of extravagance and leisure. La Dolce Vita, the managerial purview of Sŏnu, possesses an elegant, muted color scheme of red, black, white, and gray that augments the cachet of this

hotel sky lounge and bar. The widespread use of entertainment establishments, such as restaurants and bars, is symptomatic of the pervasiveness of such public spaces, as people come to parade their latest feats of consumption and furtively perform acts of label flaunting. It subscribes to the optical component's import in this film, with the hotel's white tunnel-like corridor composed of rectangular incandescent lighting summoning up a modernist undercurrent. La Dolce Vita's aesthetic economy suggests Art Deco undertones, updated yet seemingly nostalgic, as evinced by a Mayan-patterned wall à la Frank Lloyd Wright's Ennis-Brown House featured in *Blade Runner*. The hotel is set up as a dichotomous space that conceals spaces existing behind a well-appointed façade, sanctioning the ambivalence of Sŏnu's dominion, which prioritizes the visual. An early sequence shows Sŏnu navigating the numerous back entrances used by service personnel, bypassing storage rooms and surreptitious passageways out of sight and seemingly detached from the urbane aesthetic that reigns just on the other side. This long sequence adumbrates the throwaway disposability of an interior-centric perspective by exposing the transparent tenuousness of such veneer-oriented aesthetics. Even a spectacle most gingerly assembled cannot readily stave off the unflagging ethos of transience.

The extent of the film's preoccupation with the look extends to Sŏnu's personal image. Even while Sŏnu's involvement with the criminal establishment entails foreseeable duties, his identity nonetheless is defined by strict adherence to performing the right demeanor and look, for good manners and fashion sense count in this milieu. In spite of being often called upon to get physical with unruly thugs, an inescapable duty that may risk crumpling of one's ensemble, Sŏnu's sartorial statement is exactingly conveyed in his immaculately tailored pinstriped suits that take their cues from his boss Kang's fashion-conscious ways. Having internalized the art of proper comportment, Sŏnu is unrelentingly secure in his positionality at the beginning of the film. He possesses the right look but has also mastered his role and all that it requires, unlike his counterpart Moon, an uncouth boor who will eat with his mouth open and cannot even get a proper hair cut. For Sŏnu, it is not just about being on display for work; this style informs his very identity. That is to say, what is required is not simply a matter of donning the right suit but reinforcing every fragment of his being. His every gesture subtly follows a prescribed rhythm, even for a seemingly mundane act such as eating. Culinary appreciation is especially keen in Sŏnu's circle where he and Kang pursue business matters over a perfectly laid out dinner, partaking in Korean delicacies in an indoor oasis with a verdant view. Gastronomic affairs are not simply reserved for when he is with the boss, as an early shot shows Sŏnu taking time to finish savoring his chocolate mousse before setting off to mete out punishment to a band of rowdy thugs.

Sŏnu's stringent observance of code and routine cultivates a stillness predicated on order and ritual, even in the practice of marking the end of each work day with a cup of espresso properly enjoyed with a sugar cube. Chary of pleasure, he enjoys little of it with the exception of the aforesaid epicurean delights, as there is hardly other evidence of personal gratification. He is a stoic workaholic for whom La Dolce Vita substantiates his very identity, for this is where he can preserve order. Sŏnu and indeed the city purport to follow a code that maintains the look even at the expense of histories and the sublimation of the traumatic. A ripple disturbs the calm, however, upsetting Sŏnu's single-minded domain, as his experience of the city undergoes a metamorphosis. His illusions of being in perfect control as the urbane figure that he epitomizes is shattered by a moment of transgression. Everything is consequently thrown off center, as Sŏnu unknowingly suffers an unraveling of identity when he is abruptly jettisoned into the enigmatic. The vertical trajectory of his disintegration is first suggested in the opening sequence, which shows Sŏnu winding his way down through the different stories of the hotel to handle the riffraff found at the underground level daring to encroach upon his territory. Once his universe is fractured, new city spaces are opened unto Sŏnu, as he becomes subject to the labyrinth that is the city at large, leading to hidden worlds occupied by creatures beyond the scope of his imagination. This is particularly true when he comes upon a horde of ominous characters, menacing even for Sŏnu, who has seen his share of the unspeakable during his tenure in the world of organized crime.

The collapse of Sŏnu's universe coincides with the growing episodes in which his visual perception becomes compromised. This optical speciousness applies to Kang's mistress Hŭisu, a cello-toting ingénue who seems an unlikely choice for the boss of a crime syndicate. She is not the demure innocent girl that Sŏnu assesses from her appearance, however. In contrast, she turns out to be a brazen, savvy young woman who possesses the unpredictable laissez-faire attitude and disregard for social rules of her neologically inclined N-generation peers. Appearances, and the act of looking itself, go awry, with Sŏnu's vision waning to a state of precarious liability. This device of pretense gains momentum with the increasing emergence of new characters, which Sŏnu uncharacteristically misreads as being harmless but turns out to be something else altogether. An insipid figure that he astutely espies in a parking garage turns out not to be merely another adversary but an indomitable foe appointed to depose him. The city surreptitiously transmogrifies into an unknowable realm, as his encounters with thugs from the nether regions become more extreme. A group of Southeast Asians whom he casually passes at a convenience store happens not to be foreign workers from a nearby factory but hired hands out to get him. The appearance of these Southeast Asians speaks to the transnational facet of the city. The city's

tranationality is quintessentially represented by Incheon International Airport, captured in an outwardly directed shot showing the imposing structure through a glass wall, as Kang strides past other travelers. Its far-reaching implication is further highlighted in the black market pairing of Myŏngyu (Myunggu) with the Russian Mikhail, whose mutual language of communication is Russian, not the global language of English as dictated by globalization's agenda. The film, in effect, attends to Seoul's complex transnationality in which globalization does not simply pertain to economic terms but concomitantly has broader ramifications spanning the demimonde. Vacillating somewhere between the depiction of foreign laborers diligently pursuing the "Korean dream" through legitimate means, as represented in Chŏng Chaeŭn's (Jeong Jae-Eun) *Take Care of My Cat* (Koyangirŭl put'akhae, 2001), and foreigners' incorporation into the criminal world in Chang Chin's (Jang Jin) *Murder, Take One* (Paksu ch'ilttae ttŏnara, 2005), it sets forth an underlying anxiety generated in an era of transnationally mediated identities in the global terrain.

The city's diverse denizens accompany Sŏnu's urban peregrination that is not without predetermination, for fatalism inevitably hangs over film noir.[17] In Sŏnu's case, his fated course effectuating his divergence from the city that he implicitly knows is divined early on in the film. His arrival at Hŭisu's house is a harbinger of things to come, as he is met by a fierce wind causing him to stagger and lose his grounding. The disparity between Sŏnu's space and that of Hŭisu's is distinctly palpable, which is immediately established when his visit to her house initiates his initial crossing into unknowable ambits of the city. In contrast to the opening sequence that underscores the sleek space of La Dolce Vita, this gust of wind initially inducts Sŏnu into new enigmatic spaces, catching him unawares. Like what Ackbar Abbas calls "the unfamiliar in the familiar" with regard to Hong Kong, these are forgotten spaces, sublimated or not ever quite fully experienced, which at times serve as empty signifiers for an unknown nostalgia in cities subject to mercurial change such as Seoul.[18] It should be noted that Hŭisu's house is located in one of the older neighborhoods in Sŏngbuk-dong, near downtown in Kangbuk. Interestingly, the film focuses primarily on the more historical Kangbuk ("north of the Han River") section, an area that contends to have a past, rather than the upstart Kangnam sector ("south of the Han River"). Hŭisu's home is not a standard high-rise apartment that might be more suitable for a crime boss's mistress, particularly as she is part of a generation more accustomed to one of the trendy flats situated in the comparatively newer city center of Kangnam. Instead, she lives in a single-family house, the traditional kind surrounded by a wall. Filled with anachronistic kitsch and distinguished by warmer primary colors, her space evokes a seemingly outdated nostalgia, in contrast to the suave and relatively

futuristic monochrome hues of Sŏnu's world. Yet Hŭisu's space does not echo a fixation on privileging the past, for here it is a motley packaging of the past that strives for a vintage look to service the city's overall image rather than assume the historical solemnity of remembering films, albeit which may be artificially constructed.

Other spaces that I call "timeless spaces" surface with more frequency after Sŏnu's fall from grace and, for the most part, exist on the periphery. Found at the city's edge, these secluded, decentralized locations have benefited from their remoteness, allowing them to escape the incessant razing of such unappealing structures in the urban center. The terrifying nightmare in Pak Chanuk's (Park Chanwook) *Old Boy* (Oldŭ boi, 2004) is that much more unsettling precisely because O Taesu's internment takes place right in the middle of the city. Unlike *Old Boy*, Sŏnu's persecution is executed beyond the city nucleus, as he is forcibly driven out to its edge. The periphery here is a modification of Edward Dimendberg's notion of centripetal and centrifugal space that reorganizes the conventional urban core and periphery binary on equivalent terms.[19] The city's dialogical relationship to the edge in *A Bittersweet Life* designates the periphery as being outside the code's governance. The scenes of Sŏnu's torture set against the backdrop of Inch'ŏn (Incheon) and Ch'ŏngp'yŏng on the perimeter demarcate obverse extensions extrinsic to the city center. These geographically ambivalent sites are not quite within, yet not quite fully outside, the experiential city, as defined by the Seoul-centric driving culture that makes any site within a two-hour driving distance a circumstantial satellite. Temporal markers aside, these bare, inhuman spaces, archaic yet nameless, take the physical form of a fish market storehouse and an abandoned warehouse. Used as venues for Sŏnu's breaking point, they serve as antipodes to the aesthetically inclined city center embodied in the stylish La Dolce Vita. Banished to the edge, these sites conjure up traditional manual labor on the backs of which the city has been developed, in contrast to the service industry represented by the hotel where Sŏnu works. These premises appear abandoned and forsaken, as though the city no longer requires the mechanisms of such travail. In effect, their discarded state seems to imply an annotative afterthought relegating the city's past to a temporal category by and large to a remote era consigned to oblivion. However, these timeless spaces operate beyond the linear dictates of time. The gritty façade and sullied interiors of the aforementioned sites suggest extensive wearing away and impart an ageless allure. Light is a scarce commodity here, submerging the space in the sheer darkness of the netherworld into which Sŏnu has ineluctably been forced. Sinister characters that Sŏnu has been able to dismiss with relative ease within his environs inside the city limits now control this alien space and gleefully administer punishment to secure his submission. Sŏnu's impenetrable

composure, heretofore steadfastly asserted, is hence conditionally broken. Stripped of his cool demeanor, he is thrust further into the nightmarish recesses of the unknown wherein the city no longer functions contrapuntally to his being.

Transgression and the Limit: The Edges of Trauma

Film noir's insistent re-establishment of the point of reference through distinctively urban landmarks makes them intrinsic to the setting but also active accomplices to the city.[20] In the construction site scene, an extreme high angle shot gazes upward, as the awkwardly positioned camera converges upon yet another skyscraper in the process of being built. It anticipates the trauma to come and simultaneously alludes to the crumbling relationship that has somehow gone awry between Sŏnu and the city. It is here that his clashing encounters with the city escalate, for he has faltered in his failure to uphold the code. An establishing shot shows one of the unfinished floors in which an inscrutable figure emerges at the far end. The camera cuts away to show a pair of sneakers and tilts up the body. It then cuts back to give a full-length point of view shot of a nondescript figure informally attired, as a subordinate from the hotel nervously waits. Disguised as an ordinary guy off the street, Sŏnu looks unrecognizable in a baseball cap and casual outfit. Mingi promptly hands him a shopping bag, presumably containing a new suit requested by Sŏnu. The first thing Sŏnu does after fleeing his captors is not requisitioning provisions, securing weaponry, or mobilizing henchmen for that matter: it is to get back his look, which is essential to his process of getting out of his predicament. His physical escape is not enough, for he must also reclaim his sartorial identity that is sine qua non of reentering the city. He too will push Kang to the very limit that has been forced upon him, but he will do it in style.

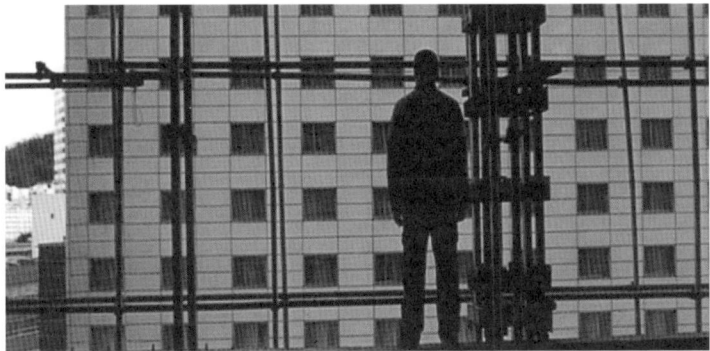

Fig. 6.5 *A Bittersweet Life*

Once his look and identity are recovered, his vitriol is unleashed, for the battle has begun. It is here surveying the cityscape below that he embraces his fate, a pivotal tide in which Sŏnu resolves to go to the point of no return. The camera positions itself behind Sŏnu, looking over his shoulder as he stares down at the hotel and its proprietor, Kang. The scene concludes with a full-length shot of Sŏnu framed by girders, making him appear as if he is suspended in mid-air against the backdrop of the city, as he contemplates revenge but also the fate that awaits him. This is a far cry from the chic surroundings of La Dolce Vita, the sanctuary where he is shielded from the cityscape outside and where the urban panorama remains elusive. In La Dolce Vita, Sŏnu's self-contained world looks down upon the city below, with the skyline awash in a painterly nighttime glow. In scenes set in the sky lounge, the cityscape recedes in the background, as if it were a fabricated backdrop rather than a transparent view of city life from the window in all of its vitality and vicissitudes. As in the driving scenes, there is a rigid division separating the inside and outside. From the lofty position within, the city's daily trials and tribulations are hardly discernible, which is corroborated by the conspicuous lack of diegetic sound referencing its sonic identity in the form of urban din throughout the film. There are several shots of Sŏnu standing by the window in La Dolce Vita in a state of ambivalent looking in which he "looks" at the nightscape of the city but concomitantly at his own reflection that is juxtaposed against its skyline, yet seeming to be merged together. This reflexivity seems to suggest an apparent self-referentiality that inherently locks Sŏnu's fate with the city itself, rather than support an unequal "specular exchange" that alienates urban denizens, as he is overlaid with the cityscape in these moments.[21] In the construction site scene, however, the windowed view has been dislodged, as it makes a stark shift from the city as seen through a glass divide, whether through an automobile windshield or the La Dolce Vita windows dominating the cityscape. Here, the windowed or screened view has been exchanged for a directly experienced, un-windowed one, exposing Sŏnu to the elements. Divested of his suited uniform and the lavish backdrop of La Dolce Vita, Sŏnu overlooks the abyss atop an edifice in the process of being built, as he finds himself on the verge glaring nakedly down the path of no return. In effect, he is stripped bare, standing on the skeletal framework of a skyscraper, the very essence of a city. The broader ramifications of the inner/outer dichotomy extend to the city itself. Whereas the city is saturated in sumptuous style, preoccupied with its temporal present and its look without regard to the historical trauma of its own development, the underpinnings of its continual reconstruction have been made invisible within its borders, transposed to the perimeter to be vitiated. This scene marks the collapse of the inside/outside divide heretofore firmly enforced by the window

filtering out the actual city. The cover granted by the windowed screen has now dissipated; the inner sanctum is no more.

Sŏnu's journey is a solitary one, which is unequivocally confirmed in the aforementioned scene. In this film, the question is not about saving others but rather saving himself, as Sŏnu undergoes a tortuous process of betrayal and its subsequent pursuit of the answer to his heartfelt question: "Why? Why did you do that to me?" The fact that Hŭisu is still alive divulges to Kang that Sŏnu has crossed (whether inadvertently or otherwise) the threshold of indiscretion, signifying a breach in code. The cause of his rapid descent removing him to the very fringes of the city is nevertheless a puzzle for him. What brings him to this point at the construction site? Sŏnu's path to the brink of this precipice is instigated by a transgressive moment that unfolds in an earlier scene. With Hŭisu's wish not to eat alone satisfied, Sŏnu walks her to the recording studio and accepts her casual invitation to step inside the booth to watch her performance. The lyrical strain of Yuki Kuramoto being played by Hŭisu's chamber ensemble wafts into the screen space, as the camera takes its place behind Sŏnu.

The recording session scene presents another transparent partition, as once again Sŏnu finds himself on the other side of a glass screen. However, this time the windowed screen does not impede him from experiencing whatever is occurring on the other side. In effect, this scene elucidates Sŏnu's confrontation with the limit and evidently leads to a violation of his code, which prioritizes upholding the façade. Michel Foucault talks about transgression in terms of its dialectical relationship to the limit, ultimately giving rise to the "flash of its passage."[22] However, Sŏnu's tragedy is not simply the traversal act of crossing the un-crossable but that he does not remember this moment as a transgression at all. He inadvertently oversteps the threshold of his sacrosanct code and in so doing experiences the "flash" as trauma, which immediately dissolves into an amnesic moment as soon as it happens. A point-of-view shot focused on Hŭisu playing her cello is followed by a jump cut in which the camera takes a withdrawn position behind Sŏnu, rather than revealing his response and intruding upon the moment. Signaling the "flash" of passage, the camera zooms in and stops for a prolonged shot, fixed on his back, followed by a flashback of the willow tree prologue. The sequence ends with a jump cut showing Sŏnu walking outside the recording studio, taking a phone call alerting him to return to the hotel.

In effect, nothing seems to have happened. Yet Sŏnu has plunged into the vortex, for trauma's all-encompassing power is not confined to its repeated return to haunt indiscriminately and at will, as forgetting is a prime component.[23] Sŏnu does not grasp what has come to pass, for the moment is mislaid, with the instant vanishing immediately into the void. As soon as Sŏnu crosses the limit,

he is seen retreating back to his place, which leads to his undoing and forfeiture of his standing in the city, as he has come to understand it. This unknowability ultimately propels Sŏnu to exact his revenge to the very end. In the impending moments before the final showdown with Kang, there is still no realization, much less recollection, of what happened, as he poignantly asks himself in the mirror: "Why did it comes to this?" The transgressive act in the recording studio scene, which Sŏnu experiences as trauma, causes him to lose his footing and catapults him to the utmost extremity from his sartorially composed earlier self. This sets off the impetus for his descent, which consequently incites him to look anew at the city in its multi-layered fullness with unwavering determination to discover a world that he did not know.

Trauma's inherent latency unveils itself with potent lucidity at the end of the film, when the transgressive moment is disclosed through a sequence of rearticulated shots, as Sŏnu's dénouement crystallizes at last. After Sŏnu has done away with Kang and his other rivals, an unexpected breeze blows through La Dolce Vita, now lying in ruins. He musters his final breath to call Hŭisu, though his efforts are in vain. The sound of her voice thrusts him into another world — his inner world — dominated by the loud echo of his breathing and slow motion of his movements. He looks up and a point-of-view shot shows falling leaves followed by a flashback of Hŭisu, which forces a grim realization: "This is too cruel." Non-diegetic sound in the form of Yuki Kuramoto launches a flashback sequence of the recording session scene. The shot is rearticulated with the camera now facing Sŏnu, whose reaction to the experience is registered at long last. He takes pleasure in the music, eyes compelled to close, while the camera proceeds to show him relishing the visage before him. This blissful moment also entails an exchange of looks between Sŏnu and Hŭisu now finally recalled. The memory is ultimately retrieved as a delayed response, the cruelty of which is not that the memory is negated but that it is experienced after the event as repetition, for trauma haunts in its literality. Sŏnu's despondent utterance expressing the cruel nature of belated remembrance ("this is too cruel") underscores the damaging effect of indiscriminate memory that represses the moment of affect and arrives too late. Trauma reduces the instant to forgetfulness against Sŏnu's straitlaced sensibility, causing its dislocation so that it seems not to have taken place. Its penultimate cruelty is unfurled, as it imposes this memory that further taunts him with its futility.

A Bitter/Sweet Conclusion

A bastion of detachment navigating his world through punctilious routine at the start of the film, Sŏnu is conscripted to violate the code, as Hŭisu disrupts

this equanimity. Although she is the precipitating agent, Hŭisu strays from the archetypal femme fatale, exuding little of the powerful aura for which femmes fatales are known. Instead, she is defined by her very unremarkability, for she is not the axis on which this film pivots. Hence the very idea of her is simply enough to act as a catalyst triggering the transgression. If the femme fatale functions as a source of outright anxiety in film noir, here it postulates a fantasy of solitude that offers a glimmer of possibility beyond the bounds of the code. The critical moment has to do with a gesture of looking that is hardly innocuous, entailing a transgressive moment. What is more, Hŭisu serves as the key that opens the door to the realm of passion, which Niklas Luhmann describes as the state of becoming "subjected to something, something unalterable and for which one cannot be held accountable."[24] Indeed, the rearticulated shot captures Sŏnu's moment of subjection, moved to the point of unwittingly producing an uncharacteristic smile for the first time in the film. Here, passion becomes an individual matter, not to be sublimated for the narrative of nation that lingers over South Korean consciousness.

Sŏnu's moment of epiphanic remembering is devastatingly transient, however, for it is abruptly curtailed when his dream world jarringly implodes at the sound of a gunshot. Trauma's latent literality, fortified by its paradoxical stipulation of innate forgetting that nonetheless enables it to be experienced at all, inevitably comes back to torment its victim at the most inopportune time and place. Although fatalism may be an indispensable condition of film noir, is Sŏnu's fate necessarily a bad thing? To this end, the framing of *A Bittersweet Life* should be noted. Sŏnu's voiceovers circumscribe the film's beginning and end, with the former accompanying a prologue of a willow tree shot in black and white and the latter preceding the epilogue. The first is a metaphysical question: a disciple asks, "Are the branches moving or are they being blown by the wind?" To which the master answers: "That which moves is neither the wind nor the branch but your heart (maŭm)," an answer that avers the power of affect that moves even the seemingly unmovable. The experience of being touched is evidently what makes us human, drawing us a step closer to this moment of profundity. The second voiceover has to do with a dream:

> One late autumn night, the disciple woke up crying. Finding this odd, the master asked him, "Did you have a nightmare?" "No." "Did you have a sad dream?" "No, I had a sweet dream." "Then why are you crying so sadly?" The disciple answered quietly while wiping away his tears, "It's because the dream I had cannot come true."

While for all intents and purposes a city film, *A Bittersweet Life* nonetheless establishes its provenance in nature, which also circumscribes Sŏnu's journey.

As Sŏnu's voiceover plays, the camera spirals upward over his body, providing an overhead shot. His eyes stay open to see the leaves fluttering down, but what should be underscored is his expression. A subtle smile materializes uncannily over his face, as Sŏnu is able to get a taste of the sweet dream before he expires. Although the voiceover has to do with what is unattainable and deferred, Sŏnu's presumed downfall nonetheless affirms the "sweet" dream and its viability, even if it means that it cannot fully come to pass. To have the dream and to realize that such a dream exists is coterminous to being moved. For Sŏnu, being affected is a sublime act in itself, which Maurice Blanchot calls "the gift."[25] Sŏnu ultimately faces his dream in equivocal terms, as "what might be" quickly resolves into "what might have been." Yet trauma *gives* him affect and potentiality, beckoning him to abandonment. His apostate descent *is* his saving grace for, however ephemeral, it proffers him a glimpse of indulgence of what could be in this city of protean possibilities: the nightmare that is tantamount to a reverie.

In this gun-filled fantasy for a non-gun metropolis, a solitary figure embarks on a quest juxtaposed against the city. Not simply a repository of illusion and façade, the city constantly confronts, transcends, and reinvents the edge, while pausing for introspection. A recurring shot shows Sŏnu's reflection on the window overlooking the cityscape, his image embossed onto this view. This motif crops up again in the final confrontation with Kang, when Sŏnu catches sight of the window behind his adversary, as he takes aim to pull the trigger. Is Sŏnu looking at himself or out into the nightscape? The look of surety cast through the window overseeing the city proffers Sŏnu a vantage point from the metropolitan vertex, but it doubtless becomes shifted. This ambivalence conjoins him with the city, as the contiguity, which may at once precipitate diffusion, ultimately posits the hero against the murky urban landscape.

Fig. 6.6 *A Bittersweet Life*

7

Technology and (Chinese) Ethnicity

*Darrell William Davis**

It is striking how Chinatown pervades imagining of the future. Asia-Pacific figurations, notably expatriate Chinese enclaves, are pronounced in popular images of urban settings, especially when dystopic. *Children of Men* (2006) renders a future London choked with snarling rickshaws, immigrants, traffic jams, and insurgents. This is a world of overcrowding, decay, and abrupt violence. Illegal immigrants are called "fugees" (refugees), though faces onscreen are so often Asian, that we might hear "Fuji," the mountain sacred to the Japanese. A wellspring of Asian-inflected futurism is Ridley Scott's *Blade Runner* (1982), adapted from Philip K. Dick's *Do Androids Dream of Electric Sheep?* (1968) and endlessly pilfered. "Since *Blade Runner*'s release, its techno-noir has been replayed in countless films, computer games, novels and other cultural objects," writes Lev Manovich.[1] Philip K. Dick, Ridley Scott, J. G. Ballard, William Gibson, Neil Stephenson, *The Matrix* films, Otomo Katsuhiro (*Akira*), Iwai Shunji (*Swallowtail*; *All About Lily Chou Chou*), and Oshii Mamoru (*Ghost in the Shell*) are examples that conjure many myths of Chinatown. Tropes of inscrutability, superstition, enigmatic codes, and dissipation underwrite layers of condensed, collaged mediation. Imaginary Chinatown spaces are appropriated to model claustrophobic hyper-realities. This involves colonial thinking, with authorities trying to "manage" rising immigration from outside (yellow peril), as well as projections of "escape," dreams of settlement into future, final frontiers. How do these tropes carry fantasies of global migration, multiculturalism, high-density

* Paper originally drafted for the conference "Technoscience, Material Culture, and Everyday Life," Chinese University of Hong Kong, March 27–29, 2003.

habitats and hives of displacement, alienation? Analysis of relevant texts would examine signage, Chinese ideograms, and perhaps their appropriation by such Western theorists as Sergei Eisenstein, Bertolt Brecht, and Roland Barthes.[2] The niceties of *guanxi*, *feng shui*, histories of opium and vice trade, varieties of overseas *tongs*, triads, martial arts and benevolence associations, with their competing dialects, politics, cuisines, and patron saints — all constitute vivid microcosms of ethnic display and articulation. We could trace such elements within popular stories, comics, and films, circulating within Asia as well as the West. But rarely are these primary, a subject, rather than stock backgrounds through which jaded white heroes gather clues and chase villains. In the science fiction novel *Snow Crash* (1992), Neil Stephenson cheekily presents Hiro Protagonist, a half-Korean super-hacker with a gift for Japanese swordsmanship. This character, with teenage sidekick YT ("whitey"), roams a world of ethnically organized "burbclaves," franchised gated communities, but spends most of his time manipulating information in the virtual Metaverse, an extrapolation of our Internet. *Snow Crash* is ingenious, vertiginous and wacky as Hollywood science fiction à la *Brazil* (1985), *Max Headroom* (1987), and *The Fifth Element* (1997).

Still, why is this techno-Chinatown imagery so extraordinarily persistent? Verisimilitude, perhaps: highly condensed layering, the abrasive striations of economic and cultural congestion in many contemporary cities. This sedimenting process will continue and intensify, despite the rise of terror-related paranoia, xenophobia, and segregation. Asian diasporas' experience of settlement in often hostile surroundings lends compelling, persistent models of multicultural survival and secular co-existence. As signs of Asian mobility, migration, and habitation, fictional worlds still evoke the seedy, confined lanes of "Chinatown," signifying varieties of unbridled technological hypermodernity. Using two animated films, my essay offers reflections on these models and signs, and theorizes contemporary ethnicities related to Chinatown. It proceeds by means of information technology, links with folklore, and finally a figure of premodern automata in Asia, the "karakuri." All these help visualize ethnic relations in tandem with historical and technological movements. This is why my title is doubly marked: bracketing Chinese, acknowledging techno-ethnicities' contingency (alternatives, such as Jewish, Hispanic, or African American). Yet it also signals the strong pull of technologized East Asia. As noted in this volume's introduction, we find here forces that are alternately charismatic and repellent.

Hollywood and pulp science fiction are not the only places where we find Chinatown. In Japanese anime, there are well-known cyberpunk stories such as *Ghost in the Shell* employing spirit imagery as premonition of future states. Oshii Mamoru's animated films *Ghost in the Shell* (1995) and sequel *Innocence* (2004) raise issues pertinent to my theme of technology and Chinese ethnicity. The first

is the reversible interface of subject and mediatized surroundings; the second concerns re-mediation, or the relations between old and new media along the winding march of progress. In Oshii's animations, a post-photographic world is dress rehearsal for ethnic transmutations. Ethnicity, like gender, body, and space itself, is exchangeable, fundamentally refigured in new media forms. But these forms may be archaic. Chinatown feels familiar in these animated environments, yet it pushes toward defamiliarized, alien, life-like zones of informational identity. Prompted by Oshii's animation, we can rethink ethnicity as remediated or produced through technology, rather than reproduced from profilmic origins.

Animated Characters, Environments Personified

Ghost in the Shell uncannily visualizes a virtual humanity performing both individual and collective roles. The film, based on Shirow Masamune's 1991 manga *Kokaku Kidotai* (Kodansha), clearly inscribes Asian reorientations via technology.

Oshii's contribution to the Sinicization of science fiction is its marriage of Asian superstition with urban cyberculture. These are clearly inscribed in Oshii's films. The title, ghost in a shell, is significant. What is a g/host but a spirit without a body to inhabit (tagline for the DVD release: "It found a voice; now it needs a body")? Ghosts are beings who have lost their host. "G/host" is residue, a mournful leftover after the body has given up its energy or animating spirit. Ghostliness is a post-corporeal state of being. But post-corporeal may have anthropological, techno-scientific sides. Enter Major Kusanagi, a cyborg whose subjectivity is an effect of (digital) discourse. Most commentaries explore Kusanagi's cyborg hybridity, the corporeal "cybernetic organism" that intertwines machine and woman. But she is also coterminous with the domain she inhabits, a trope graphically illustrated by the thermoptic camouflage sequence in the beginning. While staged like a conventional assassination — Kusanagi's bloody assault on corrupt ministers signaled only by a flutter at the window — it also represents the dissolution of individual being into an informational environment. This enables her invisibility to the officials and their heavily armed guards.[3]

Here a given environment comes alive, working as a sentient being, and bearing meanings usually disclosed by characters. It is a post-industrial urban correlative, taking many functions normally performed by human actors: motivation, event, action, drama ... story itself. In an animated feature, this environmental sentience is particularly marked, descended from early experimental animations of Max Fleischer and Disney. Sergei Eisenstein calls

this plasmaticity a form of omnipotence, ecstasy, and pure sensation beyond representation.[4] Agents acting in dramatic situations are ontologically identical with *mise-en-scène*; they are formed and melded into settings and objects surrounding them. Whereas cinematography reproduces distinctions between live performers and inanimate setting, animated figure and ground are identical stuff: graphic materials, forms, color, movement, and programs with matching provenance. There is material continuity between animated figures and ground, hinting at why Japanese animators often employ 2D characters on 3D computer-generated imagery (CGI). Japanese artist Murakami Haruki calls this continuity "superflat," a characteristic of Japanese graphic design.[5] Superflat graphics are found not only in anime and manga, but in advertising, interior design, fine arts, architecture, and typography. Notions of superflat entail smooth, even distribution of elements over a field, rather than centered, hierarchical organization around a principal hero or protagonist. Murakami's superflat principle is "the merging of distinct layers, as might be seen for example on a desktop computer screen. Rather than the resolution of these different layers, the idea is to maintain a sense of difference, or different layers of identity, but with all of these different layers coexisting on the same plane (as in the computer screen)."[6]

At the extreme, superflat graphics entail invisibility, with pictorial elements spread so evenly as to be indistinguishable. *Ghost in the Shell* presents seamless correlation, a match-on-action between physical environment, IT, and post-human agency. Kusanagi is both character and stock, intermittently rounded and flat. A cyborg experiencing existential crisis is an anomaly, oxymoronic to be sure, violating rules, conventions, and expectations. But it permits reversibility, fusing self-consciousness with inanimate object-hood. Kusanagi's personal ambience interchanges with her surroundings, her thoughts produced and punctured by the digital domain. And since visualization of this intermediation is animated, not photographic, it embodies a spectacular hybrid of cel drawings, digital compositing, and CGI.

Following the logic of "ontogeny recaps phylogeny," could we also map human consciousness itself as ghostly — anticipated obsolescence — with relentless advances to the next evolutionary stage? The discarding of human containment, or shell, happens either through collective identity or technology impersonating humans — robotics, which is the premise of *Ghost in the Shell*, *Blade Runner*, *Metropolis*, and many other science fiction stories. Ghostly "residue" is not just an entity orphaned or left behind but can be a premonition of possible futures. Following a cyber-cultural line, we could apprehend the ghost as pre-condition (not echo for the departed) for movement into new realms and unexpected evolutionary forms. The opening statement of the film: "In

the near future (2029), corporate networks reach out to the stars, electrons and light flow throughout the universe. The advance of computerization, however, has not yet wiped out nation and ethnic groups...." The future tense in these expository credits implicitly predicts: "computerization has not yet ...," as if these anachronisms are ghosts that refuse to disappear, haunting an otherwise rational universe.

Information City, Hong Kong

"You are a different species," I told him.
"We mutated," he corrected.
Peter Carey's exchange with his twelve-year-old son takes place in today's Tokyo, en route to Akihabara, Electric Town.[7] It encapsulates some of the themes in this chapter.

Ghost in the Shell is "a vision of the future that lies just beyond the landscape of reality."[8] Director Oshii Mamoru identified a specific source for his setting, the cityscape of Hong Kong. For Oshii, Hong Kong is a solution to the problem of visualizing a landscape of information, or infoscape, not only a generic future hypermodernity. For Oshii, there is also regional displacement: Hong Kong (not Tokyo or Osaka) is functionally equivalent to the "Shanghaied" city of angels in *Blade Runner*. In the mid-1990s, Hong Kong starred in the media dramas leading up to its historic 1997 handover, terrified of absorption into China. In the 1980s, it was Japan, with its runaway economic success and threats to the West. There are parallels between urban anxieties of *Ghost in the Shell* and *Blade Runner*; the former reflects and employs Hong Kong, while the latter evokes Tokyo to depict post-industrial disarray. This permits some historical differentiation based on contemporary anxieties around production contexts.[9]

Further, both are world cities; they co-opt nation as primary entity or political function, and cities have become so international they are micro-nations, virtually city-states. A scene in Spike Lee's *Inside Man* illustrates: cops amplify a recording of an obscure East European language into a New York crowd, knowing someone is bound to identify it and help expose their suspect. Cities might condense the national into the urban, but a further process collapses urban into neighborhood, with intricate tangles of post-national agglomerations. Just as cities now stand in for multinational relations, Chinatown — a gritty, convoluted cauldron of secrets — stands proxy for cities overall. *Innocence*, as we will see, uses many other urban architectural motifs, extending far back into religion, the occult and folk practices. Thus, Hong Kong animates an advanced technological future, a regionally condensed infoscape, urban hyperagglomeration, and a mystical throwback.

Blade Runner details human congress with genetically synthesized replicants, and the difficulty of telling them apart, the misrecognition of copy for human. Ultimately, the hero disregards his lover's synthetic identity, the latest generation model that makes "skin-jobs" obsolete, as so many husks or snake-skins. Rachel is so advanced, she not only replaces Zhora, Pris, and Roy, she dispatches Leon, and comes equipped with memory, self-consciousness, and a faith that she is really human. This trust and vulnerability eventually reach Deckard, who makes a fateful choice. Stephen Mulhall writes, "He can either transform subjects into what replicants are thought to be, simulacra of humanity; or he can actualize and preserve their subjectivity, as Deckard learns to do with Rachel."[10] Mulhall also identifies Deckard, with his Voight-Kampff machine and video analysis, with the filmmaker.

Blade Runner explores the theme of technology's replication of interiority, memory, and desire, not just external appearances. *Ghost in the Shell* goes further, extending that with a cyborg's synthesis with an oceanic digital environment. That environment is emphatically Chinese, specifically modeled on Hong Kong. Why Hong Kong? What is it about that place that signifies the complexity of an infinite infoscape?

Information as "Ethnic" Analogy

Hong Kong forms a perfect background for *Ghost in the Shell* for two reasons. Oshii evokes the informational city, stating that his basic theme is the power and influence of computers, and convinced this would be conveyed best in animated narrative; but the Hong Kong setting is key because its signs are externalized, so insistently visible and real, even if — especially if — illegible to newcomers. Therefore, in Hong Kong information is both patent and latent, foregrounding information as architectural form.

1) Visualizing information in a physical setting, "since the information network isn't visible," Oshii says: so how to visually represent it?
2) Hong Kong teems with information, even in imagination. Hong Kong is fixed to its ideographic neon, high-rises, and harbor. There is an arresting juxtaposition in the spectacle of giant Chinese characters, cluttering the night sky and overpowering our senses. Go there, says Oshii, and you are inundated with signage, hoardings, roaring transport, a cacophony of voices and flowing noises. "When I went to Hong Kong I felt that it would provide the perfect setting for the subject and period of the story" (special features, Manga Video).

For *Ghost in the Shell*, locale is not only crucial; it is dominant. Oshii privileges setting and mood over story itself, saying that once he had found the right

city "the actual story didn't matter," in his words. If it "[doesn't] matter," then what replaces it? What does matter? Simply, the cyborg protagonist Kusanagi exchanges with her setting, the ghost skipping her shell and dissolving into a plasmatic, iconographic environment. It is a figure-ground reversal, in other words, though the film's climax presents it as a quasi-sexual union between two avatars, or para-human containers for data processing. Most writing on this film concentrates on the wild transformations of the feminized cyborg body, and how digital information becomes a surrogate for organic identity.[11]

But there is more, involving collective identities; that is, invocations of race, nation, and ethnicity. Bodies have color and constitution as well as sex and sexuality, and these in turn are filiated with race, culture, and citizenship no less than sex and gender.

Again, note the specifically Chinese matrix of this environment, and furthermore, that this is not untypical of science fiction renditions of high-tech futures, in all sorts of popular forms. A technologized, residual Orientalism is at work; when Kusanagi enters a digital abyss coded as Chinese, this signals something more than Oshii's attraction to the flashing neon of Hong Kong. Contemporary Asian societies and audiences are also susceptible to tropics of techno-Orientalism in their cultural products. In the Japanese-language version, when Kusanagi replies to the complaint that "there's static in your brain," she says, "it's that time of the month." This differs from the English-language excuse, "I have a loose wire," a more literal reduction of communication glitch to mechanical, not hormonal failure. Oshii's film is not unique in its feminization of cyborg transmutation and disembodiment. Perhaps there is unacknowledged affinity in Oshii's assimilation of Hong Kong's informational plenitude to the ancient canals of Venice, the skyscrapers of Shinjuku, and the sexualized figure of Major Kusanagi.[12]

Which raises the question, if science fiction genres repeatedly return to tropes of "Chinatown" to stand for technologized forms of agency that are (at present) ineffable, then what role does technology play on actual streets and marketplaces of Hong Kong? Can we venture, à la *Ghost in the Shell*, a syllogism that proposes a relation or analogy between Information Technology (IT) and Iconographic Ethnicity (IE, i.e., Chinese cultural formations)?

1. IT is profoundly complex, but essentially logical, coded, and therefore knowable.
2. IE is profoundly complex, but also logical, coded, and thus knowable.
3. IT is not easily visualizable (as Oshii says) but IEs are, through archives, symbolic structures, real landscapes, and built environments.
4. IEs, like those of urban China, provide a conceptual/visual grid for mapping new forms of IT.

Discourses about new technologies work, then, by appeal to the strange and the familiar; self and other; old and new; present, past, and future. Tropes of Chinatown neatly condense exoticism, the occult, inscrutability, and dissipation (the strange) with antiquity, logic, knowledge, and power (the familiar). The *idea* of Chinatown enfolds everyday community within continuities of profound strangeness. Seemingly odd or ineffable practices like fortune-telling, calligraphy, or Chinese medicine are mundane on the streets of Chinatown. But they are systematic, pragmatic, routine. Such condensations of the esoteric and everyday are useful for visualizing technologies of knowing and being.

We have been considering narrative discourse, in forms of character and popular storytelling; now, we turn to more basic folkloric evocations from the sequel to *Ghost in the Shell*, *Innocence* (2004).

IT to IE: Visualizing Cities as Information-in-Depth

Cities are important not only as places to live and work, but also as systems that organize and move information. They contain — and are — files and archives, amalgamations of everyday and esoteric items, embodiment of technocratic modes of being and knowing. "In the thousands of years of cities, the borders between human and tool and the very idea of machine-as-complex-system have been carefully explored, usually in religion, art, and magic," writes Chris Hables Gray in a chapter called "Slouching toward the Posthuman."[13] This idea is vividly presented in a brief sequence from *Innocence*.

Midway through is an interlude wherein the heroes are flown to a future ethnic ecology, a frontier of unregulated capital growth called Locus Solus. The segment suggests a form of conversion, where it is not just people, but representational systems, too, that are "born again." Locus Solus is outlined as a limit-case in the virtual interpenetration of city and information, straining at the boundaries of urban surfaces. Repentance, recanting, transformation, and metamorphosis are underlying themes; or (more simply) a sex change, from organic forms to artificial reconstructions, from thesis, antithesis, synthesis, and finally, prosthesis in the epistemology of the cyborg.[14]

We find here a captivating ethnographic dimension: databanks structured as architectural form. In the deep expanse, a ruined cathedral recalls a Notre Dame, flocks of crying birds wheel across the sky, a Taoist procession is followed by a weird, fascist bonfire on which doll parts slowly burn, followed by a clockwork fun house, which is a more conventional structure for setups and dissimulation (cf. *Lady from Shanghai*, and Bruce Lee's *Enter the Dragon*). Simulations pile up, as location turns itself into apparently endless permutation, duplicity, and reproduction. Though the scene begins as a search, it soon becomes a sort of

feedback loop, with unexpected objects or portals that reset back to earlier points.[15]

In this sequence there is prosthetic, simulated inter-mediation, i.e., media comparisons used as thematic material. Figure and ground jockey for prominence, as 2D characters quote the Psalms and Milton, and animated simulations elbow each other out of the picture. Ethnicity is reformatted within an informational model, literally animating Manuel Castells's idea of the "Informational City."[16] Any informational ethnicity, what might be named ethnic ecologies, is intentional, unlike automatic functions of our corporeal bodies. These ecologies are not just frames or containers, but convey "social relations, which give to space ... a form, a function, a social signification," in Castells's phrase.[17] In *Innocence*, the characters use decoys and avatars as masks, trying to trap, outwit, and outrun antagonists. Pseudo-deep focus rendering of virtual environments is negotiated by flat, cut-out figures creating dimensional contrasts and tension; these background environments allude to real profilmic objects that in movie production are known as sets. Here, sets appear less as background, as a vast array of almost tactile spaces, full of volumetric detail all but impossible in cinematography. A comment by animation director T. Nishikubo is revealing: for *Ghost in the Shell* "we aimed to create animation that is more real than life."[18] In "Remapping Taipei," Jameson calls this media one-upmanship the "Hansen-Bordwell hypothesis," the stage on which cinema's ontological primacy is demonstrated — but actually rigged. Superceding earlier representational forms, like the novel, journalism, photography, television, cinema plays a competitive, if mischievous game.[19] Only here, in advanced animated worlds, cinema is the medium overtaken. This is why seventeenth- and eighteenth-century automata and dolls are employed to model twenty-first-century informational architectures, by way of cathedrals and folk iconography of centuries past.

If cinema recycles, replaces, or transcends photography then what comes after cinema? Animation, perhaps but a form that overtakes cinematography in its detail, indexicality, and even chance, in that environment responds to character agency. The space of Locus Solus is cosmopolitan and primitive, a mélange of styles and periods and gaudy religious ethnography — Taoist, Hindu, commercial neon flickering alongside ritual fires. The sumptuous visual design is illustrative, nostalgic, and prophetic all at once. "Sometimes there is far too much information on the screen to take in at a single glance," writes Mark Schilling.[20] Kenji Kawai's music is haunting, derived from Hungarian chorales and taiko drum performance. Here, animation is presented in full post-photographic display, with ethnicity prominently figured as a future of ritual, folk religion, and quasi-fascist ecstasy. There is parallelism and comparative

mediatization here, as well as historical salvage: appropriating, drawing on, and rearranging iconographies of the past. "In what ways does the endless capacity for representation [in cyberspace] invoke the need for older cartographies of territorialization that crucially depend on histories of marking to make visible an invisible expanse?" asks Rajani Sudan.[21]

Innocence suggests needs and obsession with various cognitive and emotional bonding, whatever the being (human, animal, synthetic): discrimination between self and other, crossed with identification with others, as prop, puppet, pet, or doll — all beloved objects holding some vestigial enchantment. We see then a delineation of mega-cities, and futures built on superstitious rituals of ancient memory banks. In this regard, an animated vision of the future reprises and even covets the past, in all its irrational rapture.

The landing in Locus Solus gives way to the corporate headquarters that designs the flawed "gynoids" (pleasure dolls). In the gothic funhouse-cum-headquarters, the detectives find a powerful hacker called Kim, speaking through a decrepit old man on life support. Kim leads them on and manages to possess Togusa, the more human of the two, through the attentions of a tiny automaton, a *karakuri* or wind-up serving doll. What begins as Kim's interrogation quickly spirals into an interactive game, an illusion perpetually feeding back and restarting at the company gate. Players include the cyborg Bateau, the modified human Togusa, a Korean hacker who nearly passes for dead, and the clattering *karakuri*. The imagery is HD video game, and the players convene a little gathering of ethnic and cyborg types. Boundaries between human and inanimate objects, mechanical toys, animals, and even a corpse are confounded, with every detail, every object an entity potentially sentient and active in the pursuit of a high stakes game.

Illusion(s) of hierarchical biology are here, in an ascending scale of being-as-becoming. Are humans superior to animals? Do animals take priority over robots? Do robots outrank dolls, just because they move? These questions are posed as challenges to organic embodiment, with spirit-like Kusanagi (protagonist of the first film) inhabiting the body of a gynoid, the sex doll. This responds to the hacker Kim's choice of a "neomort," or human on machine support, to execute his programs. Is the issue organic versus inanimate? Must the latter always defer to living things? What counts as living and non-living depends entirely on the uses to which they are put. And in this world, the uses of magic or religion are indistinguishable from those of data processing, simulation, and technoscience (cf. Eisenstein on animation's "omnipotence"). The issue of anthropocentrism and biological hierarchies yields to strategies of passing and recognition, because foes are more formidable if they appear inanimate or mute. Likewise, consciousness, emotion, and desire are available to

beings made of algorithms and silicon, rather than flesh and blood. Interacting with machines may be indistinguishable from human relations, and science fiction is unnecessary to recognize animals and people alike reduced to objects, hollowed out for fun and profit.

As Gray notes, "Automatons have a long history, from Hero's mechanical tableaus (300 BCE) through the cock of Strasbourg (1574) and Jacques de Vaucanson's famous shitting mechanical duck (1741), to the profitable creations of Disney's imagineers today. They are all complex feats of religious engineering."[22] We must stress the links between religious and mechanical activity, because as Bazin noted, the myth of "total cinema" predated its invention by thousands of years. No matter what the new technology may be, from holography to orbiting satellites to flight itself, there are antecedents in magic, myth, and religious prophecy.

Karakuri as Proto-Cyborg (Tech-Ethnicity)

Origins of Japanese *karakuri ningyo* (wind-up doll) are in seventeenth-century Edo (Tokyo). In 1617, the Shogun's watch broke and needed repair. While trying to fix it, the craftsman became fascinated by the interaction of the watch's cogs, wheels, and springs. The complex mechanism was useful to model human and animal behavior, and inspired the design of wind-up dolls created by Japanese artisans. These so-called *karakuri* allowed the mechanizing of figures, gesture, and motion. They were especially popular as attractions on huge, illuminated floats rolling down the streets in religious festivals. "The doll becomes almost lifelike as it performs a series of complex gestures, turns, and other movements."[23]

In Japanese, an additional meaning of *karakuri* is a person who blindly follows orders, without question. It need not be inorganic; the *karakuri* is a device or tool, a bureaucratic creature and instrument of faceless command and control. In *Innocence*, there is linguistic play on *ningyo* 人形 (human form, shape, or appearance) presented as a tool for love, both sexual in the figure of gynoids-as-love puppets, and maternal in the doll clutched by Togusa's small daughter. It is interesting to contrast that with the Japanese characters for person, *ningen* 人間 that literally reads "human-interval" or "human-space." These two characters, "human form" and "human interval," anchor the films' interest in the vitality of mechanical objects; it is not the outer form of life that matters, but the recognition of life across the gap between shells and ghosts, acknowledging other life forms as means to secure our own.

Does *karakuri ningyo* become *karakuri ningen*? From doll to person is a key transition in the work of Oshii. Bateau is described in the film's promotional

titles as a "living doll" (*ikiteiru ningyo*), with the *furigana* superscript above it that reads "cyborg" (in katakana script, used for foreign loan-words). In the earlier film *Ghost in the Shell*, Bateau refers to cyborgs as celluloid dolls. The cyborg's affinity with the dolls he destroys in *Innocence* is emphasized, since they belong within the same class of being, continuous with one another. This becomes acute when his former partner, Kusanagi, chooses to inhabit the body of one of the pleasure dolls, the better to help Bateau destroy the rest, which come lurching out like a horde of murderous Raggedy Anns.

Chikamatsu Monzaemon, the eighteenth-century playwright who wrote for kabuki and the doll theater, speculated on the special vulnerability and pathos of wooden puppets. He maintained that as audiences we identify more with the artificial than with the real,[24] pointing toward the logic of the ethnic analogy. Perhaps, artificial is to "ethnic" as machines are to humans. We associate ethnicity with others (like accents), rather than our kin; ethnicity is noticed, foregrounded when we encounter those *un*like ourselves. When faced with puppets, robots, or ethnic others, we confront beings more *and* less real than everyday life and this repositions our own humanity. As ethnic enclave, Chinatown is coded as something other; it is recognizably human, bursting with noisy signs of life, but still withheld, intractable, marked off. It is neither China nor (our) town, doggedly following its own course, known only to its denizens. Thus is it useful, even essential, in visualizing technoscientific futures.

Conclusion: "Almost Lifelike"

The gap between model and origin, between doll (human form, *ningyo*) and human being, animates many things, which is compelling to the point of fascination. Christopher Bolton compares the eighteenth-century Japanese doll theater (*bunraku*) with anime and particularly *Ghost in the Shell*.[25] In Bolton's terms, *bunraku* dolls convey both freedom (floating, lightness, mobility) and vulnerability, completely "subject to the gusting winds (or heavy hand) of fate."[26] Though the *bunraku* dolls, famously analyzed by Roland Barthes, are different from both automata and anime, they share an obsession with *lifelikeness as masquerade, displacement or fetish for life itself*.[27] Lifelikeness depends crucially on lifelessness, since dolls or puppets are by definition objects. This dependence is connected to animation in its double sense of motion and emotion. There is oscillation between life and not-life, a sense of being "both more and less real than the flesh,"[28] experienced as gap and overlap, which asks — demands, even — our involvement. The dolls solicit our involvement in stages: first, a captivation with the mechanism, then sympathy with the artisan or operator, and finally, we bypass machine and technique to project empathy, investing in character and

emotion to complete the effect. This investment is more aesthetically complete than the stage, where live people play living characters in a surfeit of pretend vitality (hence Chikamatsu's remark that too much resemblance to the real elicits "disgust"). In the doll theater's dialectic between seeing and belief, distance between object and subject is reduced, and (for a moment) bridged through spectator mediation. "One stops seeing them and instead becomes absorbed in the actions of the ... figures themselves."[29]

Passing for human, despite the handicap of thing-ness, requires the understanding (not blindness) of other humans, the acceptance extended by subjects to others in kind. As mentioned, the greatest emotion governing this double articulation is captivation, the seductions of artifice, since it is spectator (not the doll, nor even the artist) that completes the process. The beholder holds the strings. The attraction of the puppets is thus one of complete dependence, helplessness, and deference. The puppet or doll *needs* our bracketing of disbelief to perform, and in our acknowledgment of need, overdetermines the crucial epistemological shift.

Fig. 7.1 *Karakuri* doll

Fig. 7.2 *Karakuri* doll

Fig. 7.3 *Karakuri* doll

Like an act of creation, playing (with) dolls absorbs, animates, and gives life (godlike); it transforms inert figures into something living, like a person, like life — but not quite. Once this alchemical oscillation happens, the object, whether doll, dog, or child, becomes now a trusted intimate, totally dependent on us and unconditionally attached. Oshii's presentation of a parallel between animation and automata is yet further over-determined, because of his own nation and ethnicity — which is productive because *karakuri* has a vital history in Japan, and Oshii knows it sufficiently to give it a role in a twenty-first-century technoscience anime. At the same time, his choice of object produces another role for him, as a Japanese craftsman-techno-magician. Oshii's Japanese position plays him, as it were, in a meta-narrative of imperialist abjection. The role of *karakuri* in Japanese history betrays the desires and fears of an island people, adrift in an oceanic cultural context, given Chinese material, linguistic, and philosophical patrimony in Japan.

In *Japan Journals* Donald Richie describes *karakuri* as:

> [A]utomata, small as a mouse, large as a child, either string-pulled or clockwork, which so delighted the Japanese then as … now. A magician three feet tall … a bald baby acolyte who holds a tray — when you put a cup of tea on it he races across the *tatami* and, after the guest has taken the cup, turns around and races back … a Chinese gentleman walking. This one I work myself by pulling ropes: as you pull he puts one foot before the other, swings his arms and turns his smiling face. All the dolls smile, their enamel faces wreathed, their black eyes wrinkled with laughter…. Simple good nature: the state of happiness. Most of the dolls are "Chinese," that being the fashion during at least this part of the Edo period. Cute things Chinese were always conceived reassuringly small by the Japanese: little boys, tiny dogs, baby "lions," etc. All in bright primary colors. A love for the infantile, imposed upon that sprawling and dangerously mature continent.[30]

Here we find historical politics of *kawaii*, played in a scene of ethnic domestication: the awesome infinitude of continental tradition, threatening to deluge the tiny, scattered home islands, drifting like birds just out to sea. What better idol to propitiate the god of language, culture, and civilization itself than a smiling, mechanical doll, miming gestures of servility?

INTERLUDE 4

In the Name of the City

Yomi Braester

Many movies include city names in their titles. The gesture of declaring an identity between the film and the city not only grounds the film but also shackles it to its location. Understanding the film, it is implied, requires intimate knowledge of the locales it describes.

A symbiosis emerges in which the film and the city market each other. The touristy pitch in films such as *Roman Holiday* (1953) has been further accentuated since the rise of branding as an advertisement strategy in the 1990s. The city itself has become a brand name, promoted by a skyline that functions as its logo. The brand-name city is recognizable by architectural landmarks of an international lifestyle — the airport, the elevated highway, the TV tower.

It is therefore apt that films such as *Home Sweet Home* (in its Chinese title, *My Home Is in Taipei*, dir. Bai Jingrui, 1970) and *Twenty-Something Taipei* (dir. Leon Dai, 2002) start with the protagonists' arrival at the airport by international flights. The city is its airport. Taipei,

Fig. iv.1 *Twenty-Something Taipei* (Leon Dai, 2002)

the film intimates already in its title and beginning sequence, is ready for the consumption of the youthful jet set.

Other films use the city name to challenge its mystique and glamor. *Beijing Bastards* (dir. Zhang Yuan, 1991) promises already in its title a city on the verge of social breakdown. The film constructs a new urban cool, that of the rock 'n' roll counterculture. *I Love Beijing* (dir. Ning Ying, 2000) deploys its title tongue in cheek. Censors have in fact detected the irony and changed the Chinese title to the insipid *The Summer Sun Is Warm*. The censors asked Ning Ying with dismay: Why does the film start with a traffic jam? Why is a military truck in the traffic? The official line cannot accommodate the daily and the random in urban life. Beijing, in this view, must be not only represented but also representative. Unless the city is reduced to a slogan, in the censors' mind the city should exist neither in the film's title nor in visual footage.

Fig. iv.2 *I Love Beijing* (Ning Ying, 2000)

PART IV
The City Is Elsewhere

8
Imaging the Globalized City: Rem Koolhaas, U-thèque, and the Pearl River Delta

*Chris Berry**

This essay examines the imaging — and the imagination — of the Globalized City. The Globalized City is not quite the same thing as the Global City, but both terms acknowledge that globalization is transforming urban life in profound ways. What is it like to live and work in urban space under the new order of globalization? How is it different from life and work in the cities of the old international order — for example, the national capital, the imperial metropolis, or the colonial entrepôt? These questions are crucial to understanding the consequences of globalization and judging its benefits and its drawbacks. When people take photographs, write essays, shoot video documentaries, and produce all manner of other texts about urban space today, their efforts contribute to answering these questions by imaging and imagining the Globalized City.

To explore this theme, this essay focuses on three texts to compare two different visions of one urban (or conurban) space that has emerged post globalization — the Pearl River Delta. The two different visions originate in global and local spaces, and belong to Rem Koolhaas and U-thèque respectively. Koolhaas is a Dutch architect and Harvard professor. The author of numerous books and designer of various iconic buildings, he is famous internationally, although perhaps less well known in China. However, even if few Chinese

* Another version of this chapter was presented as a public lecture in the School of Journalism at Fudan University in Shanghai on May 24, 2006. I would like to thank Lü Xinyu for inviting me to Fudan, Lai Yun for helping me to prepare the lecture, and all the students and faculty who attended and gave me their valuable responses.

recognize Koolhaas's name, his daring design for the new China Central Television building in Beijing is the subject of much local controversy and debate.[1] Established in 1999, U-thèque is an independent film and video collective based in Guangzhou and particularly associated with the artist-essayists-filmmakers-photographers Ou Ning and Cao Fei.[2]

Koolhaas has discussed what I am calling here the Globalized City in a famous 1995 essay called "The Generic City." In it, he celebrates the postmodern tendencies of globalization towards homogenization, erasure of history, and loss of identity bemoaned by so many others.[3] Koolhaas does not mention China directly in the essay, but he does mention Asia often. Furthermore, he has spoken in interviews in the mid-1990s about the impact of working in Southern China on his thinking.[4] In 2003, U-thèque produced a very unusual Chinese independent documentary called *San Yuan Li* after the neighborhood of Guangzhou (also known as Canton) in Southern China that it depicts.[5] In stark contrast to Koolhaas's essay, U-thèque's documentary emphasizes history and local specificity. It could be argued that Koolhaas's is the view from inside global capitalism, with its drive towards homogenization. On the other hand, U-thèque's perspective constitutes a kind of local resistance constituting the grain which globalization attempts to grind smooth in the promotion of unimpeded flows.

There is unquestionably a tension between Koolhaas and U-thèque's visions of the Globalized City. However, it would be too simple to see this as global capitalism versus local and possibly socialist resistance. This is where the third text comes in, for it reveals that Koolhaas's position may have shifted since he wrote "The Generic City" and has worked more in Southern China, and that it may have become more ambivalent than it first appears to be. *Harvard Design School Project on the City: Great Leap Forward* was edited by Koolhaas and his colleagues, and tracks the recent transformation and urbanization of the Pearl River Delta.[6] A huge tome bound in red with gold lettering on the cover, this could be called Rem Koolhaas's Big Red Book. It was published about six years after the essay on the Generic City. Although it continues many of the tendencies from the early essay and gives concrete examples of them, it is also very much bound up with the history and local specificity that the earlier essay claims the Generic City is liberating us from. Second, just as this indicates a kind of complexity and a temporal shift within the Koolhaas perspective, it would also be an injustice to reduce the position of *San Yuan Li* to a simple anti-globalization stance. This is partly because the attitude of the inhabitants towards globalization in general and the transformation of Sanyuanli in particular is never made clear; maybe they like it? It is also because the filmmakers themselves may be in Sanyuanli but are never of Sanyuanli; they are outsiders and part of the global art scene

just as surely as Koolhaas is part of the international architecture scene. In these circumstances, I will argue that we need to understand the opposition between Koolhaas and U-thèque's visions of the Globalized City as a tension produced by difference perspectives and different histories, but operating within the new world order produced by global and secular capital. Right-Left, First World–Third World, and East-West divides are nostalgic memories now. They may structure present experiences and explain how the players got here, but other forces occupy the space outside globalization today.

The Globalized City and the Generic City

Although the *San Yuan Li* documentary is an autonomous work that can be screened alone, it was designed as part of a larger ensemble called The San Yuan Li Project. This includes a Chinese and English bilingual book,[7] a website, and various other paraphernalia. The whole project was "a collaborative effort by a team of nine cameramen and women and two sound recording artists, using a total of six digital video camcorders, one digital audiotape recorder, three digital cameras, and three conventional still photography cameras."[8]

The transformation of Sanyuanli that the project investigates is recent and coincident with the transformation of Southern China following the "opening up" (*kaifang*) of the country to global investment and trade. Now a neighborhood of Guangzhou, Sanyuanli was once a village in the countryside — but not just any village. After the opening credits of the documentary, the screen goes black and we hear a Chinese opera performance. The lyrics explain that the villagers of Sanyuanli defended the nation and went off to defend the British. This is a reference to the Opium War. Class struggle dominates the official version of the story given in the People's Republic during the Maoist period. According to this perspective, the Qing Dynasty court was weak and corrupt. As a result, it did little to support the efforts of its own official, Commissioner Lin Zexu, to eradicate the opium trade. However, the local villagers of Sanyuanli, true to their peasant class origins, rose up against the invaders.[9]

Sanyuanli has now been swallowed up by the expansion of Guangzhou, and is a neighborhood near the railway station. Furthermore, Sanyuanli is also an example of the "village in the city" phenomenon that has occurred in many Chinese cities. U-thèque emphasizes this aspect of Sanyuanli in the book part of the project by including in the unnumbered opening pages a map of Guangzhou with all the former villages clearly marked. As Ou Ning writes: "… the government requisitioned the farmlands but, at the same time, preserved the rural residents' private dwelling plots and the rural residence registration system. The subsequent urban developments … completely hemmed in the

former rural settlements, making them virtually marooned islands in a forest of modern city high-rise blocks."¹⁰

When Hou Hanru refers to the village-in-the-city as "a kind of extra-territories [sic]," the question of a link between imperialist history and contemporary globalization is raised again.¹¹ Ou Ning makes this even clearer by stating, "The violent colonization over a century ago is reincarnating itself today in the new shape of global dominance and its encroachment of cultural values."¹²

The only widely known model that has emerged so far for thinking about the city and globalization is Saskia Sassen's Global City. Yet, Sassen is very clear that only a small number of cities fit this pattern, and I do not think that Sanyuanli in particular or even Guangzhou as a whole is among the select few. In fact, Sassen's work is itself a corrective to some early ideas about globalization. She notes that many believed the tearing down of trade barriers associated with globalization results in finance and investment becoming fully mobile. However, she writes that, "The widely accepted notion that density and agglomeration will become obsolete because global telecommunications advances allow for maximum population and resource dispersal is poorly conceived. It is, I argue, precisely because of the territorial dispersal facilitated by telecommunications that agglomeration of certain centralizing activities has sharply increased."¹³

The very particular characteristics of Sanyuanli and the "village in the city" confirm Sassen's challenge to the idea of a completely "smooth" and undifferentiated environment offering no local differentiation or resistance to global flows. However, Sassen's Global Cities are the hub cities on the network of globalization. They are distinct from the imperial metropolis, the national capital, and so on. Each of these earlier urban forms stands at the central point and all else comes below it in a hierarchy. But as part of a network of other Global Cities, each Global City is becoming less connected to the areas around it as it becomes more connected to the rest of the network.

The idea of the Global City has been very important in making us think about the impact of globalization on forms of urbanization, but it does not account for other urban forms resulting from globalization, such as Sanyuanli. The Global City is one of the cities that make globalization happen, an engine house or site of collective agency. Looking at a space like Sanyuanli, I would argue that the idea of the Global City needs to be complemented by the Globalized City. This is the city globalization happens to, rather than the agent of globalization. It does not globalize as much as it is globalized. Another way of saying it would be "the city under the order of globalization." At this point, this idea can only be advanced as a suggestion, because it is certainly not based on the careful and

detailed research and elaboration associated with the Global City over the last decade and a half. Furthermore, becoming a Global City is a prize, but being a Globalized City is an altogether more ambivalent phenomenon.

However, we can note certain characteristics of the Globalized City. First, far more people live in Globalized Cities than in Global Cities. So, if we want to understand urban life under globalization, it is at least as important to study these spaces. Second, the Global City and the Globalized City often overlap. I would suggest that all Global Cities contain areas that are not the engine house of globalization and are globalized, but many Globalized Cities may not contain any Global City components at all. The Pearl River Delta may include one possible Global City, depending on whether Hong Kong is part of the Pearl River Delta area. But it includes a much wider range of urban space, all of which is being transformed by China's integration into the global economy and is entirely outside the category of the Global City. As such, the Pearl River Delta is a prime site for investigating the Globalized City.

What is the relationship of the Globalized City and the "Generic City"? Could the Generic City be a way of understanding Sanyuanli and the newly urbanized spaces of the Pearl River Delta and Globalized City? The Generic City is Rem Koolhaas's vision of urban space under the order of globalization. He begins his essay by asking, "Is the contemporary city like the contemporary airport — 'all the same'?"[14] This reference to the airport is important, because air transport is a key factor in shaping the patterns of globalization. In the pre-industrial era, cities grew up on rivers, because water transport was quicker than surface transport. In the industrial era in nineteenth-century Europe and America, the railroad was crucial because of its ability to transport large quantities of goods even more quickly and efficiently, leading to the growth of new cities around railroad hubs and the decline of river cities that were not on the railway. In the contemporary era, it is the air transport network that links together the hubs on the network of globalization.

Of course, large airports are often thought of as a hallmark of the true Global City, in Sassen's sense. But we can get an idea of the difference between Sassen's Global City and Koolhaas's broader vision of the Generic City by looking at the *Great Leap Forward* book. Not surprisingly, it contains a whole section on airports.[15] A book on the Global City would only look at Hong Kong and its new mega-airport at Chek Lap Kok, designed by Koolhaas's rival in global architecture, Sir Norman Foster. In contrast, Koolhaas and his colleagues treat the whole of the Pearl River Delta as one linked-up area of Generic City development with a number of airports. Unquestionably, the building of massive (and often underused) airports may attest to an ambition to become a Global City, but it does not mean the city has made it yet.

The main hallmark of the Generic City is the quality of sameness and indistinguishability. Like airports, they are all the same, Koolhaas says. Furthermore, he also claims that "the Generic City is largely Asian."[16] What kind of a space is this? It is one in which "The only activity is shopping."[17] It is the "city without history,"[18] in which a historic district remains only as a tourist district. It is a place in which "serenity ... is achieved by the *evacuation* of the public realm."[19] That last phrase is very important. From a classic modern perspective, Koolhaas's city sounds like a nightmare realm, one in which there is no public sphere and no society. However, for Koolhaas, this is something to celebrate. He calls the growth of the generic city "a global liberation movement"[20] and says it "is the city liberated from the captivity of center, from the straitjacket of identity."[21]

What kind of a vision of the globalized city is this? First, in regard to time, this is the same vision as articulated in Francis Fukuyama's notorious "End of History" essay[22] — the idea that with the fall of the Berlin Wall (and China's "marketization"), liberal capitalism has triumphed in the form of a globalized Americanism, and that therefore there is no further need for contest or difference. Second, I think that this is also the capitalist fantasy of total abstraction: "all that is solid melts into air," as Marx famously put it[23] — a vision where everything is taken up and rendered, much as a pig is rendered into lard, in the process of producing exchange value accumulating surplus wealth. From this perspective, there is no resistance left or necessary. Like Fukuyama, Koolhaas celebrates this vision.

San Yuan Li

If the Globalized City is the Generic City for Koolhaas, in contrast U-thèque's vision in *San Yuan Li* is local and specific. By referencing Sanyuanli's significance as the Chinese Ur-site of resistance to imperialism, the opening of the film emphasizes Sanyuanli's uniqueness. At the same time, it seems to beg the question of present-day Sanyuanli's relationship to its history and the relationship of globalization and contemporary development to imperialism. These questions hover over the whole film and are re-emphasized by a series of four closing titles, which also seem to suggest that Sanyuanli's "progress" has been both specific and possibly downwards. The titles read as follows:

> In 1841, villagers of San Yuan Li revolted and fought against the British invaders in the Opium War. This incident has been considered as a landmark of China's anti-colonial and revolutionary history.
>
> In 1999, San Yuan Li was put on a nationwide list of 17 black spots with the most serious enforcement problems in illicit substances by Drug Enforcement Commission

of the National Ministry of Public Security, and was earmarked by the Ministry as a major target for clean-up measures.

In 2002, San Yuan Li was selected as one of the experimental spots to solve the "village-amid-the-city" problems by the Guangzhou government.

In 2003, U thèque organized the members to film San Yuan Li.

Between the opening and closing titles, two textual traditions shape U-thèque's organization of the "samples for detailed analysis" that they gathered.[24] One is the new Chinese realist mode that has grown up since the late 1980s. The second is the international genre of the city film. Known as *jishizhuyi*, or on-the-spot realism, the new Chinese realism is found across literature, fictional films, and television. It originated in the late 1970s to describe the new form of reportage writing (*baogao wenxue*) that emerged then and was associated with figures like Liu Binyan.[25] This new reportage made a claim to a new truthfulness associated with observation autonomous from the Party and the state, and therefore is most usefully distinguished from socialist realism. The independent documentary makers who took up this idea at the end of the 1980s and into the early 1990s came into contact with the socially engaged work of Japanese documentarian Ogawa Shinsuke and two important foreign traditions of observational documentary: American direct cinema and French cinéma verité.[26] Both these observational traditions emphasize contingency and refusing rehearsal, and they also eschew extra-diegetic elements such as mood music and narration.

San Yuan Li follows most of these basic principles. Except for the opening and closing titles, there is no narration, leaving much room for interpretation of the material presented. The film appears to have been shot in a spontaneous manner without any organization of its subjects, except in the final tableaux scenes (see discussion below). There is much handheld camerawork. People sometimes look at the camera curiously, and it appears to discover events as they happen. Indeed, one of the two main filmmakers, Cao Fei, seems to confirm this in her account of the film. She writes:

> ... the thought dawns on us that the subjects before us are beyond our control. Innumerable pedestrians and tricycles simply keep darting about, whipping up trails of dust and smoke in their wake. It is too easy to pan them in and out of the viewfinder. People look back at the camera lens with mistrust in their eyes. We keep a critical distance behind our monitor screen ...[27]

However, *San Yuan Li* is also unique among Chinese on-the-spot realist films. This can be illustrated by relating the films to the foreign filmmaking traditions China's on-the-spot realist films appropriate into the Chinese context. In feature filmmaking, the most powerful sources have been Bazinian theory and

the Italian neo-realism that Bazin admired so much, resulting in the evolution of a style of filmmaking that emphasizes natural locations and light, synchronous sound, the use of non-professional or unknown actors, and the long shot, long-take style, best exemplified perhaps by the work of Jia Zhangke. However, the fast-paced cutting and obtrusive composed musical score of *San Yuan Li* bears no relation to the Bazinian tradition.

Nor does *San Yuan Li* relate to either the American or French observational documentary cinema traditions. Its especially composed score and cutting back and forth across settings and events is completely contrary to American direct cinema. It is even less connected to the interview-as-intervention techniques associated with French cinéma vérité, which Wu Wenguang and others have drawn upon, as the film does not use interviews at all. Instead, *San Yuan Li* draws on another foreign lineage, the city film genre. Indeed, Ou Ning explicitly claims day-in-the-life-of-a-city films such as Vertov's *Man with a Movie Camera* (1929) and Ruttmann's *Berlin, Symphony of a Great City* (1927) as *San Yuan Li*'s forerunners when he states that, "we unambiguously acknowledge Dziga Vertov as our teacher and inspiration."[28] Ou also states that Ruttmann's film was particularly important for the decision to edit the film to music, which was especially composed for it by Li Chin Sung (a.k.a. Dickson Dee).[29]

U-thèque continues the city film tradition in the structure of the film. *San Yuan Li* begins with a long opening sequence, or prelude, of approximately nine minutes, equivalent to the first quarter of the film, traveling up the Pearl River, past the huge riverside luxury apartment developments of contemporary suburban Guangzhou, then onto the roads, and finally railways. We know we are nearing our destination, because we hear the first spoken words in the film: a recording of a train announcement that we are "arriving in Sanyuanli" in Mandarin, Cantonese, and English. A montage of signs bearing the name "Sanyuanli" follows. Then the music stops and the film goes to black.

The next sequence begins in deserted alleyways, deep in the literally dark heart of Sanyuanli, and the music begins again with a pulsing noise and then some chimes. This can be interpreted as Sanyuanli waking up, and the beginning of a day in the life of the city. Much in the manner of *Man with a Movie Camera* and *Berlin, Symphony of a Great City*, *San Yuan Li* is structured as a series of montage sequences of various activities marking the specificity of life in Sanyuanli. These montage sequences composing the main body of the film are organized into three movements, so to speak, each of which is rendered as one day in the life of the city, separated by nighttime scenes. Taken together, they constitute a street-level portrait that details the features of a unique and historically specific Globalized City.

The first movement consists of two montage scenes, each of about three minutes. The first scene is set in the quiet and dark alleys, as mentioned. As the montage proceeds, in more and more shots the camera looks up from the alleyways to the chinks of sky between the buildings. In the book part of the overall Sanyuanli project, Ou Ning explains that these apartment blocks are "illegally constructed by the villagers to maximise incomes. In order to obtain the largest possible floor space when putting up these houses, village builders typically only left a small gap between adjacent structures, creating the so-called 'threads of light' in 'villages-amid-the-city'."[30]

The second montage scene takes us up to the rooftops of Sanyuanli, from which we see the planes landing and taking off at Baiyun airport. Bracketed by the opening journey into the city and the rail terminus, this places the former village of Sanyuanli in the middle of metropolitan Guangzhou and between two major transport hubs. In this scene, we also see that the former farmers maintain room gardens where they keep chickens and other farm animals, as well as grow various crops, "perhaps bringing back people's pleasures of a former pastoral life."[31] The scene and sequence ends with nighttime shots of planes landing. The airplane noise fades and is replaced by a Chinese stringed instrument, possibly an *erhu*, and a silhouette of a man on a rooftop, presumably playing it.

The remaining two movements, or days in the city, consist of four or five shorter montages each, but they also record conditions specific to Sanyuanli, rather than generic features. The first movement seems to focus more on the things that might first strike a visitor and to refer more to Sanyuanli's older reputation as anti-imperialist city. The montages consist of fashionable young women on the streets; Uyghurs from Chinese Central Asia (identifiable by the men's beards and hats); visitors to the anti-imperialist monument;[32] local opera performance;[33] and finally a lion dance. The fashionable young women and the Uyghurs are the products of Sanyuanli and China's integration into global culture and Sanyuanli's location next to the railway station, where most people joining the gold rush to China's prosperous south arrive. The remaining three montages are all of local elements predating Sanyuanli's absorption into Guangzhou. But it is notable that the lion dance, which would previously have wended its way through the village, now has to squeeze down the narrow alleyways.

After another nighttime montage, the final movement is more focused on the work and leisure activities of the present-day inhabitants. Just as with the previous movement, this one opens with a morning-in-the-city montage. However, where the earlier montage was of empty alleyways, this time we have people sitting in doorways reading newspapers, children on the way to school, and so on. The next montage is of various local manufacturing activities,

from sewing workshops to appliance repair men, followed by a montage of local recreational activities, such as playing mahjong, cards, and pool, doing taekwondo. The next montage is of media usage, and focuses on televisions visible from the street and the long-distance telephone shops from where Sanyuali's many immigrants call home. A montage of people in the barbershops and hairdressing salons is followed by one of people smiling. Sometimes they are caught smiling, and sometimes they are smiling at the camera.

This is the first scene of sustained connection between the filmmakers and the people of the neighborhood. It is followed by another long montage scene of a similar length to the two that opened the main body of the film after the journey up the Pearl River to Sanyuanli. This time it consists of tableaux of the workers in Sanyuanli inside or in front of their workplaces, ranging from the local police to the restaurant staff. After the four titles detailed above comes a final montage resembling the self-referential material that Vertov's *Man with a Movie Camera* is so well known for, with shots that show the crew working in the alleyways, taking still pictures, and video recording.

San Yuan Li versus the Generic City

Perhaps the difference between Koolhaas's perspective on the Pearl River Delta and that of U-thèque can be summed up with the imagery of air transportation that so permeates both bodies of work. As has been noted, Koolhaas and his colleagues conclude their book on the Pearl River Delta with a section on airports. The final photograph in the book of U-thèque's San Yuan Li Project is also of a plane. However, whereas many if not most of the photographs in Koolhaas et al.'s *Great Leap Forward* and especially the photographs in the section on airports are extreme long shots taken from high up — including many aerial photographs — the concluding shot of *San Yuan Li* is taken from within the neighborhood and from below, showing a plane coming in to land over the roof gardens.[34]

In his pursuit of and celebration of the deterritorializing and dehistoricizing power of global capital, Koolhaas takes up a position in the clouds, straining to transcend quotidian materiality as he gazes down upon the world. In contrast, U-thèque insists on history and stays on the ground to record its traces and the very particular results of globalization's interactions with locality in Sanyuanli. U-thèque's work can pose the singularity of individual Globalized City spaces like Sanyuanli as an implicit critique of Koolhaas's fantasy of the Generic City, "liberated" from identity and history.

Indeed, returning to "The Generic City" with *San Yuan Li* in mind, one discovers some surprising claims. If, as Koolhaas claims, the Generic City is

supposed to be a typical Asian city today,[35] Sanyuanli seems far removed from it. Koolhaas claims that, "airports now are … all the average person tends to experience of a particular city."[36] What kind of "average people" are these? Do most people living in Asian cities only know their city through the airport? Has the average inhabitant of an Asian city in fact ever been to the airport or ever flown on a plane? In *San Yuan Li*, there are no shots from inside the nearby airport, or high up looking down on Sanyuanli from the airplane, or from highways whizzing in and out of the city to the airport. Could it be that in his description of the Generic City, Koolhaas is confusing his own experiences as an international architect from those of ordinary inhabitants? Or do ordinary inhabitants not count as real people for members of the Master-of-the-Universe class?

Koolhaas also writes, "the in-transit condition is becoming universal,"[37] but even if we extend this from the first- and business-class lounges to encompass the huge waves of internal labor migration in China, this statement seems an exaggeration at best. Koolhaas claims that "the street is dead" in the Generic City,[38] but the streets we see in *San Yuan Li* are teeming with activity. "Housing is not a problem" in the Generic City, says Koolhaas,[39] but the threads of light between Sanyuanli's new apartment blocks suggest otherwise. Koolhaas claims that history only remains in the Generic City as "a quarter called Lipservice."[40] However, the manicured tourist districts of deliberate preservation Koolhaas has in mind are not the historical remnants jumbled in with the unplanned new developments of Sanyuanli.

The critique of Koolhaas's fantasy of the Generic City as a liberation from history and identity that *San Yuan Li* seems to pose is persuasive. However, it would be both unfair and wrong to represent this as a two-line struggle between local resistance and global capitalism. First, it would be unfair because Koolhaas's and U-thèque's work is more complicated and contradictory than I have acknowledged yet. And it would be wrong, because U-thèque's own perspective is neither local nor resistant to the forces of global capitalism.

The Generic City Takes a *Great Leap Forward*

The complexity of Koolhaas's work can be seen when *Great Leap Forward* is examined in more detail and compared with "The Generic City." The latter was published in 1995 and the former in 2001. We can speculate that the six-year gap between them, more time spent on the ground in the intervening years, and the involvement of a wide range of scholars with extensive local experience in the Pearl River Delta may explain some of the differences. Whereas "The Generic

City" is abstract and lacks specific examples from the Asian cities it claims are typical, *Great Leap Forward* not only contains much detail on the Pearl River Delta region, but also a lot of the history that has supposedly disappeared from the Generic City and become irrelevant.

Far from confirming Koolhaas's fantasy of a city without history or identity, *Great Leap Forward* shows us a very specific space. For example, although Nancy Lin's chapter on architecture in the Pearl River Delta is focused on the construction of new international-style buildings, she is also careful to note the locally specific variations on these patterns. These include the use of feng shui,[41] leaving panels in glass curtain walls that can be opened so as to save on air conditioning costs,[42] and regulations allowing for seven-floor walk-ups as opposed to the usual maximum of five floors in most of Asia.[43] In addition to local specificity, *Great Leap Forward* also pays much attention to local history. It details a very specific process that — by accident — prepared the Pearl River Delta to become an ideal unobstructed "smooth" space for the operations of global capitalism. After a brief introduction by Koolhaas,[44] the book opens with a chronology by Yuyang Liu, which traces significant Chinese events over the past century.[45] Mihai Craciun's chapter on ideology and Shenzhen follows.[46] Here, the book moves from the national to the local level. Craciun explains the zone itself as a specific kind of space designed to mediate Chinese-foreign interactions. He traces the long history of such spaces back from Deng Xiaoping's Special Economic Zones like Shenzhen to Guangzhou in the period preceding the nineteenth-century Opium War that "opened China up" for the first time and the territorial concessions that followed the war.

On this basis, Craciun states that, "The beginnings of modern China are linked, therefore, to territorial manifestations ... The land concessions in the Pearl River Delta established the idea of a different China — a China of enclaves."[47] Both Craciun and U-thèque locate the beginnings of modern Chinese history in the Pearl River Delta and in the encounter with the West, as indeed do most Chinese historians and also Mao Zedong.[48] However, whereas Craciun chooses to begin with the first territorial concession, U-thèque selects Sanyuanli to begin because it is the first site of resistance to imperialism.

After a long series of aerial photographs that show scenes of high rises and other anonymous modern buildings from high up in the manner so typical of *Great Leap Forward*,[49] Craciun connects the selection of the Pearl River Delta region for Deng's Special Economic Zone "massive campaign of urbanization"[50] to its "'blank' condition" as a "cultural desert."[51] In Craciun's account, this condition is not fortuitous but produced by centuries of neglect of the outlying areas of empire by various dynasties and by Mao's active anti-urban efforts. After an initial stage of copying the Soviet emphasis on the city and the proletariat,

Mao's anti-urban direction led to sending populations out from the city to the countryside and the attempt at ironing out urban-rural difference.[52]

From the point of view of this history, there is no binary opposition between Chinese socialism and global capitalism: both these forces are interested in material accumulation through capital investment, but in the former the process is driven by the state and in the latter by private ownership. I am unable to examine how accurate such a perspective is. But in the age of global warming, the shared fantasy behind both socialist and capitalist materialism that if we accumulate enough wealth we will free ourselves from all material limitations appears more frightening than liberating, because freeing ourselves from materiality may take the form of destroying the planet we depend upon.

However, to return to the specific concerns of this essay with the different imaginings and imagings of the Globalized City, it is clear that *Great Leap Forward* produces a picture of the urbanization of the Pearl River Delta that is both specific and historical. Identity has not disappeared. After reading Koolhaas's "The Generic City," this is unexpected. However, it remains unclear whether Koolhaas and his colleagues see the history they record as remnants on the path to the Generic City, or as modifying the original vision of the Generic City.

In Sanyuanli but Not of Sanyuanli

Not only Koolhaas's perspective, but also that of the makers of *San Yuan Li* is more complex than it originally appeared to be. This has two results. In addition to creating ambiguity and complexity, it places U-thèque's critical vision within the order of globalization and not outside it.

To understand this, we need to examine the perspective produced by the rhetoric of *San Yuan Li* in more detail. In the introduction to his much-reprinted collection on cinematic approaches to the modern city, David Clarke traces some important differences in approach. On the one hand, there is a bureaucratic, abstract understanding of urban space encouraged by modernity's shift from (allegedly) organic pre-modern space and society to fragmented, alienated modernity. He writes, "the modern city was, concomitantly, the world as experienced by the stranger, and the experience of a world populated by strangers." Distinct from this is the flâneur, also a stranger in the city, but one whose "existence was built upon the sustained disavowal of the cognitive ordering of space, in favour of a self-defined and self-centred aesthetic spacing … traced out by way of a ludic peregrination."[53]

This opposition between the bureaucrat and the flâneur, both operating within modernity, seems to correspond to a later distinction Clarke makes between semiotic theories of the cinema (represented in his essay by the work

of Stephen Heath) and haptic theories of the cinema (represented by the work of Steven Shaviro). The former operates according to the logic of representation, assuming that an image and knowledge already exist to be reproduced. An understanding of the cinema as haptic, on the other hand, sees the technology of the cinema as a machine for apprehending the world — negotiating, experiencing, and even (in the broadest sense) feeling it.[54]

In some ways, *San Yuan Li* would seem to be part of the first, more analytic tradition. Certainly, the film operates according to an analytic logic, breaking down "data" into montages of similar scenes and material, as described earlier. Yet, Ou Ning says that the filmmakers called themselves "city-flâneurs."[55] And it is also true that U-thèque's cameras take us into and up and down the alleyways and streets of Sanyuanli, giving us a very tactile apprehension of the space. Rather than a binary opposition, a combination of the analytic and the haptic may be at work in *San Yuan Li*. This is more visible if we take time into account. For there is a shift within *San Yuan Li* complicating its initial perspective, just as there is a shift from "The Generic City" to *Great Leap Forward*. During the first two "days" that compose the film, long shots, often without people in them, predominate. In the final days, not only is there a shift from recording the kinds of places a tourist or outsider might visit to looking at the work and recreation patterns of the local inhabitants, but also the locals begin to acknowledge the presence of the camera for the first time. In the final sequences, the locals are composed into tableaux, suggesting communication and cooperation between filmmakers and inhabitants, and then we see the interactions between them in the shots showing the filmmakers at work.

Nevertheless, just as both the bureaucrat and the flâneur are strangers in the city and products of modernity, U-thèque's perspective may be in Sanyuanli, but they are never of Sanyuanli. So perhaps it is not surprising that Cao Fei not only acknowledges the inhabitants' initial mistrust, but she also writes that even after they have gotten to know the inhabitants better, "As we leave San Yuan Li, we step back to our city life. We begin to doubt if San Yuan Li village actually belongs to the metropolitan community we live in. When we show what we have recorded about San Yuan Li to other people, few of them can really appreciate its true character ..."[56]

What conclusions can be drawn for this essay from this combination of analytic and flâneur perspectives and this move from distance to smiling engagement with the inhabitants of Sanyuanli? First, although the film starts out by raising the possibility that Sanyuanli today may mark surrender to imperialism in the form of globalization and degeneracy where once it marked glorious resistance, by the end of the film this is far less clear. Although the final titles in the film may tell us that Sanyuanli suffered the ignominy of being listed

as a national drug black spot, in the film itself we see little evidence of urban collapse and decay. Rather, we see a people who work hard and play hard as they go about life in the city. Indeed, in the book part of the overall project, Ou Ning reports:

> By the time we began filming this documentary, most of the perilous things about the village of San Yuan Li had been improved ... drug dealing and substance abuse had all but disappeared from sight. The ... sex industry no longer ruled the place ... we also came into face-to-face contact with many grassroots party member cadres and clerical administrators. Their energy and efficiency left a deep impression on us and totally changed our prejudiced view of public servants.[57]

This statement marks a strong shift in Ou's attitude. With it, the transformation of Sanyuanli and China brought about by globalization no longer appears as a pure and negative extension of imperialism. Rather, although there is no reduction in its emphasis on the local and the specific, ambivalence about U-thèque's stance on globalization appears as the film proceeds.

Furthermore, the film makes no effort to ascertain the inhabitants' own feelings and opinions about the changes that have occurred. Do the former farmers who are now landlords of apartment blocks with rooftop gardens feel a sense of loss or gain, or a mix of the two? Do the immigrants who have come to the city feel they are exploited or lucky to have gained access to the city and its opportunities? Do the local officials feel they are losing power in the face of juggernaut of globalization or shepherding their city towards a richer future? Without interviews, all of these questions cannot begin to be answered.

As well as creating ambiguity about the inhabitants' attitude towards the globalization of Sanyuanli to go along with the filmmakers' own softened stance, the absence of interviews only underlines the gap between the filmmakers and the inhabitants. If U-thèque is in Sanyuanli but not of Sanyuanli, what else can we conclude about its perspective? First, its members are intellectuals and outsiders. This is quite clear from the narrative form of the film as a journey into Sanyuanli from outside. Second, the film reveals that not only are the filmmakers intellectuals, but they are also part of a new transnational class themselves. Just as Koolhaas is part of a transnational architecture world, they are part of a transnational art world. Not only was the film produced for the Venice Biennale, but it is also part of the international genre of city films of which U-thèque members, as cosmopolitan intellectuals and artists, are very aware.

In these circumstances, we must conclude by noting that although the difference between Koolhaas and U-thèque's visions of the Globalized City is real, both of them are within the order of globalization. Socialism in its classical form does not animate this distinction despite its nostalgic invocation by

U-thèque's San Yuan Li Project. If we are looking for a possible "outside" to the global order of capitalism today, more likely and certainly more powerful candidates for this status are the various organizations of fighters stigmatized as terrorists from within the order of global capitalism and seen as heroes fighting for Islam by their adherents. Rather, the contrast between the San Yuan Li Project and Koolhaas's vision of the Pearl River Delta indicates that what postsocialist China does enable is the possibility of alternative visions of globalization and the Globalized City from on the ground.

9

At the Center of the Outside: Japanese Cinema Nowhere

Akira Mizuta Lippit

Among the unique features of individual cities, aside from the features that define each place, is the speed with which any city can become at once a singular and global place: a space defined by an indeterminate quality that renders it the only possible place where it is and everywhere else at the same time. A city and the world at once, in an instant, defined by a temporality of place that constitutes the taking place of places. Somewhere, singular and always everywhere, nowhere, the world projected into the universe. Here, I am at the center where I am, wherever I am, and everywhere else: at the center of the world and at its end. Cities are uncanny places whose very familiarity, whose visual and emotional singularity, can induce a sudden and profound disorientation. From the center to the end of where I am at once. Freud speaks of the disorientation one finds at home, the experience of homelessness (*unheimlichkeit*) one feels only at home; he also proposes the ancient city — its numerous palimpsests and archaeologies — as a model (the only model) for the unconscious. As much as they are geographical, material, and actual, cities are also psychical spaces. They are projections, defined by the heterogeneity of spatial and psychical elements that constitute them. Any city can become the repository of a unique set of projections — fantasies, memories, and imaginary values — that transform it into an atopia, if not a utopia. Most, perhaps all, do. The transformation from a distinct place to an indistinct assemblage of affects is never complete; rather, the shift takes place, in place, as a dynamic variation between the physical and metaphysical values that form each unique place. At once: cities are in the world, but worlds also open inside cities, forcing them (cities) to exceed their geographical and historical specificity (physics) and assume the properties of a world, and even a universe (metaphysics). They are centers and ends of the world.

The city is a fantastic border that separates this place from the rest of space; a frame that defines the singularity of this place against the universality that surrounds it. This place rather than any other. It is physical to the extent it is finite, but rendered metaphysical by the imaginary qualities its borders enforce. Jacques Derrida invokes the complex economy that binds physical and metaphysical spaces, the earth and world, the totality of the world and the solitude of islands. In his final seminar titled "The Beast and the Sovereign," Derrida turns increasingly toward the subject of solitude, in particular the solitude of animals and sovereigns, beings marked by a primary relation to the outside.[1] To become animal, to become sovereign, is to come into contact with the profound solitude of the outside, to sense the profound solitude of the non-human world — to experience the world as a non-human being. Outside the law, outside community, and outside humanity, beasts and sovereigns, among other outsiders, inhabit the outside and come to determine a law of the outside, a community outside. Alone, animals and sovereigns live in the outside, and as figures of it. They are exposed to an outside world, a world outside, a world whose interiority is outside. They are inside-out in the world — in the world by being outside. The world thus framed by the force of exteriority and exclusion transforms the world, the very worldliness of the world, into an island.

Reading Daniel Defoe's 1719 novel *Robinson Crusoe*, Derrida speaks in his unfinished lectures of Crusoe's exile, in particular of the world that had become for the protagonist an island: "There is no world," says Derrida, "there are only islands."[2] Islands form at the end of the world, beyond or outside the world's end. The vast expanse of the world, which determines an inclusive form of being and life — a being in the world — has been turned inside out: alone and at a distance from humanity, from others, the outsider is sovereign on an island of one. The totality of worlds has been replaced by the multiple singularities of islands. He says:

> Between my world, the "my world"; what I call "my world," and there is no other for me, every other world making up part of it, between my world and every other world, there is initially the space and the time of an infinite difference, of an interruption incommensurable with all the attempts at passage.[3]

Between the singularity of "my world" (and "there is no other for me," Derrida claims) and the universality of "every other world" is "the space and the time of an infinite difference," he says, of an interruption that cannot be bridged; between "my world" and the world, between singularity and universality, there can be no passage, no "communication" or "translation."[4] My world is not a world at all, but an island: an absolutely singular space, incommunicable (incapable of community) and untranslatable. "There is no world, there are

only islands." Derrida is drawing from a long philosophical tradition that understands the world as a specifically human topography, a uniquely human formation of space that surrounds but also forms each human being. To lose oneself in the world, to abandon oneself to it but also to be abandoned by it, is to lose the very humanity of being human. If there is no world but only islands, then each individual human being on his or her own island is rendered uniquely non-human, ex-human, which is to say no longer human, beyond the laws of space that establish the humanity of the human as such. Each island is an end of the world, my end at the end of my world.

My end in the world, at the end of the world. In another idiom but one that reverberates with Derrida's, Jean-Luc Nancy invokes the end of the world, and its effect on one's *sense* of the world; on one's perception, understanding, and experience of the world; on one's relation to and place in it. For Nancy also, "there is no longer any world." He says:

> There is no longer any world: no longer a *mundus*, a *cosmos*, a composed and complete order (from) within which one might find a place, a dwelling, and the elements of an orientation. Or, again, there is no longer the "down here" of a world one could pass through toward a beyond or outside of this world. There is no longer any Spirit of the world, nor is there any history before whose tribunal one could stand. In other words, there is no longer any sense of the world.[5]

Nancy's sense of the world provides order and orientation in the world but also the possibility of passage from one place to another, one state to another, in both the geopolitical and spiritual senses of the word "state." The loss of this sense of the world propels one into a space without orientation, spirit, or passage. A space without; a worldless space. "We know, indeed," says Nancy, "that it is *the end of the world*, and there is nothing illusory ... about this knowledge."[6]

But what comes to an end in Nancy's declaration, the world or one's sense of it? How can one distinguish between the two? Has the world indeed ended, as Nancy seems to suggest, or has the *sense* of the world come to an end, as he also seems to suggest? Is he referring to the end of the world as such, or the end of my world, my sense of the world? This depends on whether one understands the world as a concrete or conceptual space, finite or infinite; whether the world is conceived within the laws of physics or metaphysics. The two are ultimately inseparable. This distinction, this dilemma disappears in Nancy as well as in other philosophical discourses of the world (Heidegger and Merleau-Ponty, for example) before it develops further: the world is at once a sense, and all sense is *a priori* a world, the world as such. Neither exists without the other. "Thus," says Nancy, "*world* is not merely the correlative of *sense*, it is structured as *sense*, and reciprocally, *sense* is structured as *world*. Clearly, 'the sense of the world' is a

tautological expression."[7] A tautology and redundancy, "the sense of the world," in Nancy's formulation, merges *sense* and *world* into one: all sense is sense of the world, and the world appears already only as sense. They are linked, in the end, to the end of the world, to the sense always of finitude. The affect that defines the sense of the world is the sense of its imminent finitude, of its limit, and of its end. In the end and at the end of the world, there is no world, only islands.

At the end of the world, I discover it to have been an island; the world revealed to be a planet scattered with islands. Each island a limit, each island an end of the world. On each island one person, alone, rendered sovereign of a worldless outside. To be outside, to be in the world in this sense is always to be at the center of one's own world, to *exhabit* a world that is no longer a world, no longer the site of plenitude, future, and others — neither *mundus* nor *cosmos* — but the discrete place of an absolute singularity outside: an absolutely singular outside and senseless world. To be outside is also to be at the center; at the center of the outside. I am alone at the center of the outside.

There Is No World, There Are Only Worlds

Among the recurring themes of the new Japanese cinema, a cinema whose resurgence in the 1990s brought many new directors to prominence, has been an acute focus on the specificity of places — cities, states, worlds, and spaces — and on the relation between particular places and the larger world that surrounds it, to a "sense of the world." From Okinawa in Kitano Takeshi's *Sonatine* (1993) to Otaru in Iwai Shunji's *Love Letter* (1995); from Gunma in Oguri Kōhei's *Sleeping Man* (Nemuru otoko, 1996) to Hiroshima in Suwa Nobuhiro's remake of *Hiroshima mon amour*, *H Story* (2001); from the lost capital Nara in Kawase Naomi's *Sarasojyu* (2003) to the *metrope* of loss, Tokyo in Sofia Coppola's neo-Japanese *Lost in Translation* (2003); from an unrecognizable Japan everywhere in Sai Yōichi's *All Under the Moon* (Tsuki wa dotchi ni dete iru, 1993) to an unremarkable Japan everywhere in Aoyama Shinji's *Eureka* (2000); from Oku Noto in Kore-eda Hirokazu's *Maborosi* (Maboroshi no hikari, 1995) to a small apartment in Tokyo in Kore-eda's *Nobody Knows* (Dare mo shiranai, 2004); Japan in the world (Los Angeles) in Kitano's *Brother* (2000) to the world in Japan in Miike Takashi's *The City of Lost Souls* (Hyōryū-gai, 2000), among many other examples, specific places ground numerous contemporary Japanese films, producing as it were a collective atlas of Japan projected in these films. Evident in this specificity is a tension unique to specificity at such: specificity defines a fragile condition and such places are at risk of losing their specificity into the abyss of universality or atopicality. Recognizable places risk disappearing into the world, unrecognizable. They are vulnerable to the terms of their own specificity.

In many of these films, specific places become islands, ends of the world, in the spatial and temporal idiom of that term. Beyond the uncanny economies of singularity, places become islands, marked by isolation and solitude. Specific places become ends of the world but also centers of an outside that open up beyond the limits and finitude even of worlds. And the center of the world is also the end of the world — the center establishes its finitude, *the moment of its end*. There is no world, only worlds; there are no cities, only *specificities*.

One film among many possible examples, neither exemplary nor exceptional in this regard, seeks to forge the "incommensurable" communication Derrida describes between "my world," the singularity of the world I inhabit, and the world populated and constituted by others, another's world (another world). Yukisada Isao's 2004 *Crying Out Love, in the Center of the World* (Sekai no chūshin de, ai o sakebu) navigates a complex geography of disparate elements in space, time, history, and memory, developing a mode of transit that takes characters to and from specific times and places in a phantom passage between this world and that other world.[8] It is a film suspended in the interruption of a world, in the paralysis this interruption creates. As the title suggests, the film invokes a sense of the world, a center of the world, in the form of a sense or affect (love and loss) and a mode of expression, crying, or more accurately, shouting (*sakebu*).[9] *Crying Out Love* takes place in and invokes specific sites — Takamatsu in Shikoku, where much of the film is set, and Uluru (Ayers Rock) in the Northern Territory of central Australia, where the film concludes. Each location forcefully establishes the sense of the film's place, its colors, affects, and fantasies. But the space of the film, the center of the world it conjures, takes place at a distance from any specific site, establishing a mediated and technological space that is irreducibly distant from the present and near only to the disappearance of space as such, to a radical form of *atopia*. An auratic space: at the center, nowhere, the specificity of place is constituted as and by distance.

The melodrama, a blockbuster hit throughout Asia, portrays two periods in the life of Matsumoto Sakutarō; as an adult in the present (Ōsawa Takao) and as a high school student in 1986 (Moriyama Mirai). In the present, Sakutarō is on the eve of marrying Fujimura Ritsuko (Shibasaki Kō), through whom he is thrown back into his past and forced to recall and relive his ill-fated love affair with Hirose Aki (Nagasawa Masami). The film alternates between 1986 and the present, between two moments in the life of Sakutarō, between two worlds that have been severed from one another. What sutures the past to the present, and each of the characters to one another, is a technological device and audio trope, the Sony Walkman.

Crying Out Love establishes the voice as a central motif, recorded audio as a dominant trope, and the Sony Walkman as a central signifier for the passage

between peoples, spaces, times, and worlds. While preparing for her move and new life with Sakutarō, Ritsuko discovers in an old sweater an audio cassette tape; she has to go to an electronics store to buy a device to play the cassette tape. All the machines have disappeared, evoking the trope of archaeology (a search for lost memories, lost voices, and lost machines) that continues throughout the film. The tape, recorded by Aki on the night of her death, is the last of a series of exchanged audiotapes between the young Sakutarō and Aki, which began after they competed to win a Sony Walkman through a radio contest. The competition between Sakutarō and Aki is to see who can be the first to have a postcard read on a late-night radio program. Sakutarō wins the competition by making up a story about a young girl who resembles Aki and has been stricken with leukemia. This upsets Aki, who initiates a series of recorded exchanges with Sakutarō as a means of reconciling. The technique of recorded missives allows Aki and Sakutarō to speak candidly to one another; in this way, their courtship is mediated, canned, and assumes much later a form of indelible uncanniness. Aki eventually falls ill with the leukemia. As a result of their courtship and sustained communication with recorded audio, a virtual archive of their romance remains intact, as a record of their love affair. They leave behind a trace of their brief romance in 1986. Seventeen years later, Ritsuko leads Sakutarō back to Takamatsu, where he rediscovers the taped archive, and the world that is both preserved and lost.

The Walkman operates as a historical signifier (1986), an emblem of the era, its representative technology, perhaps, but also as a trope, a mode of communication and a way of rendering the world through private audio.[10] It is a way to bring privacy, intimacy (honesty), and interiority into a public space. It renders the inside out and the outside in, transforming the world of audio into an island. Although they are together, each speaks alone, and each listens alone, a solitary conversation with the other. The Walkman shuts the world out for individuals, replacing it with a private and interior world. It also repositions the listening subject at the center of the world.

A climactic scene takes place in the high school gymnasium, where Sakutarō replays the tape of Aki playing the piano. The tape was recorded in the hospital where Aki is already sick; Sakutarō listens to the tape again, for the second time in the space where, presumably, he listened to it for the first time seventeen years earlier. The audio represents a doubled and deferred reproduction, recorded once, heard earlier and then again later. Aki tells Sakutarō to walk through the gymnasium and onto the stage, and where she instructs him to stand before the piano and close his eyes. She insists that he keep his eyes closed, and when he opens his eyes, she immediately scolds him, as if she were there not at the moment she recorded the tape, but seventeen years later. Sakutarō responds by closing his eyes, but immediately says her name, "Aki." As if, in the instant

that he opened his eyes, he saw her there. Aki continues to speak, and her voice becomes increasingly embodied, an effect throughout of the uncanny liveness of the Walkman sound quality. The camera begins to track backwards, still focusing on Sakutarō, whose eyes remain closed. The moving camera establishes throughout this scene the presence of some other subjectivity, neither here nor there but everywhere. A point of view not located in any one person, in anybody, but dispersed throughout the gymnasium and the frame, at once diegetic and non-diegetic. Gradually the piano enters the frame and Aki comes into view there at the piano. With his headset still on and his eyes closed, Sakutarō listens to Aki play the piano. Feeling her proximity, Sakutarō removes the headset, eyes still closed: without any break, the sound of Aki's piano continues. The sound of rain of the outside enters the audio diegesis, breaking the interiority of Aki's performance. The sound levels are complex and uneven throughout this scene, including Aki's voice, which appears to move from recorded audio to embodied voice, from distant to close. The sound of the rain cuts in then out, establishing an economy of sound not unlike the moving camera that shifts or rather disperses the locus of subjectivity throughout the frame. She is there before him, embodied, transposed from the phantom audio to an impossible presence, a representation.

At that moment the camera cuts to Ritsuko who has entered the gymnasium. She sees Sakutarō alone on the stage, staring at the empty piano. But the sound of Aki's piano remains suspended along the line of the diegesis: it is unclear whether Ritsuko can hear the piano; the diegesis offers no indication. Sakutarō hears Aki's piano without the headset, and he sees her there with his eyes closed. His sense of the world is confirmed by her embodied entry through his senses. At this moment the stability of *this* place, its thereness, dissolves. Somewhere is no longer here nor there, but everywhere. The singularity and incommensurability of these disparate moments have been merged into an impossible topography. The audiotape has established a place, a specific site and set of senses, a world from an island. It is a phantom world; the collapse and convergence of worlds and of islands — Sakutarō then and now, Aki then, and Ritsuko now meet in this extra-sensory world where sounds and views are merged without a unified perspective or point of reference. Aki then, preserved as a schoolgirl, takes the hand of Sakutarō now, seventeen years later. Her otherworldly hand reaches through time, from one lost moment to another. She leans against him in a deferred embrace, one they never managed seventeen years ago. She says, "I love you."

Ritsuko witnesses the rematerialization of Aki; she stares intently in the direction of Sakutarō and Aki's phantom embrace, although the film does not provide a reaction shot to confirm what she sees. Instead, the scene appears to

dissolve into a sepia-toned shot of the young Sakutarō and Aki embracing on the same stage, which turns into an extended flashback in which Aki reveals to Sakutarō that she is sick. When the scene ends, the camera returns to a visibly shaken Ritsuko, who appears to have witnessed this flashback. It is unclear what exactly Ritsuko has seen: Sakutarō's hallucination, Sakutarō's memory, or the return of Aki into this world. The spectacle that Ritsuko witnesses remains ambiguous, unverified. Moved to tears by this scene of resurrection, Ritsuko rushes out of the gymnasium. In this scene, all of the systems have collapsed into one: past and present, technological audio and embodied sound, phantom and flesh. Each island assembled, reassembled for a moment into a world. The scene represents the center of the world, an impossible center that converges into a world for one instant before vanishing.

The ghostly economy that brings Sakutarō, Aki, and Ritsuko together constitutes a world because the here and now of this impossible moment — a palimpsest of multiple solitudes and multiple islands — yields a point of contact between the past and present, the here and there, the here and beyond: a passage, a spirit, a *cosmos*. The scene ends when Sakutarō opens his eyes and immediately looks in the direction of Ritsuko. Disoriented by his encounter with Aki, Sakutarō begins to flee the stage when he receives a call from his friend, Ryu (one technology displaced by the next — Walkman to mobile phone; both modes of disembodied vocal communication — one live, the other recorded). The sound of his phone penetrates this space from the outside, infusing it with another phantom, another world, elsewhere. "I just saw Aki," says Sakutarō. "She's not a memory," he insists. "Aki died alone seventeen years ago," he says. "At the end, she didn't try to see me, so when I'm here, I feel as if she's still here." History and memory, physics and metaphysics, the world and a sense of the world appear in the figure of Aki, whose very name, as she once explains to Sakutarō, refers to prehistory. The world she forms and performs at the moment falls outside history, prehistoric but also ahistorical and technological.

Crying Out Love constitutes a virtual archive of lost others: photographs, audio recordings, souvenirs, memories, and bones and ashes. It is a technological archive that forms a world of solitary figures suspended in time. Lost others and lost worlds (worlds lost in others) are remembered in the technological artifacts that litter the landscape of this film, like relics, tombs, and ruins — small indices that nonetheless make contact between people lost in time and in space possible, between the many solitary islands that form the world of this film. Audio devices including the audiotape, radio, and mobile phone dictate this film's narrative, establishing a mode of passage between people, places, and times; between one world and another. Sound makes possible a passage through the world, to invoke Nancy. The audiotape, but more specifically the Sony Walkman,

becomes itself a place; it takes and gives place, taking the place of place and establishing a locus for the unresolved affair that did not in fact end with Aki's death. Her undelivered missive, the voice that travels across seventeen years, finally returns through the hands of Ritsuko, who limps to deliver the tape.[11] Or, one could say, Aki's farewell — her uttered, recorded, but unheard goodbye — has remained in transit during this time until it enters the ears of first Ritsuko, then Sakutarō, before it is released into and out of the diegesis. The place opened up by the audiotape, by the Walkman, and the phantom and restless voice of Aki, allows the relationship to finally rest, to take its place at the "center of the world," here the vast and distant and prehistoric Uluru, Australia. Sakutarō and Ritsuko take Aki's ashes and her voice, traces of her life and body — to Uluru, a place that Aki saw only in photographs she found left in another's camera. It is a postponed voyage, one that Sakutarō and Aki never completed together.

The pursuit of a center, first Yumejima (Yume island, dream island) then Uluru, Australia, becomes for Aki and Sakutarō the center of their world together. During a clandestine trip to the depopulated Yumejima, arranged by Sakutarō's friend who conspires to facilitate the consummation of Sakutarō and Aki's love, the two discover among the abandoned relics of previous visitors a camera loaded with a roll of undeveloped film. They contain images of Uluru; retrieved from another's memories, from another's past, the photographs point Sakutarō and Aki toward the future and the end of the world — the end of the world at its center.

On Yumejima, Sakutarō's only attempt at physical (quasi-sexual) contact is rebuffed; he is scolded by Aki who postpones their first kiss until the right moment. This moment remains deferred indefinitely in life and takes place only in the metaphysics of the gymnasium scene where Aki reaches out from the past to embrace Sakutarō, from the other world into this one. (Later, as Aki nears death from a sanitized hospital room sealed in plastic, Sakutarō and Aki attempt to kiss each other through the plastic barrier; a prophylactic consummation made tragic and comic by the poignancy of the missed occasion earlier.) Yumejima is also where the first symptoms of Aki's fatal illness appear, a nose bleed followed by her collapse. It marks the beginning and end of Sakutarō and Aki; a beginning already in the end, and an end discovered in the beginning, from Yumejima to Uluru.

The central site of their mourning; a quasi-imaginary place where their eternity is preserved, far away in a vast exteriority. In Uluru, a sacred place for the dead, Sakutarō puts on his headset and listens to Aki's final communication. She recalls their time together and thanks him for having been so close. Invoking an uncanny temporality, she declares "I will never forget the precious time we spent together." Her memory will survive her. On the eve of her death, at the

moment of her death, she invokes a future memory: "I will never forget." The sonic force of her presence as a recorded audio renders her claim true: she can speak now, seventeen years after her death, of a past she has not forgotten. Her memory has survived her. Aki asks Sakutarō to "scatter her ashes on the winds of Uluru," then to live his life, to go on with his life which has been suspended, literally to live "his now" (*ima wo ikite*). The past and present, the living and dead, Takamatsu and Uluru are brought together in one world — the center of the world but also its end. The world kept alive by Aki's voice — a world preserved in the Walkman, itself a finite historical apparatus — comes to an end. At the end of the world and at the end of time, this time particular to this world, Aki returns from and returns to the phantom site of technology, to the space of a haunted audiocassette. To prehistory. She has become non-human, no longer human, but phantom and sovereign; she releases Sakutarō from the solitude of his island.

Sakutarō returns from the end of the world, from the paradoxical plenitude of his island, of the multiple islands he inhabits, into the outside and into the world, as an exile in the outside. Sakutarō rediscovers the world at its end, in its end, recognizing the essence of the world, its center, as the end of the world. For Sakutarō the world begins essentially at its end, as its end, as it ends. No longer defined in contrast to an island, no longer defined dialectically against solitude, the very possibility of the world, of being in it, requires the redemption of the island as its center: the possibility of the world in the island and as an island. In the end, in this end, there are no longer any places, only worlds, only ends, only centers.

Notes

Introduction

1. The report is available online at http://www.un.org/esa/population/publications/wup2007/2007WUP_Highlights_web.pdf, p. 1 (accessed February 28, 2009).
2. Peter G. Rowe, *East Asia Modern: Shaping the Contemporary City* (London: Reaktion Books, 2005), 7.
3. Zhang Tingwei, "Land Market Forces and Government's Role in Sprawl: The Case of China," *Cities* 17.2 (April 2000): 128.
4. See Saskia Sassen, *The Global City: New York, London, Tokyo* (Princeton: Princeton University Press, 2001).
5. Neil Smith, "Contours of a Spatialized Politics: Homeless Vehicles and the Production of Geographic Scale," *Social Text* 33 (1992): 66.
6. Ashley Dawson and Brent Hayes Edwards, "Introduction: Global Cities of the South," *Social Text* 22.4 (#81) (Winter 2004): 1.
7. One of the key texts analyzing the particular image environment that develops in these eras of accelerated economic development is Angelo Restivo's *The Cinema of Economic Miracles: Visuality and Modernity in the Italian Art Film* (Durham, NC: Duke University Press, 2002).
8. See Anna Klingmann, *Brandscapes: Architecture in the Experience Economy* (Cambridge, MA: MIT Press, 2007).
9. See program of The 18th Hong Kong International Film Festival, *Cinema of Two Cities: Hong Kong and Shanghai* (Hong Kong: Shi Zhenju, 1994).
10. Anna Tsing discusses the charismatic force of globalization rhetoric, the successor in many ways to the equally "seductive" and related rhetoric of modernization in "The Global Situation," *Cultural Anthropology* 15.3 (August 2000): 330.
11. Walter Benjamin, *The Arcades Project*, ed. Roy Tiedemann, trans. Howard Eiland and Kevin McLaughlin (Cambridge, MA: Harvard University Press), 405.
12. From an interview with Chen Kuo-Fu at "Double Vision: Taiwan Cinema Here and There," an international conference at Yale University in 2003 and quoted in Dudley Andrew's essay in this volume.
13. These volumes include the following: Mark Shiel and Tony Fitzmaurice, eds., *Cinema and the City: Film and Urban Societies in a Global Context* (Oxford: Blackwell Publishers, 2001); Shiel and Fitzmaurice, eds., *Screening the City* (London: Verso, 2003); Linda Krause and Patrice Petro, eds., *Global Cities: Cinema, Architecture, and Urbanism in a Digital Age* (Piscataway, NJ: Rutgers University Press, 2002); Stephen Barber, *Projected Cities: Cinema and Urban Space* (London: Reaktion Books, 2002); and David B. Clarke, *The Cinematic City* (London: Routledge, 1997).

14. "Mass Production of the Senses," *Modernism/Modernity* 6.1 (1999): 68.
15. Alys Eve Weinbaum et al., eds., *The Modern Girl around the World: Consumption, Modernity, and Globalization* (Durham, NC: Duke University Press, 2008); Zhang Zhen, *An Amorous History of the Silver Screen: Shanghai Cinema, 1896–1937* (Chicago: University of Chicago Press, 2006).
16. Christine Boyer, *The City of Collective Memory: Its Historical Imagery and Architectural Entertainments* (Cambridge, MA: MIT Press, 1996), 47.
17. Geoffrey Nowell-Smith, "Cities: Real and Imagined," in Shiel and Fitzmaurice, eds., *Cinema and the City*, 104.
18. Miriam Bratu Hansen, "Fallen Women, Rising Stars, New Horizons: Shanghai Silent Film as Vernacular Modernism," *Film Quarterly* 54.1 (Fall 2000): 10–22, see 10.
19. Fredric Jameson, "Notes on Globalization as a Philosophical Issue," in Fredric Jameson and Masao Miyoshi, eds., *The Cultures of Globalization* (Durham, NC: Duke University Press, 1999), 55, 57.
20. Anthony Vidler, *Warped Space: Art, Architecture, and Anxiety in Modern Culture* (Cambridge, MA: MIT, 2003), 234.

Chapter 2
1. Fredric Jameson, "Remapping Taipei," in *The Geopolitical Aesthetic: Cinema and Space in the World System* (Bloomington: Indiana University Press, 1992); Ackbar Abbas, *Hong Kong: Culture and the Politics of Disappearance* (University of Minnesota Press and Hong Kong University Press, 1998).
2. Fredric Jameson, "*Diva* and French Socialism," in *Signatures of the Visible* (New York: Routledge, 1990).
3. Dudley Andrew and Steven Ungar, *Popular Front Paris and the Poetics of Culture* (Cambridge: Harvard University Press, 2005), 347–50.
4. Margaret Cohen, *Profane Illuminations: Walter Benjamin and the Paris of Surrealist Revolution* (University of California Press, 1993), 90.
5. Cited in ibid.
6. In 1983 Assayas visited the Hong Kong film festival and began to champion Asian cinema, reporting on this for *Cahiers du Cinéma* (special issue, September 1984). As a filmmaker he has returned again and again to Asia, often with Maggie Cheung whom he married in 1991.
7. Hou Hsiao-hsien, "In Search of New Genres and Directions for Asian Cinema," *Rouge* 1 (2003).
8. Ibid.
9. Chen Kuo-fu, remarks after screening *Double Vision* at Yale University, October 31, 2003.
10. Kyung Hyun Kim, *Remasculinization of Korean Cinema* (Duke University Press, 2004).
11. Ackbar Abbas, in Linda Krause and Patrice Petro, eds., *Global Cities: Cinema, Architecture, and Urbanism in a Digital Age* (New Brunswick, NJ: Rutgers University Press, 2003).
12. Garrett Stewart, *Framed Time* (University of Chicago Press, 2008). Stewart deals exclusively with American and European films, leaving open speculations about Asian representations.

Interlude 2

1. For information about the locations used in the film, see the August–October, 2002 issue of "Hong Kong on Location: The Film Services Office Quarterly Newsletter," no. 8, pp. 3–4. The newsletter is available online at http://www.fso-tela.gov.hk/accessibility/common/newsletter/NewsletterE08.PDF.

Chapter 3

1. Darrell William Davis, "Japanese Popular Cinema: Cause for Cautious Optimism," in Anne Ciecko, ed., *Contemporary Asian Cinema: Popular Culture in a Global Frame* (London Berg Publications, 2006), 193–206.
2. Aaron Gerow, "The Sadness of the Impossible Dream: Lack and Excess in the Transnational Cinema of Miike Takashi," http://www.asianfilms.org/japan/gerow3.html (accessed December 15, 2005).
3. Darrell William Davis, "Re-igniting Japanese Tradition with *Hana-Bi*," *Cinema Journal* Vol. 40.4 (Summer 2001): 55–80.
4. Mark Schilling, *The Yakuza Movie Book: A Guide to Japanese Gangster Films* (Berkeley, CA: Stone Bridge Press, 2003), 80.
5. Kanazawa Makoto, "Miike Takashi," in Muto Kiichi et al., eds., *"Nihonsei eiga" no yomikata 1980–1999* (Tokyo: Film Atosha, 1999), 127.
6. Iwabuchi Koichi, *Recentering Globalization: Popular Culture and Japanese Transnationalism* (Durham, NC: Duke University Press, 2002), 28.
7. Michael Raine, "Ishihara Yujiro: Youth, Celebrity and the Male Body in Late 1950s Japan," in Dennis Washburn and Carole Cavanaugh, eds., *Word and Image in Japanese Cinema* (New York: Cambridge University Press, 2001), 202–25.
8. In addition to Ishihara, there were many other stars in the world of Nikkatsu action who were more or less modeled after American youth idols such as James Dean, Elvis Presley, Marlon Brando, Liz Taylor, and Natalie Wood: Kobayashi Akira ("Mr. Dynamite"), Akagi "Tony" Keiichiro ("the Japanese James Dean"), Shishido Jo, and female stars like Asaoka Ruriko, Matsubara Chieko, and Mari Annu. Titles were invariably sensational: *Pistol Rap Sheet: Quick Draw Ryu* (dir. Noguchi Hiroshi, 1960), *Roughnecks from Shimizu* (dir. Matsuo Akinori, 1959), *Pistol #0* (dir. Yamazaki Tokujiro, 1959), *Storming Brotherhood* (dir. Inoue Umetsugu, 1959). More familiar today are the experimental genre films by Suzuki Seijun: *Branded to Kill*, *Tokyo Drifter*, *Elegy to Violence*, *Youth of the Beast*. For a comprehensive coverage on the stars of Nikkatsu action films, see online source: "Nikkatsu Action Lounge," http://shishido0.tripod.com. See also Mark Schilling's *The Yakuza Movie Book: A Guide to Japanese Gangster Films* (Berkeley, CA: Stone Bridge Press, 2003), 31. For an introduction to Suzuki Seijun and his Nikkatsu films, see Simon Field and Tony Raynes, eds., *Branded to Thrill: The Delirious Cinema of Suzuki Seijuned* (London: Institute of Contemporary Arts and Japan Foundation, 1994).
9. Yomota Inuhito, "Miike Takashi DOA," Miike Takashi Retrospective, Torino International Film Festival, 2006.
10. Mika Ko, "The Break-up of the National Body: Cosmetic Multiculturalism and Films of Miike Takashi," *New Cinemas* 2.1 (2004): 29–39.

11. Tom Mes, *Agitator: The Cinema of Miike Takashi*, 2nd edition (New York: FAB Press, 2004), 114.
12. "Miike Takashi Interview," Special Features, DVD of *Rainy Dog* (London: Tartan Video, 2001).
13. Gerow, "The Sadness of the Impossible Dream." See note 2.
14. For tunnel-vision composition, see Emilie Yueh-yu Yeh and Darrell William Davis, "Navigating the House of Yang," in *Taiwan Film Directors: A Treasure Island* (New York: Columbia University Press, 2005), 104–18.
15. See the section on "Style," in Markus Abe-Nornes and Yueh-yu Yeh's website, *City of Sadness, Narrating National Sadness* (Berkeley, CA: Film Studies Program, University of California, Berkeley, 1998), http://cinemaspace.berkeley.edu/Papers/CityOfSadness/table.html.
16. For Hou Hsiao-hsien's critical reception in Japan, see Emilie Yueh-yu Yeh, "Poetics and Politics of Hou Hsiao-hsien's Films," in Sheldon Lu and Emilie Yueh-yu Yeh, eds., *Chinese-Language Film: Historiography, Poetics, Politics* (Honolulu: Hawai'i University Press, 2005), 169–72.
17. Yomota Inuhiko, *Nihon eiga no radikaru na ishi* (Radical will of Japanese cinema) (Tokyo: Iwanami Shoten, 1999), 145–228.
18. For the exuberant reception of East Asian cinema, see Yomota Inuhiko's *Eiga fuu'un* (Cinema turbulence) (Tokyo: Baishui sha, 1993).
19. Edward Soja, *Thirdspace: Journeys to Los Angeles and Other Real-and-Imagined Spaces* (Cambridge: Blackwell, 1996), 61.

Chapter 4
1. See Anthony Sutcliffe, "The Metropolis in the Cineman," in Anthony Sutcliffe, ed., *Metropolis: 1890–1940* (Chicago: University of Chicago Press, 1984), 160.
2. Sutcliffe, "The Metropolis in the Cineman," 160–61.
3. The figures of "Teddy Boy" (feizai) and "Teddy Girl" (feinu) frequently appeared in the 1960s Hong Kong cinema and popular culture. A definitive film example is *The Teddy Girl* (Feinu zhengzhuan) (dir. Lung Gang 1969). The emergence of these youth figures signaled the enunciation of Hong Kong youth culture in connection with the global postwar youth cultural craze.
4. See Georg Simmel, "The Metropolis and Mental Life" and "The Berlin Trade Exhibition," quoted in Iain Borden, "Space Beyond: Spatiality and the City in the Writings of Georg Simmel," *The Journal of Architecture* 2 (Winter 1997): 313–35, see 325.
5. See Borden, "Space Beyond," 329, emphases mine.
6. Among these directors, only Inoue Umetsugu kept his original name in the film credits, all others adopted a very Chinese-looking name, and were credited and billed under that name. Nakahira Ko, who directed the two films under study here, for instance, was renamed "Yang Shuxi."
7. "Transnational Collaborations and Activities of Shaw Brothers and Golden Harvest: An Interview with Chua Lam," conducted by Law Kar, Kinnia Yau Shuk-ting, and June Lam Pui-wah, compiled by June Lam, in Law Kar, ed., *Border Crossings in Hong Kong Cinema* (Hong Kong: Leisure and Cultural Services Department, 2000), 138–43, see 139.

8. Yueh-yu Yeh and D. W. Davis, "The Well of Youth: The Shaw Films of Inoue Umetsugu," in Wong Ai-ling, ed., *The Shaw Screen* (Shaoshi dianying chutan) (Hong Kong: Hong Kong Film Archive, 2003), 255–71, see 270.
9. See Lawrence Venuti, *The Translator's Invisibility: A History of Translation* (New York: Routledge, 1995), 25. "Foreignizing translation," according to Venuti, hinges upon "a violent rewriting of the foreign text [or source text], a strategic intervention into the target-language culture, at once dependent on and abusive of domestic values."
10. Jeremy G. Butler, *Toward a Theory of Cinematic Style: The Remake* (Ph.D. dissertation, Northwestern University, 1982), 187.
11. "Fang Hu Yan'ni tan zai riben pai 'Kuang lian shi'" (Interview with Jenny Hu on shooting *Money, Sex and Love* in Japan), in *Nanguo dianying* (Southern screen) (August 1968), No. 126: 30–33. Hu did mention that some exterior shots were completed in Hong Kong after they returned from Japan. The English title for *Summer Heat* was initially *Money, Sex and Love*.
12. For a historical analysis of how the train technology and the correlated industrialization around the mid-nineteenth-century Europe reshaped the space-time and the ways the population related to their surroundings, see Wolfgang Schivelbusch, *The Railway Journey: The Industrialization of Time and Space in the 19th Century* (Berkeley, CA: University of California, 1986).
13. Charles H. Harpole, "Ideological and Technological Determinism in Deep-Space Cinema Images: Issues in Ideology, Technological History, and Aesthetics," *Film Quarterly* 33.3 (Spring 1980): 11–22, see 14.
14. Jean-Louis Comolli, "Technique and Ideology: Camera, Perspective, Depth of Field [Parts 3 and 4]," in Philip Rosen, ed., *Narrative, Apparatus, Ideology: A Film Reader* (New York: Columbia University Press, 1986), 421–43.
15. Comolli, "Technique and Ideology," 424.
16. Ibid., 430, emphasis original.
17. Ibid., 438.
18. Ibid., 435, emphasis mine.
19. This refers to Japan's Benshi tradition during the silent era, when the screening of a foreign silent film was accompanied by a Benshi who stood next to the screen and narrated (oftentimes made up) what was going on in the film. By comparing the professor's capitalist discourse to this outmoded tradition, the iconoclastic Taiyōzoku characters satirize the adults' self-delusion and helplessness.
20. Note the irony that the iconoclasts often wear spotless Western suits over their Hawaiian shirts, and that their outdoors activities, such as water skiing, yachting, night-clubbing, and cruising, all presume prestigious economic status rarely seen in postwar Japan.
21. Nakahira's and Inoue Umetsugu's films made for the Shaw Bros. came with English subtitles as well as Eastman Color and Shawscope, which amply demonstrates that one important reason for contracting Japanese directors was to tap into the non-Chinese-speaking Japanese and Euro-American market. For original Hong Kong posters of *Summer Heat* and Inoue's *Hong Kong Nocturne*, see the color plates in Wong Ai-ling, ed., *The Shaw Screen*, n.p. It is noteworthy that Nakahira was credited and billed as Yang Shuxi, a Chinese-sounding name, whereas Inoue Umetsugu,

who insisted on using his Japanese name, was credited in the film as himself, but completely removed from the poster for *Hong Kong Nocturne*.
22. Rem Koolhaas, *S, M, L, XL*, quoted in Ackbar Abbas, "Cinema, the City, and the Cinematic," in Linda Krause and Patrice Petro, eds., *Global Cities: Cinema, Architecture, and Urbanism in a Digital Age* (New Brunswick, NJ: Rutgers University Press, 2003), 142–56, 146, 147.
23. Abbas, "Cinema, the City, and the Cinematic," 149.
24. Shen Jianzhi, "Siqian xianghou hua dangnian" (Remembering the olden days), in Wong Ai-ling, ed., *An Age of Idealism: Great Wall and Feng Huang Days* (Lixiang niandai: Changcheng, Fenghuang de rizi) (Hong Kong: Hong Kong Film Archive, 2001), 282. Quoted in Lo Wai-lok, "Qishi niandai chu zuopai shehui xieshi dianying de shequn kuangjia" (The community frame of the leftist social realist cinema from the early 1970s Hong Kong), in Lo Kwai-cheung and Evan Man Kit-wah, eds., *Age of Hybridity: Cultural Identity, Gender, Everyday Life Practice and Hong Kong Cinema of the 1970s* (Zamai shidai: wenhua shengfen, xingbie, richang shenghuo shijian yu Xianggang dianying 1970s) (Hong Kong: Oxford University Press [China], 2005), 181–91, 183. The earliest film that directly reflects radical movements and social unrests in Hong Kong is perhaps *Yesterday, Today, Tomorrow* (Zuotian, jintian, mingtian), shot by a small leftist studio, Rong Hua, in 1968, with documentary footages of the 1967 anti-Britain activities. This film was not released until 1970, after heavy self-censorship and cutting. The promotion activities made no mention of the content or the background of film. See *Xianggang dianying yu shehui bianqian* (Hong Kong film and social change) (Hong Kong, 1988), 41; Shen Jianzhi in Wong Ai-ling, ed., *An Age of Idealism*, 280–81.
25. Lo, "Qishi niandai chu zuopai shehui xieshi dianying de shequn kuangjia."
26. Ibid.
27. Jean-François Lyotard, "Acinema," in Philip Rosen, ed., *Narrative, Apparatus, Ideology*, 348–59, see 355, emphases mine.

Chapter 5
1. For a discussion on the artistic representation and intellectual debate on the "post-material" condition in China, see Sheldon Lu, "Tear Down the City: Reconstructing Urban Space in Contemporary Chinese Popular Cinema and Avant-Garde Art," in Zhang Zhen, ed., *The Urban Generation: Chinese Cinema and Society at the Turn of the Twenty-First Century* (Durham and London: Duke University Press), 137–60.
2. Ackbar Abbas, "Cinema, the City, and the Cinematic," in Linda Krause and Patrice Petro, eds., *Global Cities: Cinema, Architecture, and Urbanism in a Digital Age* (New Brunswick, NJ: Rutgers University Press, 2003), 142–56.
3. Abbas, "Cinema, the City, and the Cinematic," 150–52.
4. As quoted in Margot Lovejoy, *Postmodern Currents: Art and Artists in the Age of Electronic Media* (Upper Saddle River, NJ: Prentice Hall, 1997), 247.
5. It was a "garage show" of Zhang Peili's famous "Hygiene No. 3" (featuring the artist soaping and washing a chicken over and over again) on Hengshan Road in Shanghai. Charles Merewether, "The Long Striptease: Desiring Emancipation," *Parachutte: art contemporain*, no. 114 (2004): 43.

6. They are "The First Guangzhou Triennial, Reinterpretation: A Decade of Experimental Chinese Art (1990–2000)," opened in Guangzhou, China, November, 2002, and "Between Past and Future: New Photography and Video from China," opened at International Center of Photography and Asia Society in New York, June, 2004. The latter is an international touring show. The photo and video art works examined in this chapter, except for those indicated otherwise, are drawn from these two exhibitions and their catalogues.
7. See Arif Dirlik and Xudong Zhang, eds., Introduction, *Postmodernism and China* (Durham and London: Duke Univerity Press, 2000).
8. See, for instance, Paul Pickowicz, "Huang Jianxin's and the Notion of Postsocialism," in Nick Browne et al., eds., *New Chinese Cinemas: Forms, Identities, Politics* (New York: Cambridge University Press, 1994).
9. For an outline of the debate, see Zhang Yingjin, *Screening China: Critical Interventions, Cinematic Reconfigurations, and the Transnational Imaginary in Contemporary Chinese Cinema* (Ann Arbor, MI: University of Michigan Press, 2002), 340–43. See also Chris Berry's overview and evaluation in the introduction for his book, *Postsocialist Cinema in Post-Mao China: The Cultural Revolution after the Cultural Revolution* (New York and London: Routledge, 2004).
10. Berry, *Postsocialist Cinema in Post-Mao China*, 5.
11. Leo Ou-fan Lee, "The Tradition of Modern Chinese Cinema: Some Preliminary Explorations and Hypotheses," in Chris Berry, ed., *Perspectives on Chinese Cinema* (London: BFI, 1991).
12. For a useful study on the impact of piracy on contemporary film culture in the region, see Wang Shujen, *Framing Piracy: Globalization and Film Distribution in Greater China* (Lanham, MD: Rowman & Littlefield, 2003).
13. Robert Stam, *Film Theory: An Introduction* (Malden, MA: Blackwell, 2000), 315.
14. See my introduction, "Bearing Witness: Chinese Urban Cinema in the Era of 'Transformation' (*Zhuangxing*)," in Zhang Zhen, ed., *The Urban Generation: Chinese Cinema and Society at the Turn of the Twenty-First Century*.
15. Karen Smith, "Zero to Infinity: The Nascence of Photography in Contemporary Chinese Art of the 1990s," in Wu Hung et al., eds., *The First Guangzhou Triennial/ Reinterpretation: A Decade of Experimental Chinese Art (1990–2000)* (Guangzhou, China: Guangdong Museum of Art, 2002), 41.
16. Philip Rosen, *Change Mummified: Cinema, Historiography, Theory* (Minneapolis: Minnesota University Press, 2001).
17. Stam, *Film Theory: An Introduction*, 319.
18. Rosen, *Change Mummified*, 307–9.
19. Ibid., 348.
20. It refers to a form of "historiography that knowledgeably confronts the instabilities of the relationships that modern historicity established between past and present." "It abandons neither sequenciation, nor the necessity of assuming a positionality (however complex) in the present. But this sequenciation and this positionality are, among other things, themselves understood as being temporalized, as being 'in history'" (ibid., 354).
21. Charles Merewether, "The Long Striptease: Desiring Emancipation," 47.

22. See Yang Xiaoyan's perceptive analysis of this work and other experimental photo work with a focus on woman's body in her article, "Jingtou yu nüxing: kan yu beikan de mingyun" (Lens and women: the fate of looking and being looked at), *Dushu* 2002.
23. See a perceptive deployment of the concept in Kevin Hetherington, *The Badlands of Modernity: Heterotopia and Social Ordering* (London and New York: Routledge, 1997).
24. Pierre Bourdieu, *Photography: A Middle-Brow Art* (Stanford University Press, 1990 [1965]).
25. Wu Hung et al., *The First Guangzhou Triennial/Reinterpretation*, 274.
26. A similar installation/performance work, *One-Hour Game* (1996), by another Guangzhou's "Big Tail Elephant" group member Liang Juhui features the artist-cum-worker playing a game in a construction elevator for an entire hour. The action creates a personal space as well as alternative time in contrast to the overdeveloped surrounding. Wu Hung et al., *The First Guangzhou Triennial/Reinterpretation*, 276–77.
27. Peter Wollen, "The Situationist International: On the Passage of a Few People through a Rather Brief Period of Time," in his *Raiding the Icebox: Reflections on Twentieth-Century Culture* (Indiana University Press, 1993), 120–21.
28. Ibid., 122.
29. Xu Zhen's video *Scream* (1999) works in a similar but simpler manner. Xu utters a series of loud screams in a busy street in Shanghai. When people turn around he shoots their reactions. The video is thus marked these "fits and starts," breaking down the continuum or numbness of consumerism.
30. Tom Gunning, "'Now You See It, Now You Don't': The Temporality of the Cinema of Attractions," in Richard Abel, ed., *Silent Film* (New Brunswick, NJ: Rutgers University Press, 1996), 71–84.
31. For a critical overview of the emergence of the new documentary see Chris Berry, "Facing Reality: Chinese Documentary, Chinese Postsocialism," in Wu Hung et al., eds., *The First Guangzhou Triennial/Reinterpretation*, 121–31. Also Berenice Reynaud, "New Visions/New Chinas: Video Art, Documentation, and the Chinese Modernity in Question," in Michael Renov and Erika Suderburg, eds., *Resolutions: Contemporary Video Practices* (Minneapolis: University of Minnesota Press, 1996), 229–57.
32. Wu Wenguang, "He jilu fangshi youguande shu" (A book that has something to do with documenting), in Wu Wenguang, ed., *Xianchang* (Document) (Tianjing: Tianjing shehui kexueyuan chubanshe, 2000), 274–75.
33. Charles Leary, "Performing the Documentary, or Making It to the Other Bank," http://www.senses of cinema.com/contents/03/27/performing documentary.html.
34. Personal communication with Wen Hui.
35. Yin Yangzi, "Yanchu baogao: yu mingong yiqi wudao" (Report on a performance: Dance with farm workers), *Xinchao* (Next wave) (October 2001): 9.
36. See Yomi Braester, "Chinese Cinema in the Age of Advertisement: The Filmmaker as a Cultural Broker," *The China Quarterly* (2005): 549–64. Braester puts the Wu-Wen project in the same phenomenon of the emergence of the "filmmaker as a cultural broker" linking or mediating different interest groups.

37. Marcos Novak, "Transmitting Architecture," in Arthur and Marilouise Kroker, eds., *Digital Delirium* (New York: St. Martin's Press, 1997), 262.
38. Barbara Pollack, "Mainland Dreams on Tape," *Arts in America* (June/July 2004): 133.
39. Brian Winston, *Claiming the Real: The Griersonian Documentary and Its Legitimations* (London: BFI, 1995), 251–58.
40. Rey Chow, *Primitive Passions: Visuality, Sexuality, Ethnography, and Contemporary Chinese Cinema* (New York: Columbia University Press, 1995).
41. Berry, "Facing Reality," 122.
42. For an extended discussion on the nature of this form of urban modernity see my book, *An Amorous History of the Silver Screen, Shanghai Cinema, 1896–1937* (University of Chicago Press, 2005), especially Chapter 2.
43. Mayfair Yang, "Mass Media and Transnational Subjectivity: Notes on (Re) Cosmopolitanism in a Chinese Metropolis," in Aihwa Ong and Donald M. Nonini, eds., *Ungrounded Empire: The Cultural Politics of Modern Chinese Transnationalism* (New York and London: Routledge, 1997), 287–319.
44. Jane Perlez, "Casting a Fresh Eye on China with Computer, Not Ink Brush," *New York Times* (December 3, 2003), E5.
45. "Testing Ground," *Shanghai Star* (January 30, 2003), http://www.shanghaiart.com/texts/yfd04.htm.
46. Yang Fudong, "Yang Fudong Talks about the Seven Intellectuals," *Artforum* 42.1 (September 2003): 183.
47. Ibid., 183.
48. Cui Zi'en, *Diyi guanzhong* (The first spectator) (Beijing: Xiandai, 2003), 104–8.
49. In fact, I first heard about Chen's film through Wu in summer 2001. As the godfather of the independent documentary, he regularly receives requests for advice and was asked to council on the project.
50. Wang Yiman, "The Amateur's Lightning Rod: DV Documentary in Postsocialist China," *Film Quarterly* 58:4 (Summer 2005): 16–26.
51. Amelia Jones, *Body Art/Performing the Subject* (Minneapolis: University of Minnesota Press, 1998), 13.
52. http://www.netloungedv.de/2002/ e/DV-Filme/Andrew_Cheng_Yusu/.
53. http://www.netloungedv.de/2002/ e/DV-Filme/Andrew_Cheng_Yusu/.
54. Rosen, *Change Mummified*, 309.
55. Their commercial distribution is, however, within the purview of state censorship.
56. Stephen Wright, "Shanghai/Shanghai: Spaces without Qualities/Spaces of Promise," *Parachutte: art contemporain* 114 (2004): 31.
57. Paul Virilio, *The Lost Dimension*, trans. Harry Zone (New York: Semio-text(e), 1991), 11.
58. Ni Ching-ching, "Movies: A Drought in Shanghai," *Los Angeles Times*, May 19, 2002, F8.

Chapter 6

1. See Ackbar Abbas's discussion of Rem Koolhaas's Generic City, "Cinema, the City, and the Cinematic," in Linda Krause and Patrice Petro, eds., *Global Cities: Cinema,*

Architecture and Urbanism in a Digital Age (New York: Rutgers University Press, 2003), 147.
2. Maurice Blanchot, *The Writing of the Disaster*, trans. Ann Smock (University of Nebraska Press, 1985), 3.
3. Cathy Caruth, "Introduction," in *Trauma: Explorations in Memory* (The Johns Hopkins University Press, 1996), 4.
4. For a discussion of Maurice Blanchot's notion of disaster vis-à-vis trauma as well as trauma and history, see Oliver Harris, "Film Noir Fascination: Outside History, but Historically So," *Cinema Journal* 43:1 (2003).
5. Blanchot, *The Writing of the Disaster*, 6.
6. Jinsoo An, "*The Killer*: Cult Film and Transcultural (Mis)Reading," in Esther Yau, ed., *At Full Speed: Hong Kong Cinema in a Borderless World* (Minneapolis: University of Minnesota Press, 2001), 106–7.
7. Mun Sŏk, "Interview with the Director," *Cine 21*, no. 454 (March 22, 2005), http://www.cine21.com/Magazine/mag_pub_view.php?mm=005001001&mag_id=29198.
8. James Naremore, *More Than Night: Film Noir in Its Contexts* (Berkeley: University of California Press, 1998), 2.
9. Ibid., 6.
10. Ibid., 22.
11. While such displays of material prosperity have been ubiquitous in television dramas, there has been a tendency in Korean cinema to diffuse the focus to deal with other urbanization issues or more recently, to converge on issues of remembering.
12. Edward Dimendberg, *Film Noir and the Spaces of Modernity* (Cambridge: Harvard University Press, 2004), 168.
13. Ibid.
14. Michel de Certeau, *The Practice of Everyday Life*, trans. Steven Randall (Berkeley: University of California Press, 1984), 93.
15. The term "automobility" is coined by Dimendberg, *Film Noir and the Spaces of Modernity*, 101.
16. Gilles Deleuze, *Cinema 1: The Movement-Image*, trans. Hugh Tomlinson and Barbara Habberjam (Minneapolis: University of Minnesota Press, 1986), 8.
17. Maureen Turim, *Flashbacks in Film: Memory and History* (New York: Routledge, 1989), 70.
18. Ackbar Abbas, *Hong Kong: Culture and the Politics of Disappearance* (Minneapolis: University of Minnesota, 1997), 78.
19. Dimendberg, *Film Noir and the Spaces of Modernity*, 93.
20. Ibid., 92.
21. Ibid., 36.
22. Michel Foucault, "A Preface to Transgression," in Donald Bouchard, ed. and trans., *Language, Counter-memory, Practice: Selected Essays and Interviews by Michel Foucault* (Ithaca: Cornell University Press, 1977), 34.
23. Caruth, "Introduction," 8.
24. Niklas Luhmann, *Love as Passion: The Codification of Intimacy* (Stanford University Press, 1998), 25.
25. Blanchot, *The Writing of the Disaster*, 8.

Chapter 7

1. Lev Manovich, *The Language of New Media* (Cambridge, MA: MIT Press, 2001), 63.
2. Sergei Eisenstein, "The Unexpected" (1928) and "The Cinematographic Principle and the Ideogram" (1929), in *Film Form* (New York: Harcourt Brace), 28–44. These essays are indebted to Japanese art and theater, but in the mid-1930s Eisenstein encountered Mei Lan-fang, virtuoso of Beijing opera, together with Brecht. Brecht's theory of the epic theater, rejecting empathy, psychologism, and interiority of performance, was inspired by Chinese opera's symbolic conventionalism. *Brecht on Theatre*, trans. J. Willet (New York: Hill and Wang, 1964), 91–99. See also Renata Berg-Pan, "Mixing Old and New Wisdom: The 'Chinese' Sources of Brecht's Kaukasischer Kreidekreis and Other Works," *German Quarterly* 48.2 (March 1975): 204–28. For Barthes, see note 27 below.
3. Brian Ruh notes that Kusanagi's diplomat victim is also a cyborg, as we see cables and cords explode from his body alongside blood and organs. The office fish tanks are similarly revealed to be holographic illusions that simply go out, and do not flood the room in water. Brian Ruh, *Stray Dog of Anime* (Palgrave Macmillan, 2004), 130–31.
4. Jay Leyda, trans. and ed., *Eisenstein on Disney* (London: Methuen, 1988). Livia Monnet quotes from this work: "ecstasy is an … experiencing of the primal omnipotence — the element of coming into being — the plasmaticness of existence, from which everything can arise. And it is beyond any image, without any image, beyond tangibility — like a pure sensation" (46). "Towards the Feminine Sublime …" *Japan Forum* 14.2 (2002): 225–68.
5. Murakami Hiroki and Azuma Hiroki, *Superflat* (Tokyo: Madra, 2000).
6. Thomas Looser, "From Edogawa to Miyazaki: Cinematic and Anime-ic Architectures of Early and Late Twentieth Century Japan," *Japan Forum* 14.2 (2002): 309.
7. Peter Carey, *Wrong about Japan* (London: Faber and Faber, 2005), 53.
8. Susan J. Napier, *Anime from Akira to Princess Mononoke: Experiencing Japanese Animation* (New York: Palgrave, 2000), 272.
9. I owe this point to James Tweedie.
10. Stephen Mulhall, "Kane's Son, Cain's Daughter: Ridley Scott's *Alien*," in *On Film* (London: Routledge), 51.
11. Ruh, *Stray Dog of Anime*, 133–34; Napier, *Anime from Akira to Princess Mononoke*; Carl Silvio, "Reconfiguring the Radical Cyborg in *Ghost in the Shell*," *Science Fiction Studies* 26.77 (March 1999): 54–72.
12. Oshii toned down the fetishized sexuality of Kusanagi from how Shirow represents it in *Kokaku Kidotai*.
13. Chris Hables Gray, *Cyborg Citizen: Politics in the Posthuman Age* (Routledge, 2001).
14. Gray, *Cyborg Citizen*, 158, quoting Lisa Moore and Monica Clark.
15. On the importance of feedback loop as narrative principle, see Manovich, *Language of New Media*, 314–22.
16. Thomas Foster, in a discussion of *Snow Crash* called "Franchise Nationalisms," in *The Souls of Cyberfolk: Posthumanism as Vernacular Theory* (Minneapolis: University of Minnesota Press, 2005), 207. The novel takes place in a future "organized around an informational logic of reproducibility that allows [burbclaves] to mediate between the local and the global, to thrive in one place as well as another" (205).

17. Manuel Castells, *The Urban Question* (London: Edward Arnold, 1977). Quoted in Edward W. Soja, *Postmodern Geographies: The Reassertion of Space in Critical Social Theory* (London: Verso, 1989), 83.
18. Ruh, *Stray Dog of Anime*, 121.
19. *Inside Man* also has an example of Hansen-Bordwell hypothesis: the white hero inspects a black kid's ultraviolent Gameboy, blown up to theatrical screen size, in which an enemy player is beaten up, shot, and has his mouth stuffed with a hand grenade that is promptly detonated. Inside Man, visibly shocked, says (something like) "Your parents let you play this?"
20. Mark Schilling, review, *Screen International* (April 9, 2004): 17.
21. "Sexy SIMS, Racy SIMMS," in Beth Kolko, Lisa Nakamura, and Gilbert Rodman, eds., *Race in Cyberspace* (New York: Routledge, 2000), 71.
22. Gray, *Cyborg Citizen*, 4.
23. Quoted from brochure, "Takayama Yatai Kaikan" (Processional float hall), Hida Takayama, Gifu ken, Japan.
24. Christopher A. Bolton "From Wooden Cyborgs to Celluloid Souls: Mechanical Bodies in Anime and Japanese Puppet Theater," *Positions: East Asia Cultures Critique* 10.3 (2002): 740.
25. Ibid., 729–71.
26. Ibid., 738.
27. See Barthes's account of the puppets in *Empire of Signs*, trans. R. Howard (New York: Hill and Wang), 1982.
28. Bolton, "From Wooden Cyborgs to Celluloid Souls," 740.
29. Ibid., 752.
30. Donald Richie, *The Japan Journals* (Berkeley: Stone Bridge Press, 2004), 166.

Chapter 8

1. Koolhaas and his partners' firm is The Office for Metropolitan Architecture (OMA). Its website address is http://www.oma.nl/.
2. U-thèque's website address is www.u-theque.org.cn/ (accessed September 22, 2009). The websites of Ou Ning and Cao Fei are www.alternativearchive.com and www.caofei.com/, respectively (accessed September 22, 2009).
3. Rem Koolhaas, "The Generic City," in Rem Koolhaas, Bruce Mau, Jennifer Sigler, and Hans Werlemann, eds., *S, M, L, XL* (New York: Monacelli, 1995), 1248–994.
4. "Learning from China," *ArchiNed Nieuws*, December 5, 1996, http://www.classic.archined.nl/news/9612/rem_marina.htm (accessed May 20, 2006). The title of this interview is, of course, itself a kind of answer to Robert Venturi's famous architectural manifesto, *Learning from Las Vegas* (Cambridge: MIT Press, 1972).
5. The opening title reads "Participating in Z.O.U., the 50th Venice Biennale." The fiftieth biennale was held in 2003, and according to David Barrett "Z.O.U." stands for "Zone of Urgency." David Barrett, "Flown In, Zoned Out," *Art Monthly* No. 268 (2003), http://www.royaljellyfactory.com/davidbarrett/articles/artmonthly/am-venice03.htm (accessed April 14, 2006).
6. Chihua Judy Chung, Jeffrey Inaba, Rem Koolhaas, and Sze Tsung Leong, *Harvard Design School Project on the City: Great Leap Forward* (Köln: Taschen, 2001). A taster of

Koolhaas's work on the "great leap forward" has been translated and published in Chinese in Jiang Yuanlun and Shi Jian, eds., *Yichu de dushi* (Brimming city) (Guilin: Guangxi Shifan Daxue Chubanshe, 2004), 31–45.
7. Ou Ning and Cao Fei, in association with U-thèque members, eds., *The San Yuan Li Project* (Guangzhou: U-thèque Organization, 2003).
8. Ou Ning, "Shadows of Times," in Ou et al., eds., *The San Yuan Li Project*, 38.
9. This version is given, for example, in the 1959 film, *Lin Zexu and the Opium War*. For more discussion of this and other film versions of the Opium War story, see Chris Berry and Mary Farquhar, *China on Screen: Cinema and Nation* (New York: Columbia University Press, 2006), 23–29.
10. Ou, "Shadows of Times," 37.
11. Hou Hanru, "Introduction," in Ou et al., eds., *The San Yuan Li Project*, 26.
12. Ou, "Shadows of Times," 39.
13. Saskia Sassen, *The Global City: New York, London, Tokyo* (Princeton: Princeton University Press, 1991), 5.
14. Koolhaas, "The Generic City," 1248.
15. Chung et al., *Harvard Design School Project on the City*, 625–701.
16. Koolhaas, "The Generic City," 1261. It has been pointed out to me that the idea that generic cities all look the same resonates with the Euro-American racist claim that all Asians look the same. I think this is not without relevance, but it should not be made too much of.
17. Ibid., 1260.
18. Ibid., 1250.
19. Ibid., 1251.
20. Ibid., 1248.
21. Ibid., 1250.
22. Francis Fukuyama, "The End of History?" *Quadrant* 33.8 (1989): 15–25. Originally published in *The National Interest* (Summer 1989). Available online at http://www.wesjones.com/eoh.htm (accessed September 7, 2006).
23. Karl Marx and Friedrich Engels, *The Communist Manifesto* (London: Penguin, 1985), 83.
24. Ou, "Shadows of Times," 38.
25. A translation has recently appeared of Liu's most famous writings: Liu Binyan, *Two Kinds of Truth: Stories and Reportage from China*, ed. Perry Link (Bloomington: Indiana University Press, 2006).
26. For further details, see Chris Berry, "Getting Real: Chinese Documentaries, Chinese Postsocialism," in Ping Jie, ed., *A New Look at Chinese Contemporary Documentary* (Lingyan Xiangkan: Haiwai Xuezhe Ping Dangdai Zhongguo Jilupian) (Shanghai: Wenhui Press, 2006), 69–83, and in Zhang Zhen, ed., *China's Urban Generation* (Duke University Press, 2006), 115–34.
27. Cao Fei, "A Wild Side of Guangzhou," in Ou et al., eds., *The San Yuan Li Project*, 49–50.
28. Ou, "Shadows of Times," 43.
29. "*Shidai Weekly* Interviews the Makers of *San Yuan Li*," in Ou et al., eds., *The San Yuan Li Project*, 314.
30. Ou, "Shadows of Times," 40.

31. Ibid.
32. This includes an interesting shot of the monument from below, appearing so tall that its top is out of frame. High in the sky, a plane approaches it, making it look like the Twin Towers on 9/11. But unlike 9/11, the plane disappears behind the monument and then reappears on the other side. One could read this as suggesting the anti-imperialist monument endures whereas the monument to capitalism did not.
33. At the end of the anti-imperialist monument montage, kids on a school visit are shown raising their fists to swear allegiance and then bowing to the monument. In the next shots, older people are shown lighting incense and bowing at a temple. In contrast to the shot discussed in the previous endnote, this might be read as comparing anti-imperialism and the rhetoric surrounding it to religious superstition.
34. While I do want to insist on these general tendencies in literal perspective, I am not claiming that *Great Leap Forward* contains no photographs taken on ground level, or that *San Yuan Li* does not include shots taken from high up — on the rooftop gardens, for example — looking down into the alleyways.
35. Koolhaas, "The Generic City," 1261.
36. Ibid., 1251.
37. Ibid., 1252.
38. Ibid., 1253.
39. Ibid.
40. Ibid., 1256.
41. Chung et al., *Harvard Design School Project on the City*, 179.
42. Ibid., 216–25.
43. Ibid., 245–46.
44. Ibid., 27–28.
45. Ibid., 32–43.
46. Ibid., 44–155.
47. Ibid., 83.
48. Mao Tse-tung, *The Chinese Revolution and the Chinese Communist Party* (Peking: Foreign Languages Press, 1960).
49. Chung et al., *Harvard Design School Project on the City*, 90–110.
50. Ibid., 117.
51. Ibid., 111.
52. Ibid., 47–61.
53. David B. Clarke, "Introduction: Previewing the Cinematic City," in *The Cinematic City* (London: Routledge, 1997), 4–5.
54. Clarke, "Introduction," 7–9.
55. Ou, "Shadows of Times," 42.
56. Cao, "A Wild Side of Guangzhou," 55.
57. Ou, "Shadows of Times," 41.

Chapter 9

1. At the time of this writing, Derrida's 2002–03 lectures have not been published. J. Hillis Miller quotes one passage from the unpublished manuscript in the original

French and in English translation. It appears in J. Hillis Miller, "Derrida Enisled," in W. J. T. Mitchell and Arnold I. Davidson, eds., *The Late Derrida* (Chicago: The University of Chicago Press, 2007), 30–58.
2. Cited in Miller, "Derrida Enisled," 48. "Il n'y a pas de monde, il n'y a que des îles."
3. Ibid., 47.
4. Ibid., 47.
5. Jean-Luc Nancy, *The Sense of the World*, trans. Jeffrey S. Librett (Minneapolis: University of Minnesota Press, 1997), 4.
6. Ibid., 4.
7. Ibid., 8.
8. Yukisada Isao served as assistant director for Iwai Shunji's *Love Letter* (1995), *Swallowtail* (1996), and *April Story* (Shigatsu monogatari, 1998) — three films acutely attuned to the fluctuation of worlds — and previously directed *Go* (2001), about a young Korean-Japanese torn between two selves, two communities, and two worlds.
9. The film's title in Japanese and in the English translation contains a poetic comma that serves no true grammatical or syntactical purpose; it creates a slight break, an interstice or afterthought that allows the phrase "in the center of the world" (sekai no chûshin de) to stand alone. In the English title, the order of the two clauses has been reversed.
10. According to the Sony website, the first Walkman, originally called Soundabout, was launched on June 22, 1979. The first model went on sale on July 1 of that year.
11. Ritsuko's limp, visible throughout the film, is never explained until the end. On the way to her last delivery of the tape that will remain suspended in transit, Ritsuko is struck by a car. The accident leaves her with a limp and prevents her from completing her task. Aki dies and the undelivered tape remains sealed in Ritsuko's sweater (itself a relic of her past, of this moment, of her trauma) until she uncovers it seventeen years later. Ritsuko bears her limp like Oedipus, always behind herself, always late to the place where she is destined.

Index

2046 (Wong Kar-wai), 26, 30–32
25 Hour (Spike Lee), 103
3-Iron (Kim Ki-duk), 45–46
9 Souls (Toyoda Toshiaki), 18

Abbas, Ackbar, 12, 37, 45, 85, 87, 129
Abe-Nornes, Markus, 65
action film genre, 14, 40, 55, 59, 63, 183*n*8; borderless, 57–61, 66; noir, 121
airports, 38, 43, 50, 129, 151, 159–65
Akira (Otomo Katsuhiro), 137
All about Lily Chou Chou (Iwai Shunji), 137
All under the Moon (Sai Yōichi), 174
Althusser, Louis, 107
American cinema, 9, 50, 58, 59, 69, 85, 99, 121–22, 138, 161, 162, 183*n*8
androids, 32, 60, 137. *See also* automatons; cyborgs
animation, 57, 139, 145–50
Asaoka Ruriko, 183*n*8
Assayas, Olivier, 39–40, 182*n*6
Audition (Miike Takashi), 41
automatons, 146–47. *See also* karakuri

Ballard, J. G., 137
Balzac, Honoré de, 38
Barking Dogs Never Bite (Bong Joon-ho), 22
Barthes, Roland, 138, 148
Bayside Shakedown (Motohiro Katsuyuki), 56
Bazin, André, 7, 80, 100, 147, 161, 162
Beckett, Samuel, 25
Beijing, 4, 14, 15, 21, 29, 30, 89, 96, 101, 102, 107–13, 152, 156

Beijing Bastards (Zhang Yuan), 108, 152
Beijing Bicycle (Wang Xiaoshuai), 38
Benjamin, Walter, 7, 30, 39
Berlin, Symphony of a Great City (Walter Ruttmann), 162
Berry, Chris, 99
billboards, 39, 91, 105
Bird People of China, The (Miike Takashi), 60, 61
Bittersweet Life, A (Kim Jee-woon), 119–36
Blade Runner (Ridley Scott), 127, 137, 140–42
Blanchot, Maurice, 120, 136
blockbuster, 17, 40, 49, 175
Borden, Iain, 70
Bordwell, David, 145, 192*n*19
Bourdieu, Pierre, 103
Boyer, Christine, 9
Boys from Fenggui (Hou Hsiao-hsien), 7, 64, 65
Brando, Marlon, 183*n*8
Brazil (Terry Gilliam), 138
Brecht, Bertolt, 138, 191*n*2
Breton, André, 39, 41
Brighter Summer's Day, A (Edward Yang), 64
Brokeback Mountain (Ang Lee), 35
Brother (Kitano Takeshi), 56, 174
Buddhism, 33
Bumming in Beijing (Wu Wenguang), 108
Butler, Jeremy, 73

Café Lumière (Hou Hsiao-hsien), 7, 22
Cao Fei, 15–16, 156, 161, 168; *San Yuan Li*, 15, 155–70

capitalism/market economy, 4, 5, 28, 30, 50, 51, 73, 82, 86, 90, 96, 98, 102–8, 111, 156, 160, 165–70, 185n19, 194n32
cars, 19, 77, 123–25, 132, 195n11
Castells, Manuel, 31, 145
Cat on a Hot Tin Roof (Richard Brooks), 58
CCTV Tower (Beijing), 15, 30
cell phones, 6, 33, 39, 43, 46, 50–51, 117, 178
censorship, 41, 58, 99, 104, 116, 152, 186n24, 189n55
Chandler, Raymond, 124
Chaplin, Charlie, 70
Cheerful Wind (Hou Hsiao-hsien), 7
Chen Kaige, 61
Chen Kuo-fu, 8, 41
Chen Lingyang's *25:00*, 102–3
Cheng Yusu (Andrew Chen), 113–16
Cheung, Maggie, 31, 32, 39, 40, 182n6
Chinatown, 14, 137–44, 148
Chŏn T'ae-il, 43–44
Chongqing, 17
chop'ok (gangster genre), 120, 121
Chow, Rey, 112
chronotope, 104
cinéma vérité, 161
city, global, 1, 4, 25, 31, 42, 51, 85, 111, 155, 158, 159, 171
city, globalized, 155–70
city, laminate, 116
city, modern, 9, 75, 97, 158, 167
city, transphysical, 111
city film genre, 7, 161, 162, 169
city in disappearance, 45
City of Lost Souls, The (Miike Takashi), 60, 174
City of Sadness (Hou Hsiao-hsien), 65
City of Violence, The (Ryoo Seung-hwan), 22, 120
Clarke, David, 167
Cohen, Margaret, 39
Cold War, 59–61, 83, 106, 119
Comolli, Jean-Louis, 80–81
computer-generated imagery (CGI), 140
Confucian Confusion, A (Edward Yang), 7

construction sites, 96, 104–10, 116, 131–33
Craciun, Mihai, 166
Crazed Fruit (Nakahira Kō), 12, 70–84
Crazy English (Zhang Yuan), 26, 28–30
Crazy Stone (Ning Hao), 17
Crouching Tiger, Hidden Dragon (Ang Lee), 97
Crying Out Love, in the Center of the World (Yukisada Isao), 175–80
cult films, 41, 55, 56, 66
Cultural Revolution, 19, 85, 99, 106, 113
cyber-culture, 139–40
cybernetic organism, 104, 139
cyberpunk, 136
cyberspace, 12, 16, 29, 116, 146
cyborgs, 14, 60, 139–48, 191n3. See also androids; automatons

Dance with Farm Workers (Wu Wenguang), 109–15
Davis, Darrell William, 14, 71
Dawson, Ashley, 4, 5
Days, The (Wang Xiaoshuai), 108
Dean, James, 183n8
Debord, Guy, 33, 106
deep focus, 80–81, 145
Deleuze, Gilles, 124
Delon, Alain, 122
Deng Xiaoping, 28, 30, 166
Derrida, Jacques, 172n75
Destination Shanghai (Cheng Yusu), 114
detective thriller film genre, 58
Dick, Philip K., 137
digital imaging, 13, 100. See also cyberspace; Second Life; virtual reality
digital software, 114–15
Dimendberg, Edward, 124, 130
direct cinema, 161, 162
Dirty Carnival, A (Yu Ha), 120
Disney, Walt, 139, 147
Disneyland, 15
Diva (Jean-Jacques Beineix), 38
DOA 2 (Miike Takashi), 60
DOA Final (Miike Takashi), 60

documentary film, 15, 26–28, 49, 96, 98, 104, 108, 109, 112–18, 161, 162. *See also San Yuan Li*
Double Vision (Chen Kuo-fu), 41
drug abuse and trafficking, 44, 62, 64, 115, 117, 169
Durian, Durian (Fruit Chan), 26–28
Dust in the Wind (Hou Hsiao-hsien), 65
DV (digital video), 13, 104, 109, 112–17
dystopia, 2, 14, 15, 34, 61, 66, 92, 96, 100, 116, 117, 122, 137

Eagle and Hawk (Inoue Umetsugu), 58
East Village, 108
Eastman Color, 73, 185n21
Eco, Umberto, 29
economic miracles, 1, 4, 5, 7
Edwards, Brent Hayes, 4–5
Eisenstein, Sergei, 138, 139, 146, 191n2
Enter the Dragon (Robert Clouse), 144
Estranged Paradise (Yang Fudong), 113, 114
ethnicity, 14, 57, 60, 66, 137–50
experimental film, 183n8

Fifth Element, The (Luc Besson), 138
Fifth Generation, 61
film genre, 6, 11, 40, 41, 43, 49, 55, 61, 66, 75, 104, 115, 121. *See also specific genres*
film sound, 64, 69, 73, 121, 132, 134, 162
film studios, 58, 66, 70, 114, 117, 186n24
flâneur, 167–68
Fleischer, Max, 139
floating population, 96. *See also* migrants
Foster, Norman, 159
Foucault, Michel, 103, 133
Freud, Sigmund, 171
Friend (Kwak Kyung-taek), 120
Frozen (Wang Xiaoshuai), 108
Fuji Television, 57
Fukuyama, Francis, 160
fusion cuisine (*mukokuseki ryori*), 57, 61

gangster film genre, 41, 50, 51, 55, 57, 58, 61, 69, 120, 121

gangsters 10, 27, 33, 34, 55–66, 138. *See also* gangster film genre
gender, 100, 132, 143
Generic City, 12, 14, 29–30, 38, 69–71, 85, 87, 97, 116, 119, 156–60, 164–68, 193n16
Gerow, Aaron, 64
ghost film genre, 41, 45
Ghost in the Shell (Oshii Mamoru), 137–45, 148
ghosts and spirits, 5, 12, 29, 37–47, 51, 135, 138–47
Gibson, William, 137
global vernacular: film as, 9
globalization (economic and cultural), 1, 3–7, 11–16, 25–31, 37, 42, 51, 56, 58, 61, 69–72, 85, 96–98, 104, 106, 109, 114, 120, 123, 125, 129, 137, 155–60, 163–70, 171
Good Men, Good Women (Hou Hsiao-hsien), 44
Good Morning, Beijing (Pan Jianlin), 21–22
graffiti, 31, 42, 102,
Gray, Chris Hables, 144, 147
Great Wall, Phoenix, Xin Lian (studios), 85
Grierson, John, 112
Guangdong, 3, 100
Guangzhou, 3, 97, 105, 156–66

H Story (Suwa Nobuhiro), 174
Hanabi (Kitano Takeshi), 56
Hansen, Miriam, 9, 10, 145, 192n19
Heidegger, Martin, 173
high-rises, 18, 21, 123–26, 129, 142, 158
Hiroshima Mon Amour (Alain Resnais), 174
Hitchcock, Alfred, 21
HIV-AIDS, 115, 117
Hollywood, 9, 50, 59, 85, 99, 138. *See also* American cinema
Home Sweet Home (Bai Jingrui), 151
homosexuality, 35, 46, 56, 60, 63, 64
Hong Hao, 101

200 Index

Hong Kong, 1, 3, 5, 7, 8, 12, 13, 26, 141–43, 159, 184n3, 185n11
Hong Kong Nocturne, 1–8, 12, 13, 25–35, 37–40, 45, 50–52, 55, 60, 69–87, 129, 141–44, 159, 185–86n21, 186n24
horror film genre, 12, 55, 120
Hou Hanru, 105, 158
Hou Hsiao-hsien, 21, 40–41, 44, 61, 64, 65

I Love Beijing (Ning Ying), 152
Iconographic Ethnicity (IE), 143
illness, 176–79
In the Mood for Love (Wong Kar-wai), 31–32, 45
Incheon, 43, 129, 130
Infernal Affairs (Alan Mak and Andrew Lau), 26, 33–34, 49–52
Innocence (Oshii Mamoru), 138, 141, 144–48
Inoue Umetugu, 58, 70, 71, 183n8, 184n6, 185n21
Inside Man (Spike Lee), 141, 192n19
instant cities, 1
Internet, 6, 15, 97, 116, 138
Ishihara Shintarō, 70, 72, 75
Ishihara Yujirō, 58–59, 72, 183n8
IT (Information Technology), 138, 143

James Bond films, 49, 57
Jameson, Fredric, 11, 37, 38, 145
Japaneseness, 56–59
jishizhuyi (on-the-spot realism), 161
junkspace, 51

Kan Xuan, 107
karakuri (wind-up doll), 14, 138, 146–50
Kawai, Kenji, 145
Kim, Kyung Hyun, 43
Ko, Mika, 60
Kokaku Kidotai (Shirow Masamune), 139, 191n12
Koolhaas, Rem, 12, 14, 15, 29, 30, 37, 51, 69–70, 85, 87, 97, 119, 125, 155–60, 164–70
KTV (karaoke bars), 97, 115, 116

Kuramoto, Yuki, 133–34
Kurosawa, Akira, 67

Lady from Shanghai (Orson Welles), 144
Lam, Chua, 71
Leary, Charles, 108
Léaud, Jean-Pierre, 39–40
Lee, Leo Ou-fan, 99
Lee Myong Bak, 125
Lefebvre, Henri, 106
Li Chin Sung (Dickson Dee), 162
Li Wei, *Mirroring*, 102
Li Yi-hsu, 64
Lin, Nancy, 166
Lin Cheng-sheng, 8
Liu Binyan, 161
Liu Lan (Yang Fudong), 113
Living Dance Studio, 109
Lo Wai-lok, 85
Loft (Kurosawa Kiyoshi), 41
Lost in Translation (Sophia Coppola), 174
Love Letter (Iwai Shunji), 174, 195n8
Lu Xun, 29
Luhmann, Niklas, 135
Lukácz, György, 106
Lumière brothers, 116
Luo Yongjin, 101
Lyotard, Jean-François, 86

Ma Qingyun, 116
Maborosi (Kore-eda Hirokazu), 174
Mahjong (Edward Yang), 64
Man with a Movie Camera (Dziga Vertov), 162, 164
Manovich, Lev, 6, 137
Mao Zedong, 166
Maoist period, 157
Mari Annu, 183n8
masculinity, 55, 59, 120
Matrix, The (Wachowski brothers), 137
Matsubara Chieko, 183n8
Matsuo Akinori, 183n8
Max Headroom (cyberpunk), 138
Méliès, George, 116
Melville, Jean-Pierre, 121, 122

memory, 15, 18, 31, 32, 39, 43, 47, 63, 74, 96, 101, 110, 111, 117, 119–23, 134, 142, 146, 157, 171, 175–80
Merewether, Charles, 102
Merleau-Ponty, Maurice, 173
Metropolis (Rintaro), 140
Mianmian, 114, 117
migrants, 9, 27–28, 37–40, 61, 96, 98, 104, 108–11, 114, 137, 138, 164, 165, 169
Millennium Mambo (Hou Hsiao-hsien), 7, 64
Milton, John, 145
Mitry, Jean, 80
Mizoguchi, Kenji, 67
modern architecture, 78, 186
Modern Girl, 9
modernism, 2, 8, 37, 122, 127
modernism, vernacular, 9
modernity, 8–12, 16, 17, 40, 43, 44, 45, 69, 70, 77, 78, 85–87, 89, 92, 104, 112, 114, 138, 141, 167, 168
modernization, 5, 7, 10, 12, 51, 64, 76, 77, 78, 98, 125
MP&GI, 70
MTR (Hong Kong metro), 78
Mulhall, Stephen, 142
Murakami, Haruki, 140
Murayama Mitsuo, 70
Murder My Sweet (Edward Dmytryk), 124
Murder, Take One (Jang Jin), 129

Nakahira Kō (Yang Shuxi), 12, 70–79, 284*n*6, 185*n*21
Naked Youth (Oshima Nagisa), 19–20
Nancy, Jean-Luc, 173–74, 178
Naremore, James, 121–22
nation, 3–5, 42–46, 56–61, 69, 86, 98, 122, 135, 141, 143, 150, 155–61, 166. *See also* nationless; transnational
nationless (*mukokuseki*), 13, 56, 57–61, 64, 66, 67
neon lights, 42, 89–92, 142, 143, 145
networks, 1–5, 9–13, 16, 25, 29, 31, 38–42, 50–81, 85, 119, 141, 142, 158, 159

new media, 1, 6, 10, 16, 96–100, 107, 118, 139
Nikkatsu Film Studio, 58, 66
Nobody Knows (Kore-eda Hirokazu), 174
noir film genre, 14, 57–58, 69, 72, 119–22, 129, 131, 135, 137
Nosferatu (F. W. Murnau), 40
nostalgia, 7, 57, 63–66, 102, 114, 121, 122, 127, 129, 145, 157, 169
nouvelle vague, 40
Novak, Marcos, 111
Nowell-Smith, Geoffrey, 9
Nowhere to Hide (Lee Myung Se), 120

Office Kitano, 57
Ogawa Shinsuke, 161
Okinawa, 63, 174
Old Boy (Park Chan-wook), 130
Old Men (Yang Lina), 115
Olympic games (Beijing, 2008), 4, 15
Opium War, 157, 160, 166
Orientalism, 67, 143
Other Bank, The (Jiang Yue), 108, 110
Ou Ning 156–8, 162–63, 168–69; *San Yuan Li*, 15, 155–70
outlaws, 61. *See also* migrants
overpasses, 21

para-cinematic, 118
Paris, 8, 9, 25, 38–40
Park Chung Hee, 125
Pearl River Delta, 155–70
Personals, The (Chen Kuo-fu), 8
photography, 9, 13, 39, 42, 45, 62–64, 96–103, 113, 116, 118, 140, 145, 155–57, 164, 166, 178, 179, 194*n*34
Pistol #0 (Yamazaki Tokujirō), 183*n*8
Pistol Rap, 183*n*8
political unconscious, 59, 86
pop culture, 59, 71, 72, 83, 99, 108, 184*n*3
post-cinema, 7, 96, 99, 100, 116, 118
postcolonial condition, 4, 57, 85
post-filmic cinema, 45
posthistoricism, 30
posthuman, 96, 140, 144

postmodern, 30, 37, 40, 42, 45, 87, 97, 98, 104, 109, 113, 114, 156
postsocialism, 95–104, 116–17, 170
postspatial void, 12
postwar era, 58–61, 69–78, 83–84, 105–6, 119, 123, 125, 184n3, 185n20
President's Barber, The (Lim Chan-sang), 123
President's Last Bang, The (Im Sang-soo), 123
Presley, Elvis, 183n8
Puppetmaster, The (Hou Hsiao-hsien), 65

Railroad Man (Furuhata Hasuo), 56
Rainy Dog (Miike Takashi), 57, 60–64
real estate developers, 45, 109, 111
reportage, 106, 161
Revision of World Urbanization Prospects (UN), 2
Richie, Donald, 79, 150
Rilke, Rainer Maria, 26
Ringu (Nakata Hideo), 40–41
RMB City, 15–16
Robinson Crusoe (Daniel Defoe), 172
Roman Holiday (William Wyler), 152
Rong Rong, 101
Rosemary's Baby (Roman Polansky), 41
Rosen, Philip, 100, 106
Roughnecks from Shimizu (Matsuo Akinori), 183n8
ruins, 62, 97, 102, 103, 109, 110, 134, 144, 178

Safely Crossing Linhe Road (Lin Yilin), 105, 106
Samourai, Le (Jean-Pierre Melville), 122
San Yuan Li (Ou Ning and Cao Fei), 15, 155–70
Sanyuanli (Guangdong), 15, 156–69
Sarasojyu (Kawase Naomi), 174
Sartre, Jean-Paul, 106
Sassen, Saskia, 4, 158–59
Schilling, Mark, 145
science fiction film genre, 14, 41, 55, 143
Scott, Ridley, 137

Second Life, 15–16
Seoul, 3, 5, 14, 21, 22, 37, 42–43, 45, 119–36
Seven Intellectuals in a Bamboo Forest (Yang Fudong)
Shanghai, 3, 5, 9, 14, 15, 29, 30, 95–97, 102, 107, 112–17
Shanghai in Sixty Years (Yang Xiaozhong), 96
Shanghai Panic (Cheng Yusu), 114–17
Shaw Brothers, 70–78, 85–86, 185n21
Shaw Brothers (film studio), 70, 78
Shawscope, 73, 185n21
Shenzhen, 3, 29, 30, 166
Shima Kōji, 70
Shining, The (Stanley Kubrick), 42
Shinjuku, 55, 57, 61–64, 67, 143
Shinjuku Triad Society (Takashi Miike), 57, 61–64
Shiri (Kang Je-gyu), 41
Shochiku, 56, 57
shop windows, 39, 104
Sil-Metropole, 85
Simmel, Georg, 70
Single Spark, A (Pak Kwang-su), 43–44
Situationist International, 13, 105–7, 117
Sixth Generation, 28, 99, 108,
Sleeping Man (Oguri Kōhei), 174
Smith, Karen, 100
Smith, Neil, 4
socialism, 28, 82, 83, 91, 96–99, 104–6, 110, 111, 156, 167, 169
socialist realism, 161
Society of the Spectacle (Guy Debord), 33, 106
Soja, Edward, 66
Sonatine (Kitano Takeshi), 174
Song Dong, 107, 110, 112
Sorum (Yoon Jong-chan), 42–43
Soviet Union, 83, 166
Special Autonomous Region (SAR), 28
Special Economic Zone (SEZ), 28
Stanley (Hong Kong), 73–75
Stephenson, Neil, 137, 138
Stewart, Garrett, 45

Storming Brotherhood (Inoue Umetsugu), 183*n*8
studio directors, 56
studio shooting, 12, 13, 78, 80, 81, 85, 116
Sudan, Rajani, 146
Summer at Grandpa's (Hou Hsiao-hsien), 7
Summer Heat (Nakahira Kō), 72–86, 185*n*11
Super Citizen (Wan Jen), 65
superflat, 140
Sutcliffe, Anthony, 69
Suzuki Seijun, 89–90, 183*n*8
Swallowtail (Iwai Shunji), 66, 137, 195*n*8

Taegukgi: The Brotherhood of War (Kang Je-gyu), 122–23
Taipei, 7–8, 12, 13, 18, 38, 41, 55–67, 151
Taipei Story (Edward Yang), 7
Taiyōzoku (Sun Tribe, youth film genre), 12, 69–87, 185*n*19
Take Care of My Cat (Jeong Jae-Eun), 38, 42, 43, 129
Tale of Two Sisters, A (Kum Jee-woon), 120
tape (audio), 157, 176–79
Taylor, Liz, 58, 183*n*8
teddy boys and teddy girls, 69, 184*n*3
Teddy Girl (Lung Gang), 184*n*3
Terrorizer (Edward Yang), 7, 37–41
Third World, 60, 62, 66, 157
Three Times (Hou Hsiao-hsien), 7, 44
Time to Live and a Time to Die, A (Hou Hsiao-hsien), 7, 65
Tokyo, 3, 5, 8, 12–13, 18, 19, 21, 38, 40, 61, 64, 65, 89, 141, 147, 174
Tokyo Drifter (Seijun Suzuki), 89–90, 183*n*8
Tong Biao, 106
total cinema, 147
tourism, 5, 13, 26, 27, 30, 40, 63, 73–75, 78, 151, 165, 168
trains, 7, 17, 21, 32, 43, 74, 77–78, 110, 162
transnational co-productions, 56
transnational economy and culture, 50, 56, 57, 61, 69, 73, 76, 86, 87, 99, 119, 128, 129, 169
trauma, 14, 40, 42, 43, 45, 119–21, 125, 128, 131–36, 195*n*11
triads, 10, 27, 33, 34, 61, 138
Tropical Fish (Yu-Hsun Chen), 18
Tropical Malady (Apichatpong Weerasethakul), 46–47
Tsai Ming-liang, 8
TV: as medium, 34, 38, 39, 45, 111, 116
Twenty-Something Taipei (Leon Dai), 152
Twilight Samurai (Tasogare Seibei), 56
Twin Towers (World Trade Center, 9/11), 103, 194*n*32

Uluru (Ayer's Rock), 175, 179–80
un-Japaneseness (*Nihon banare*), 59
U-thèque, 155–70
utopia, 5, 6, 10, 13, 15, 17, 60, 92, 98–107, 112, 117, 171

Venice Biennale, 169
Venturi, Robert, 89, 192*n*4
Venuti, Lawrence, 71
Victoria City (Hong Kong), 74
Victoria Harbour (Hong Kong), 78
video art, 13, 96, 98, 109, 113, 118
Vidler, Anthony, 12
Village Election (Wu Wenguang), 112
village-in-the-city, 15, 157–58, 161, 163
Virilio, Paul, 28, 116
virtual reality, 27, 99

Wakasugi Mitsuo, 70
Walkman, 175–80, 195*n*10
Wang Jingsong, 101
Wang Wei, 101
Welcome to Dongmakgol (Park Kwang-hyun), 123
Wen Hui, 109–10
western film genre, 57
What a Family (Wang Haowei), 89
Wollen, Peter, 106
Wong Kar-wai, 26, 30–32, 45

Woo, John, 121, 122
Wood, Natalie, 183*n*8
Wright, Frank Lloyd, 127
Wu Wenguang, 105, 108–12, 162

Xianchang, 96, 104–12, 116
Xiao Wu (Jia Zhangke), 102
Xing Danwen, 101

yachting, 73–75, 78, 185*n*20
yakuza, 55–66
Yang, Edward (Dechang), 7, 37, 61, 64

Yang Fudong, 101, 102, 113, 116
Yeh, Emilie Yueh-yu, 12–13
yellow peril, 14, 137
Yi Yi (Edward Yang), 7, 37

Zatoichi (Kitano Takeshi), 56
Zhang Dali, 101, 102
Zhang Yimou, 61
Zhang Yonghe (Yong-ho Chang), 109
Zhang Zhen, 9, 13
Zheng Guogu, 100
Žižek, Slavoj, 49